THE ILEX
INTRODUCTION
TO PHOTOGRAPHY

THE ILEX
INTRODUCTION TO PHOTOGRAPHY

Capturing the moment every time, whatever camera you have

HAJE JAN KAMPS

ILEX

First published in the UK in 2013 by:
ILEX
210 High Street
Lewes
East Sussex
BN7 2NS
www.ilex-press.com

Distributed worldwide (except North America)
by Thames & Hudson Ltd., 181A High Holborn,
London WC1V 7QX, United Kingdom

PUBLISHER: Alastair Campbell
ASSOCIATE PUBLISHER: Adam Juniper
MANAGING EDITOR: Natalia Price-Cabrera
SPECIALIST EDITOR: Frank Gallaugher
EDITORIAL ASSISTANT: Rachel Silverlight
CREATIVE DIRECTOR: James Hollywell
DESIGN: TwoSheds Design
COLOUR ORIGINATION: Ivy Press Reprographics

British Library Cataloguing-in-Publication Data
A catalogue record for this book is available from the
British Library.

ISBN 978-1-78157-986-2

CONTENTS

Introduction 6

1 EQUIPMENT

Fixed-lens cameras 10
Interchangeable-lens cameras 12
What to look for in a camera body 14
Fixed vs. interchangeable lenses 16
What to look for in a lens 18
Prime lenses vs. zoom lenses 20
What camera do you need? 22

2 PHOTOGRAPHY FUNDAMENTALS

What is an exposure? 26
Controlling exposure 28
Aperture & exposure 30
Shutter speed & exposure 32
Get creative with shutter speeds 34
Focus & depth of field 36
Focus & focusing modes 38
ISO & exposure 40
Shooting modes 42
Learning to look 44

3 LIGHT & COLOR

How light affects photography 48
Light quality 50
Basic studio lighting 56
Using flash 58
Flash control 60
Flash techniques 62
Off-camera flash 64
What is color? 66
Color & white balance 68
Creative color balance 72

4 BETTER COMPOSITION, BETTER PICTURES

Improving technique	76
Getting creative	78
Varying your viewpoint	80
Eliminating blur	82
Rule of thirds	84
The power of lines	86
Symmetry & repetition	88
Creating depth	90
Frames within frames	92
Break the rules	94

5 HOW TO SHOOT ANYTHING

Perfect landscapes	98
Portrait photography with natural light	100
Portrait photography with artificial light	102
Shooting in a studio	104
Street photography	106
Photographing pets	108
Architecture & city scenes	110
Close-up & macro	112
Travel photography	114
Photographing children	116
Photographing families	118
Wedding photography	120
Wildlife photography	122
Night photography	124
Still life photography	126
Food photography	128
Abstracts	130
Black & white photography	132
Shooting panoramas	134
HDR imagery	136
Focus stacking	138

6 SHARING & EDITING

Sharing on the move	142
Smart cameras & apps	144
Editing on the move	146
Sharing your photos	148
Desktop imaging software	150
Raw format	152
The editing workflow	154
Global editing	158
Spot editing	162
Black & white conversion	164
Exporting & backing up	166
Tracking progress	168

Resources

Glossary	170
Index	173
Acknowledgments	176

INTRODUCTION

Hello and welcome to the Introduction to Photography! Over the following pages we're going to make a fantastic journey through the world of photography, and I'm very happy that you've decided to come along!

Before we get started, I'd like to dispel two myths right off the bat, if you don't mind. The first one is that you need very high-end equipment in order to be able to take good photos. Nothing could be further from the truth. Sure there are occasions where a fancy camera might make your job easier, and there are indeed certain techniques that are impossible unless your camera has certain features, but on the whole, you really don't need to spend all that much money to hugely improve your photography.

The other myth is that photography requires "a good eye" or "natural talent." Hogwash. Getting started from the very beginner level—where you are right now—is easy. Once you've got to grips with the basics you'll find there are loads of very simple ways to drastically improve your shots, and this book is full of tips that will help you to progress quickly. Further down the line when you start getting the hang of things, you may find that in order to reach the next level you need to start developing an "eye for photography," but the secret not a lot of photographers will tell you is this: As soon as you realize that you want to start developing your own style, and training your eye for composition, you're already halfway there.

My number one top tip to becoming a better photographer is to be self-critical. Take a lot of photos, all the time. Use the camera built into your phone, take a compact camera with you everywhere you can, and dig out a bigger camera (if you have one) as often as possible. In the beginning, you may find that only one in a thousand photos is any good. But look on the bright side: If you take a thousand photos, you'll get at least one fantastic picture!

With practice, the tricks shown in this book, and a good idea of what all the buttons and dials on your camera do, you can start working on improving that ratio of good-to-bad shots: taking it from one in a thousand, to one in a hundred, to one in ten. Yes, it's a lot of work, but it's incredibly rewarding, and I promise you'll have a lot of fun along the way.

So what are you waiting for? Grab your camera, flip the page, and let's get started!

—Haje Jan Kamps

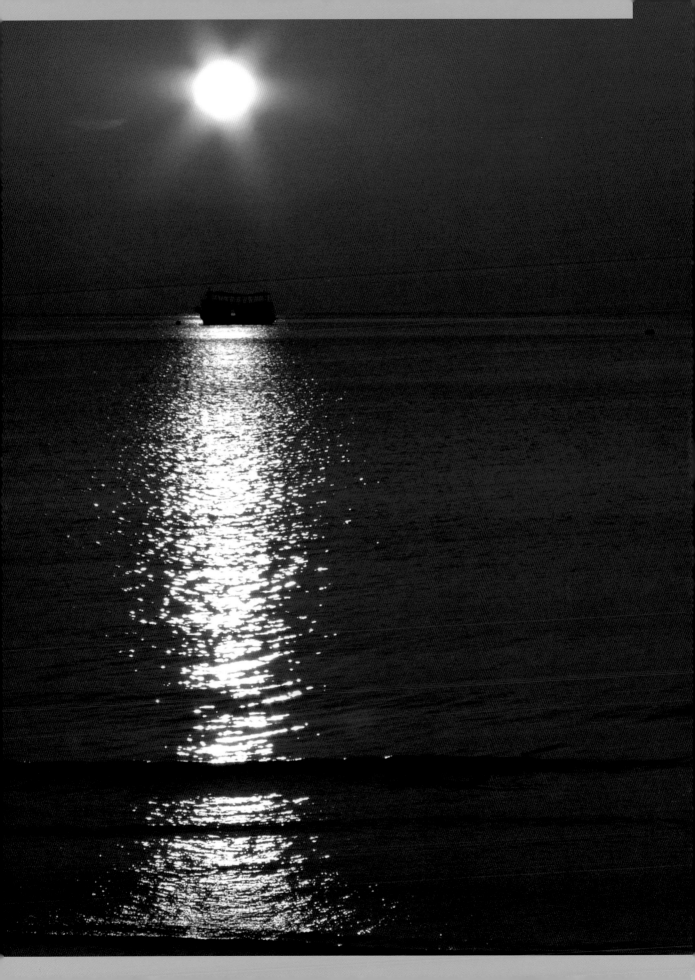

CHAPTER 1

EQUIPMENT

It's quite ridiculous how often discussions about photography can degenerate into "Mine's bigger than yours"-style conversations. It's doubly curious because, in our experience, among amateurs, the people with the most extravagant equipment often have the least clue about how to use it.

On the other hand, you are going to need equipment—if there's one way to guarantee you'll not capture a single good photo, it's by not having a camera with you!

Frequently, the most experienced photographers, who have dabbled with all sorts of high-end cameras, find themselves turning back to relatively simple equipment. This means that if you want to be a better photographer, you really shouldn't worry too much about your equipment. Worry about the person holding the camera. Work on becoming a better photographer, and your photos will improve. All the camera gadgets in the world are only going to be a distraction if you're struggling with the basics.

FIXED-LENS CAMERAS

The term "fixed-lens camera" applies to any camera with a lens that cannot be removed from the main body of the camera. There are numerous types of fixed-lens cameras, ranging from inexpensive, mostly automatic point-and-shoot models, through "bridge" or superzoom cameras with powerful zoom lenses, to high-end compacts with large imaging sensors that are capable of producing photos comparable to those taken with a DSLR (digital single-lens reflex camera—explained on the following pages).

Point-and-shoot cameras

Point-and-shoot cameras are small in size, typically have limited manual controls, and feature autofocus zoom lenses. Such cameras, often referred to as "compact cameras," are very simple to operate and are designed for people who primarily want a quick-and-easy visual record of vacations, birthdays, weddings, and similar events. In bright daylight conditions, point-and-shoot cameras can provide good quality images that look sharp at up to 8×10 inches.

The principal drawbacks with this type of camera are the small size of the sensor and, typically, a lack of manual control. A small sensor is less efficient at gathering light, therefore in high-contrast lighting conditions (e.g., bright sunlight combined with dark shadow areas) point-and-shoot cameras will struggle to produce clean-looking or accurately exposed images. The lack of manual control also makes it difficult to shoot creatively—for choosing focus or high-key effects, for example, which we'll cover later.

Bridge or superzoom cameras

So-called because they "bridge" the gap between compact point-and-shoot cameras and digital SLRs, bridge cameras tend to be larger and have a richer photographic feature set compared to compacts. Most offer manual controls, an incredible range of focal lengths (from wide-angle to super telephoto). In addition, unlike most point-and-shoot cameras which utilize a rear LCD screen for composing images, bridge cameras also have an electronic viewfinder (EVF) through which photos can be composed. This is an advantage in bright conditions when it can be difficult to see an LCD screen.

Bridge cameras are aimed at photographers who are keen to experiment with image making and like the convenience of having a 20x to 50x zoom in single package. Some bridge cameras can cost as much as entry-level digital SLRs and are capable of producing good-quality images up to small poster size. However, all that zoom range comes at the cost of a much smaller sensor, so bridge cameras can't cope with challenging lighting conditions, and are harder to control when it comes to creative shooting.

Large-sensor compacts

As a broad category, large-sensor compact cameras are the most recent type of fixed-lens cameras. Aimed at experienced enthusiasts, such cameras are often bought as portable backups to bulky professional equipment. These cameras offer full manual control, big imaging sensors (the same size or near to most digital SLRs) and high-quality lenses. However, the tradeoff is usually that the lens cannot zoom—it's the only way to put a large sensor in such a small body. Instead, it's typically locked at a moderate wide angle.

The level of control, combined with the quality of the lenses and their large sensors, make these cameras complete creative photography tools capable of producing high-quality images. Their discrete size makes them popular with photographers who don't want to attract attention to themselves, such as street photographers and some photojournalists.

SMART CAMERAS

This new breed of camera is Wi-Fi enabled and often comes with an advanced operating system, like the Android OS you might find in modern smartphones. In most cases this allows users to connect the camera with their smartphone, from where they can upload images to the internet. Other cameras feature software that allows users to edit images in-camera and share them directly on the internet without having to go via a smartphone. A more complete description of smart cameras can be found on pages 144–145.

← So-called point-and-shoot cameras are characteristically simple to use, offering fully automated features as well as any number of preset settings for photographing at night, or taking portraits, landscapes, sports, snow, or beach scenes. However, an increasing number of compact cameras also feature manual modes that allow users to set exposure, ISO, image size and format, and a number of other parameters. These manual overrides allow for greater user input and creativity.

→ Bridge cameras look like DSLRs. They tend to have larger imaging sensors than most point-and-shoot compacts, and most feature powerful zoom lenses. A compromise between a compact point-and-shoot and a DSLR, bridge cameras feature all the manual controls you'd find on an entry-level DSLR, but rather than an optical viewfinder, they feature an electronic viewfinder (EVF) through which users can compose images.

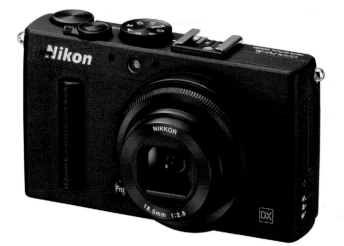

← Large-sensor compacts are for enthusiast photographers who are looking for image quality comparable to a DSLR, but in a much smaller, lighter package. With full manual controls and good optics these cameras are capable of producing extremely high-quality digital image files, with low noise and high dynamic range.

INTERCHANGEABLE-LENS CAMERAS

"Interchangeable-lens camera" describes any camera that has a detachable lens. The benefit here of course is versatility—it's possible to swap a wide-angle lens with a telephoto one and still use the same camera body. As with fixed-lens cameras there are a number of different types of interchangeable-lens cameras.

Digital SLR (Single-Lens Reflex)

The best-known type of interchangeable-lens camera is the digital SLR (DSLR). SLRs became a popular camera format in the middle of the 20th century, offering an ideal compromise between image quality, versatility, and portability. As imaging sensors improved these attributes were carried forward, and today's DSLRs are used by professional photographers in a host of photographic genres, including wedding, sport, studio, fashion, landscape, wildlife, photojournalism, and commercial photography.

DSLRs have a number of key features that make them popular with both enthusiast and professional photographers alike. They all have bright optical viewfinders; large imaging sensors (full-frame or APS-C), which provide excellent image quality even in high contrast and low-light situations; they offer accessible manual controls for creative shooting; they are responsive (quick to focus and suffering from imperceptible shutter-lag); and, combined with a selection of lenses, are capable of shooting a hugely varied range of subjects from sweeping wide-angle landscape scenes, through macro close-ups, to long-range wildlife photography. But this

comes at a price. Professional DSLR bodies cost thousands of dollars, with lenses often costing as much as the camera bodies. However, entry-level DSLRs with "kit" lenses are increasingly affordable and provide a relatively inexpensive way of starting a DSLR camera system.

Compact system cameras

Compared with DSLRs, compact system cameras (CSCs) are a relatively new camera format. These cameras lack the reflex mirror (and therefore the optical viewfinders) of a DSLR, allowing for a much smaller camera body. Instead of an optical viewfinder, users compose images either through an electronic viewfinder or via an LCD screen—some models only have the latter—making them closer in this respect to compact or bridge cameras. Unlike compact and bridge cameras however, CSCs have sensors close in size or as large as the majority of DSLRs, therefore enjoying all the advantages in image quality this brings.

The aim of these types of mirrorless cameras is to offer DSLR-style image quality, combined with the versatility of interchangeable lenses in a smaller, lighter, and less conspicuous package. While in many respects these cameras live up to that promise, they tend to be less capable when photographing fast-moving subjects. This is due to the different focusing system employed by DSLRs compared with almost all other types of camera.

SONY SLT (single lens translucent) In recent years Sony have developed a camera system that falls between a conventional DSLR and a CSC. Its SLT series of cameras feature a mirror (much like that of a DSLR), but it doesn't flip up when the shutter release is pressed. Instead, the fixed mirror is translucent, allowing some light to pass through it constantly to the sensor, while the rest is reflected to a dedicated (phase-detection) autofocus sensor (similar to the system used in a DSLR when shooting stills). The idea is that SLT cameras gain the advantage of using faster phase-detection autofocus even when shooting video and in Live View mode, unlike DSLRs which have to resort to slower contrast-detection autofocus when in these modes, and unlike the vast majority of compacts, bridge, and CSC cameras, which usually don't have fast phase-detection autofocus at all.

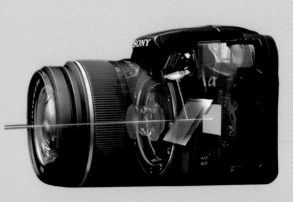

→ DSLRs feature a movable, "reflex" mirror that rests in a "down" position. Light enters the lens, which focuses the image on the mirror. In turn, the mirror reflects the image up through a prism and out of an optical viewfinder. Unlike an electronic viewfinder, an optical viewfinder provides a much brighter, clearer, and lag-free view. When the shutter release is depressed the mirror flips up and the light from the scene travels straight on and is recorded by the sensor located behind the mirror.

← There are two broad categories of compact system cameras: those that feature an electronic viewfinder; and those that have only a rear LCD screen for composing images. The former offer pretty much everything the enthusiast photographer needs, combining manual controls, good image quality, and the convenience of high quality interchangeable lenses on a comparatively small body.

→ The smallest CSCs, when fitted with the right lens (often a "pancake" design), can easily fit into a coat pocket or small purse—something of a gold standard for portability. The disadvantage of CSCs is that they are lacking a "real-time" responsive viewfinder and they rely on a slower (but more accurate) autofocusing system—but this is the most rapidly developing photography technology, and it's only a matter of time before CSCs will give SLRs a serious run for their money.

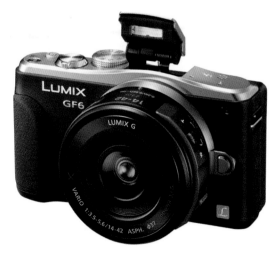

WHAT TO LOOK FOR IN A CAMERA BODY

When considering a camera body there is an astonishing number of things to consider. Before you descend into panic, however, let us tell you something that will make the buying experience much less stressful: as of right now, there aren't any truly terrible camera bodies out there. In fact, in the hands of a capable photographer, you can create gorgeous photos with every single camera body that is currently on sale. So if you can't go wrong, what should you be looking for?

Viewfinder

It's useful to be able to see what you are shooting before you take a picture, and the way you look at your photos varies from camera to camera.

Optical viewfinder—Some cameras come with an optical viewfinder. This can work in two different ways: either you're looking through the lens itself (this is how it works on an SLR camera), or you're looking through a little viewfinder hole. The viewfinder can be built into the camera (as with a DSLR and CSC), or it can be an add-on optical viewfinder.

LCD screen with Live View—Most recently launched cameras support Live View on the LCD screen. This is similar to how people have become used to using compact cameras: you point it at something, and the screen on the back shows what you're aiming at.

Electronic viewfinder—An electronic viewfinder is a combination of the above two technologies: you're looking into an eye-level viewfinder at the back of the camera, as with an optical viewfinder, but instead of looking straight through the camera lens via a mirror, you are looking at a display mounted inside the viewfinder. The EVF has a benefit over LCD screens in that it's easier to use in bright sunlight.

The type of viewfinder you want will impact on the choice of your camera—but before you make the choice, ensure that you go to a shop and try before you buy. The three viewfinder options are quite dramatically different from each other, and some people find that they can't get used to an EVF, for example.

There are also huge differences between cameras that use the same technology. LCD screens especially can vary wildly—from the nearly-useless, low-resolution units found on some older compact cameras, to the high-quality screens you find on newer cameras. The only way you'll know if the viewing system is good enough for your needs is to give it a try yourself.

Lens mount

An important thing to check before you decide to splash out on a new camera is what the lens mount is, and which lenses are available for the lens mount you have on your camera. Bear in mind that lenses with different mounts aren't easily transferable from one mount to another, so if you're going to start investing serious cash in your lenses, the lens mount will be one of the most important choices you'll make in your photographic career.

Controls

Camera controls come in all sorts of shapes and forms, from the super-intuitive cameras that are so easy to use you'll never even dream of opening the manual, to cameras that are so infuriatingly complicated and counter-intuitive you'll want to throw them against a wall.

You should know if you'll get along with a camera after around 20 minutes use. If you can, walk into a camera shop and do just that. Spend some time changing various settings and taking some pictures, then change the settings again and take some more photos. It's a good idea to make a little test script of the things you do when you take photos on an everyday basis.

Flash

Simple: does the camera have a built-in flash? Can you use external flashes? What flashes are available—and are they easy to use? You don't have to run off and buy an external flash unit right away, of course, but it's good to know that you'll have the option should you want to at a later date.

Shutter speed

Unlike aperture, which is controlled by the lens you attach to your camera body, the shutter speed is controlled by your camera body, so it's worth checking

← Many CSCs that don't feature an electronic viewfinder will accept a proprietary detachable electronic viewfinder. These attach to the camera body via the accessory shoe, and display exactly the same image and information as the rear LCD. The advantage is that the image is visible in bright sunlight.

it has all the features you need. The three things to look for are the maximum shutter speed, minimum shutter speed, and Bulb mode.

Maximum and minimum are self-explanatory—most cameras have a shutter-speed range from several seconds (usually 30 or 15 seconds) to a fraction of a second (usually 1/2000 second or faster for DSLRs and CSCs). You're unlikely to run into problems with your maximum shutter speed being too slow, but it's entirely possible that you'll have issues with the slowest shutter speed on some cameras.

Bulb mode is the final shutter speed you should check. "Bulb" (or just B) allows the shutter to stay open for as long as you keep the shutter button pressed. That means you can use as long a shutter speed as you want—great for taking photos of fireworks, rivers in motion, or photos of the night sky, for example.

↑ Sony's popular NEX range of cameras feature a lens mount that accepts not only Sony's range of E-mount lenses designed for the NEX range, but, by using an A-mount lens adapter, the cameras are also compatible with A-mount lenses, which are made in association with the prestigious lens manufacturer Carl Zeiss.

ISO

The ISO range of the camera is important because at high ISO settings you're able to take photos in low light with decent shutter speeds. However, don't just go for the number—there's a huge difference in ISO 2000 on a ten-year-old camera and a brand new one. Technology is developing rapidly, and not all the manufacturers are as cutting edge as they'd like to think.

Testing low-light capability is tricky, as you don't really start appreciating how good (or bad) your camera is until you've been using it for a while. The best approach is probably to go to a reputable online review site, such as Digital Photo Review (www.dpreview.com), and see how they rate the camera for low-light photography.

Raw or JPEG?

These days, it's rare to find a camera aimed at serious photographers that doesn't offer the Raw file format— but it's worth checking. If the camera you are considering doesn't have Raw, we'd suggest you walk away; there are plenty of other cameras to choose from and, as you'll later discover, Raw is incredibly useful to have.

↑ As you become increasingly interested in photography, you'll quickly want to move away from the camera's Auto and Scene modes, in order to give full reign to your photo creativity. If you're looking to purchase a new camera, it's strongly recommended that you buy one that has a good level of manual control. Even if you don't think you'll use it initially, you'll certainly be turning to manual as you develop your skills.

Video mode

If you're planning to use your new camera to make videos in addition to taking photos, you will have to consider the video mode on the camera as well. Important things to look for are what the resolution of the video is, and whether the camera has support for external microphones.

Megapixels

The resolution of your final photos—seriously, don't worry about it too much. Resolution (i.e. the number of pixels in a single photo) means a lot less in the grand scheme of things than how easy your camera is to use, the quality of the lenses you are using, and how good you are at finding the shot.

FIXED VS. INTERCHANGEABLE LENSES

One of the biggest reasons for picking an interchangeable-lens camera over a fixed-lens camera is the ability to switch lenses and enjoy a range of focal lengths from very wide-angle to super zoom—but is that really such a big deal?

Advantages of interchangeable lenses

When you are using an interchangeable-lens camera, whether a DSLR or mirrorless camera, it is useful to stop thinking of your camera simply as a single device and more as a "system" for taking photos. How you choose to upgrade is up to you, but the great thing is that you can upgrade your system by adding another lens (or lenses) whenever you want to explore a different genre or aspect of photography, such as macro or wildlife for example.

But what about the "superzoom" compact cameras that have up to 50x zoom lenses (equivalent to around 24–1200mm)? Don't they offer just about every focal length a photographer would need? Strictly, yes, but the very nature of glass and the laws of optics means that a single zoom lens with such a massive focal length range will have compromises built in. Such lenses, for example, are less likely to be as sharp as lenses with a narrower range of focal lengths. They are more likely to suffer from distortions and aberrations at either end of the zoom range, and they won't have as large a maximum aperture setting as many lenses designed for interchangeable-lens cameras. This is important because, as you'll learn later, the wider the aperture on your lens, the more creative you can be with your images.

However, there's no denying that having such a zoom range in one convenient package makes life simpler if you can't carry around a bagful of equipment. But an interchangeable-lens camera with the appropriate set of lenses for the job will be able to take far better

↓ A zoom lens is great when you want your photos to show the action up close, but you can't get close enough yourself. Lovely for safaris, concerts, and sports events, for example.

← A wide-angle lens is great for taking photos of vistas and landscapes; and when you're indoors or in confined spaces, the wide viewing angle means you get all the action in your photo!

↑ If you're interested in macro photography, interchangeable lenses are a must—compact cameras simply don't have the advanced, specialized optics needed to take photos like this one.

photos than even an advanced compact camera could ever hope for.

The other advantage of interchangeable lenses is that, although expensive initially, they will last as long as you're taking photos. And when camera manufacturers release cameras with even better sensors, you can replace your camera body with a new one and your fantastic lens is likely to take even better photos than before.

Disadvantages of interchangeable lenses

Of course the principal disadvantage of being able to extend your camera system is the fact that lenses—especially high-quality lenses—are very expensive. If you go down this route you have to be honest and ask yourself whether or not you're really making the most of equipment that could potentially cost thousands. For example, it's possible to buy an advanced bridge camera with full manual control and a built-in 23–810mm (36x) zoom for a third of the cost of a single professional 50mm prime lens. For many, the super-zoom camera will provide perfectly acceptable results and will cover most shooting situations. For a minority, however, a superfast 50mm prime will provide the ultimate in image quality and creative possibilities.

The second disadvantage is that if you own a lot of fantastic lenses, leaving them behind becomes difficult. If you know what you're going to photograph it's less of

an issue, but if you're embarking on an exotic overseas trip, there are only so many lenses you can carry at any one time. One of the most painful things you'll experience as a photographer is spotting a perfect photograph, and then realizing that the lens you need is stored in a bag 6,000 miles away.

The last downside of interchangeable lenses is that when you change them, the inside of your camera is, however briefly, exposed to the elements. Dust and moisture can make its way inside your camera body, which isn't great: dust on the imaging sensor shows up as blotches, and although most interchangeable-lens cameras now feature self-cleaning sensors, there may come a time when you have to clean the sensor yourself—which can be a nerve racking experience. This is the greatest advantage of fixed-lens cameras: they are sealed units, so dust should never get inside.

WHAT TO LOOK FOR IN A LENS

If you do decide to opt for the interchangeable-lens camera approach there are some basic things you need to know before splashing out on expensive glass.

Focal length

Focal length is the distance the light travels from the imaging sensor to the front lens element. This distance is generally measured in millimeters (mm).

A long focal length (200mm, for example) is called a "telephoto" lens, and it works much like a pair of binoculars: it makes objects that are far away look closer to you. Telephoto lenses are great for portraiture, concerts, sports, and wildlife photography.

A short focal length (such as 24mm) is called a "wide-angle" lens, and does the opposite to a telephoto lens. By photographing a wider field of view, you can get more in the photo. Wide-angle lenses are fabulous for landscapes, shooting indoors, and architectural photos.

Focal length tends to be marked on the lens. If the lens has a single focal length marked on it, it's a prime lens. If it has two focal lengths with a dash in between (such as 17–35mm), you're looking at a zoom lens.

Maximum aperture

The next thing you'll want to look for on your lens is its maximum aperture. We'll look at apertures in detail in

the next chapter, as they are fundamental to photography, but for now just think of it as the hole in a lens. The maximum aperture is the biggest hole the lens has. The bigger the hole, the more light can enter the camera, which is generally a good thing. Apertures are measured in "f" stops.

On a prime lens (one with a fixed focal length), this is usually written as something like "50mm f/1.8" (rather confusingly, as we'll discover, the smaller the f number, the bigger the aperture). In this case, f/1.8 is the maximum aperture of the lens. Which is pretty large.

On zoom lenses, maximum aperture can be written in two ways. If your lens reads "70–200mm f/2.8," you have a constant maximum aperture lens. Here it means that your lens can zoom from 70mm to 200mm, but regardless of how far you zoom in, the maximum aperture will always be f/2.8. Constant maximum aperture lenses tend to be of higher quality than other zoom lenses, but they are also a lot more expensive.

The other option on zoom lenses is a variable aperture lens. This would be written as "17–35mm f/2.8–3.5." On these lenses, the maximum aperture goes down as you zoom in further—so at 17mm, you have a maximum aperture of f/2.8, but when you zoom in to 35mm, your maximum aperture is f/3.5. A lens with a large maximum aperture is often referred to as a "fast" or a "bright" lens.

↓ Using a wide-angle lens is great when shooting in a cramped space, but it can do strange things to the perspective when you're close to your subject: look how big the model's hand looks in this shot! In this case, a 17mm lens was used on a APS-C camera with a crop factor of 1.6x—the equivalent of a 27mm focal length on a full-frame sensor.

Manual focus

Most lenses have a way of being focused manually. If you care about this, it's a good idea to take a closer look at how the lens works, and whether you like the way manual focus is implemented. On some lenses, you have direct control of the focusing. This means that you can turn an adjustment wheel (called a "focus ring") on the lens, and it will physically move the lens and adjust focus. This form of control is fast and precise, and intuitive to use. Some lenses require you to select manual focus on the lens or camera before you can take control, while others can override automatic focus for fine-adjustments after you've already focused.

On other lenses, you're given an adjustment wheel. You don't actually adjust the lens elements themselves, but use a focusing ring that tells the camera you want to change the focus. The camera then adjusts the focus for you using its internal focusing motors. This type of manual control can be sluggish and difficult to use accurately, but it's better than not having any manual focusing controls at all.

Optical stabilization

The final feature you'll find on some lenses is optical image stabilization. This is some pretty nifty technology that moves a lens element inside the lens to counteract vibration or camera shake. If you shoot handheld a lot (as opposed to having the camera on a tripod), it may be worth considering a lens with an optical stabilizer, especially if you tend to shoot in low light.

Do pay attention, though—it may be that your camera body already has stabilization built in, in which case lens-based stabilization is unnecessary.

CROP FACTOR EXPLAINED

Traditionally, 35mm film cameras used film frames sized 36x24mm, and photographers would talk about a lens' focal length as it related to that film frame size. When digital photography came along, the earliest imaging sensors were smaller than that of film, but photographers still used the same lenses. Because most sensors are smaller, with a narrower field of view than a 35mm frame, the result is a higher magnification. This effect is known as the crop factor.

On a camera with a Four Thirds sensor (which is 17.3×13mm in size) the crop factor is 2x. That means that if you were to attach a 200mm lens to a Four Thirds camera, it would be the equivalent of a 400mm lens. APS-C sensors, as found on most DSLRs, measure around 25×16mm and have a crop factor of 1.5x or 1.6x. So a 200mm lens has an "effective focal length" (efl) of 300mm or 320mm. Naturally, on a "full-frame" sensor camera (one with a 36×24mm sensor) a 200mm lens still behaves like a 200mm lens.

The crop factor of a lens won't be marked on the lens, as this depends on the camera body it is attached to.

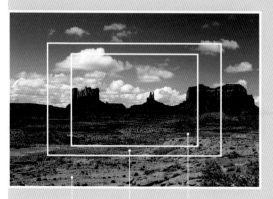

Full frame (1.0x) APS-C (1.6x) Four-thirds (2x)

← This was taken with a 200mm lens on a camera with a crop factor of 1.6x; the advantage of using telephoto lenses on crop sensor cameras is the extra reach you get. Because of the 1.6x crop factor a 200m lens has an effective focal length of 320mm, while a 300mm becomes almost 500mm. This is great for wildlife shooters as a 300mm lens is almost certainly going to be less expensive than a 500mm lens of a similar specification.

PRIME LENSES VS. ZOOM LENSES

When picking a lens, there are two main categories of lenses. You're probably familiar with zoom lenses: most cameras come with a zoom lens, whether it's a compact with a lens built in, or a kit lens that comes with your interchangeable-lens camera system.

Prime lenses are lenses with a single or fixed focal length—or "non-zoom lenses," if you will. Most new photographers see primes as relics from a time gone by, but there are some excellent reasons to add a prime lens (or two) to your camera bag.

The pros & cons of zoom lenses

There's nothing wrong with zoom lenses in themselves; they're very convenient indeed, and you can save yourself a lot of walking around by using one.

There are a few downsides to using zoom lenses, though. Most importantly, most cheap zoom lenses have variable maximum apertures, which means that as soon as you zoom in you potentially lose a lot of brightness.

The other downside with zoom lenses is that by strict definition they are a compromise. Because they are designed to work at a range of different focal lengths, the quality is slightly reduced compared with a good prime lens, which only has to work at one focal length.

Of course, there are zoom lenses that rival and in some cases exceed the quality of prime lenses—but they are so eye-wateringly expensive it makes your bank manager twitch. Unless you have a serious stack of dollar bills hidden behind your sofa, or you are taking photos for a living, the top-end zoom lenses remain a distant dream for most of us.

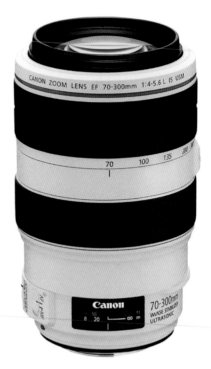

↑ Canon's 70–300mm f/4.0–5.6 L zoom lens is a professional lens capable of producing images of extremely high quality. Its variable aperture means that it's not as capable in low light or as good at selective, shallow-focus effects as some other lenses; however, those other lenses are also much larger and considerably more expensive.

→ The Nikkor 85mm f/1.4 is one of Nikon's classic professional lenses. With such a large maximum aperture it's possible to isolate very narrow elements of an image. For this reason this lens is popular with portrait photographers, some of whom like to show their subject's eyes sharply in focus, while other features are softly blurred.

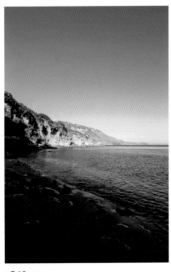

efl 16mm

efl 32mm

efl 56mm

→ In low-light situations, you can't beat a fast prime. This photo was taken with an aperture of $f/1.4$ at ISO 800. With a slower zoom lens this image may not have been possible.

The biggest advantage of zoom lenses, as alluded to earlier, is pretty obvious. The flexibility of being able to zoom in on something that's further away, or to zoom out to get the wider picture, is hard to argue with.

The case for prime lenses

Prime lenses can seem rather inconvenient the first time you hear about them. Only a single, fixed focal length? Really? However, primes have a couple of fantastic tricks up their sleeves too. Because the lens manufacturers know exactly what the focal length is going to be for the lens, they don't have to make compromises and can create a lens that does one thing—and does it really well.

Prime lenses tend to have much larger maximum apertures, and are generally sharper, delivering crisper photos than their zoom-lens counterparts. It is not unusual to find prime lenses with apertures as wide as $f/2.0$ or even $f/1.4$.

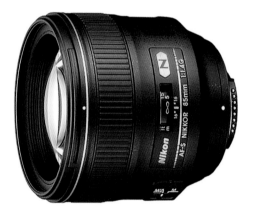

Even if you don't want to go to the extremes when it comes to brightness of lenses, primes tend to be cheaper, lighter, and sharper than comparable zoom lenses.

So, what should you buy?

Of course it's impossible for us to recommend which lenses you should buy without knowing your personal photography style and subject preferences (and how much you are prepared to spend on glass). With advances in sensor technology you may feel that faster lenses are less important, or you may still need wide apertures for shallow depth of field.

The best thing we can recommend is that you try any lens before you buy it. Some lenses are available to hire, or you may find that your local camera store is prepared to let you try out a lens. Read reviews to see what other photographers who have similar interests to your own have to say about the lenses you're considering. The good thing about high-quality lenses is that they tend to hold their value, so even if you do change your mind after a purchase, you're not going to lose a fortune.

21

efl 112mm

efl 220mm

efl 320mm

← This series of images was captured with three lenses on a cropped sensor camera: a 10–20mm (efl 16mm and 32mm) zoom, a 35mm prime lens (efl 56mm), and a 70–200mm (efl 112mm and 320mm).

WHAT CAMERA DO YOU NEED?

There's been a lot of talk about cameras and equipment in the first chapter of this book. So apologies to those of you who already know your camera equipment and the pros and cons of the various options available. However, for those of you who are still unsure which camera is right for you, here's a quick round up of the sort of features you'll need in your camera to make the most of the shooting projects and techniques that we're going to cover later in the book. It doesn't really matter if you have an advanced compact, a bridge camera, a CSC, or a DSLR. After all, the laws of physics don't change depending on what camera you happen to be holding in your hand. But here are some features to look out for.

Embrace the PASM & Raw

Many of the creative techniques in this book depend on you being able to directly influence what the camera is doing. The simplest compact cameras might not do everything you hope for, but then again, that's where most of us start—and it's as good a starting point as any!

To get the most from this book, however, you need a camera with PASM settings—that's photographer speak for Program mode, Aperture Priority, Shutter Priority, and full Manual mode. That means that you should be set with any CSC or DSLR camera, and quite a few bridge and advanced compact cameras, too. Look for a dial or some other form of control on your camera's body that displays the letters PASM.

The other feature worth looking for on your digital camera is the ability to take photos in Raw format. We'll talk about Raw in more detail in Chapter 6.

The basics & beyond

The perfect camera equipment to get started with alongside this book would be as follows, in approximate order of importance:
• A camera with PASM settings (Canon uses P, Av, Tv, M)
• A zoom lens (28–80mm equivalent or thereabouts)
• A tripod

Beyond these things, what you choose to buy depends on the type of photos you want to take. In Chapter 5 we'll discuss the perfect equipment setup for different types of photography. In general, when it comes to buying equipment, it is best to wait until you know what you need, and then buy the highest-quality item you can afford—especially when it comes to optical components of your camera system.

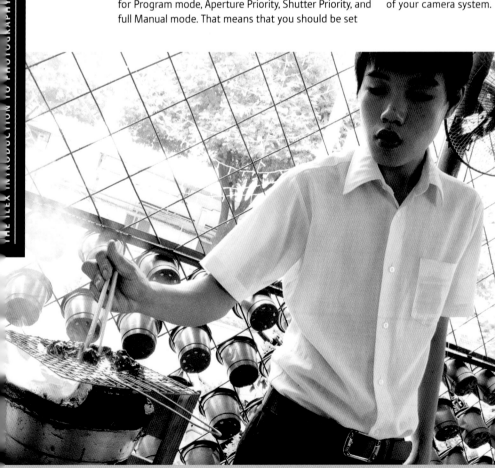

← There's no law that says that compact cameras can't take lovely photos. This one was taken with a Canon PowerShot model. It's tiny, but it does shoot in Raw, and has full PASM settings.

↑ To check if a camera has a good level of manual control, look on the top; if it has a dial with the letters PASM then you're in good shape.

↑ Flash photography can add a whole new dimension to your pictures—but there are a lot of additional skills to learn.

→ Mother nature can be surprising and confusing all at once. This sunset over Koh Tao in Thailand is an extreme lighting situation—if it hadn't been for shooting in a manual exposure mode and in the Raw format, it's doubtful whether the photo would have been usable at all!

↓ Without a tripod, this photo would have been impossible. A 30-second exposure was used to turn the waves hitting the rocks into a white mist.

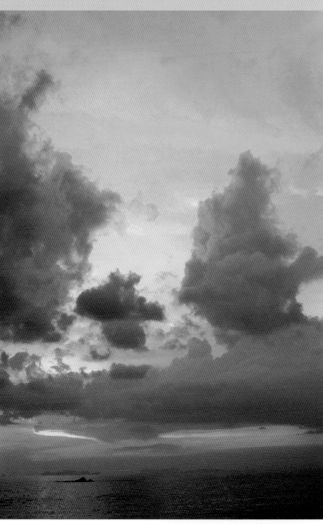

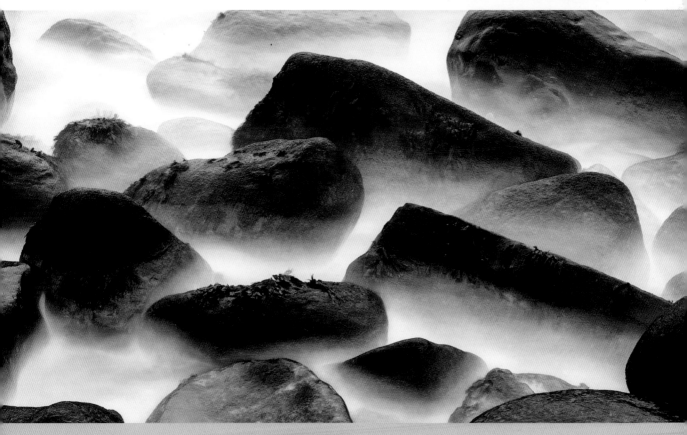

PHOTOGRAPHY FUNDAMENTALS

There are many ways you can look at photography. Some photographers see it as a way to document the world around them; others choose to see photography as an artistic endeavor; and some are fascinated by the science involved.

You may be surprised to learn that the camera you're used to holding in your hands is actually an astonishingly sophisticated piece of scientific equipment, and the science bit is very broad-ranging. Engineering is pretty obvious, but beyond that every lens you use on your camera is the result of some rather impressive physics—and that's without dwelling on the advanced mathematics that happen inside your camera body.

If your heart beats a little faster when you start thinking about mathematical formulae, unfortunately this is probably the wrong book for you. But in order to become a good photographer, you do need to have at least some basic knowledge of how light works, and how your camera takes light and turns it into the tasty image files you're striving for.

In this chapter we'll take you step-by-step through the basic concepts of photography, exploring how you can develop a closer relationship with your camera, and take much better photos in the process.

WHAT IS AN EXPOSURE?

**Photographers love talking about "exposure,"
but not everybody understands what exposure
is or how it works.** Not to worry; that's why you're
reading this book, right?

A camera is, at its most basic level, a light-proof box
with a light-recording element inside. If you were using
a Polaroid camera, the light-recording element would
be instant film. If you are holding a conventional
film-based camera, the light is recorded on film. In the
digital era, the camera contains an imaging sensor,
which does the light-recording for us.

Regardless of what the light-recording element inside
your camera is, one thing's for sure—it is sensitive to
light. And when you take a photo, you "expose" the
light-recording element to light. If it is exposed to too
little light, the recorded image will come out very dark;
if the sensor is exposed to too much light, the photo
will come out too bright.

A "correct exposure" means your camera's sensor is
getting just the right amount of light so that the image
is not too dark and not too bright.

What is a good exposure?

Throughout this chapter—and the rest of this book,
for that matter—we'll often mention words like
"overexposed," "underexposed," and "right exposure."
These things mean, respectively, that a photo is too
bright, too dark, or somewhere in-between.

It's definitely worth keeping in mind, however, that
the "right" exposure is a subjective judgment call.
The right exposure is the exposure that achieves
the photo you planned to shoot.

IMAGING CHIPS

In the infancy of digital photography, there were a
lot of discussions about different types of imaging
chips, and what was best. The battle was (and is)
largely between Charge-Coupled Devices (CCD)
and Complementary-Metal–Oxide–Semiconductor
(CMOS). Both technologies are still in use, and, from
a practical point of view, they are both about as
good as each other.

↑ Three versions of the same
scene. The darkest of these
shots (top) is underexposed,
with lots of the image too
dark to make out detail. The
brightest shot (bottom) is
overexposed, with large
areas of pure white. The shot
in the middle is "correctly"
exposed, with detail in both
the shadows and highlights.

↗ This image is extremely
contrasty, and is both
overexposed (the entire
background has blown out
into being pure white) and
underexposed (the razor-wire
has "clipped blacks"—pure
black without any detail).
Despite breaking both the
so-called "rules" of exposure
at once, it's still an appealing
graphic photo.

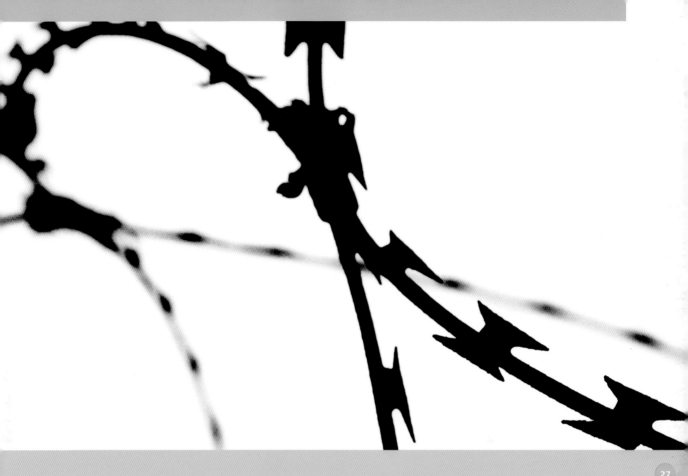

EXPOSURE & HISTOGRAMS

The top photo is overexposed in a bad way: it's so white that definition has been lost entirely in the grasshopper's eye, and the background has totally blown out to detail-free white.

You can use a histogram display (either the one on your camera or in your photo-editing software) to see how bright or dark an image is. Histograms are visual representations of all the tones present in an image, with dark tones on the left and light tones on the right.

The histogram for the top image shows almost all the tones bunched up against the right-hand side, which indicates the image is badly overexposed.

Compare that with the second shot. Here the tones in the histogram are more evenly spread, with a spike to the right representing the pale background. It's easy to see which photo looks best. Histograms are therefore an excellent way of quickly assessing an image's exposure, particularly in bright, sunny conditions when it's hard to see the image on the LCD screen.

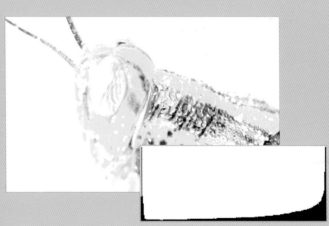

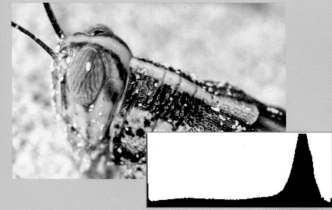

CONTROLLING EXPOSURE

Exposure is determined by three variables: shutter speed, aperture, and ISO. Adjusting any of these three changes the exposure of a photo, but to complicate things further, changing one of the settings has effects other than just making a photo brighter or darker. The true magic in photography comes from applying these three simple settings in different ways for creative effect.

Shutter speed—Inside most cameras, there is a shutter. This is a mechanical device that opens and closes a set of curtains that are positioned in front of the imaging sensor. The duration that the shutters are open is known as the shutter speed. A long shutter speed lets in a lot of light, while a shorter shutter speed lets in less light. This is easy to remember in this way: if you turn on your kitchen tap for 10 seconds, less water comes out than if you turn it on for 30 seconds.

Aperture—"Aperture" comes from a Latin word meaning "hole." Your camera lens will have a variable aperture inside it. A variable aperture means that through using

a series of aperture blades, your lens can make the hole smaller or bigger. It's all pretty obvious, really: a big hole lets in more light, and a small hole lets in less light. To go back to the shutter speed analogy: if you turn your kitchen tap on full, you get more water coming out than if you turn it on just a little bit.

Do be aware, though, that aperture numbers are backwards: counter-intuitively, $f/2.0$ is a bigger aperture than $f/3.5$.

ISO—The final variable in our exposure puzzle is ISO. In the days of film, ISO was a number describing how sensitive the film was to light—an ISO 400 film was twice as sensitive as an ISO 200 film. This isn't quite how it works in the digital world, but for all practical purposes, it's best to think of ISO as light sensitivity: higher ISO is more sensitive, lower ISO is less sensitive.

↓ Because the details in the model's face have vanished into pure whiteness, most people would consider this photo to be overexposed. It doesn't mean it's not a good photo, though.

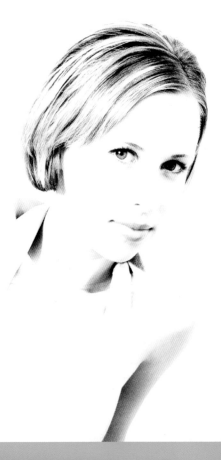

↓ In this photo, the exposure is better: the background is still blown out, but you can see how the model's skin is still visible in all detail.

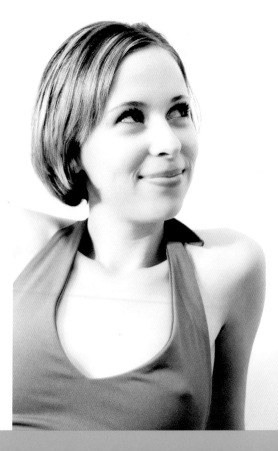

Equivalent exposures

As we have mentioned, changing, for example, the aperture on your camera changes more than just the amount of light that gets into your camera. As such, you might decide that you want a smaller aperture, in order to get a greater depth of field. A smaller aperture means that less light comes in to the camera, which might lead to an underexposed image. So how do we avoid this?

Your camera has three different adjustments for exposure. If you adjust one so the exposure would be brighter, you can adjust another one to compensate for the additional light captured.

For example, let's start with an exposure of 1/100 second, $f/4.0$, and ISO 200. You could change your camera settings to 1/200 second, which would let half the amount of light into your camera, because the shutter is only open for half the duration. Your photo will now be darker. If you change your ISO to 400, however, the sensitivity of the sensor is doubled, and the photo will come out looking the same as your original exposure (from a brightness point of view).

You can change any of the settings to compensate for any of the other settings: a smaller aperture can make up for a higher ISO; a faster shutter speed can make up for a larger aperture; and a lower ISO can make up for a slower shutter speed.

EXPOSURE VARIABLES

It can be useful to think of the three variables in an exposure as a slider: if you increase one and decrease another, you end up with the same brightness overall. However, as you will discover, adjusting one element, such as aperture, can have other effects on an image.

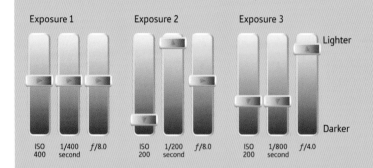

Exposure 1			Exposure 2			Exposure 3			
									Lighter
									Darker
ISO 400	1/400 second	$f/8.0$	ISO 200	1/200 second	$f/8.0$	ISO 200	1/800 second	$f/4.0$	

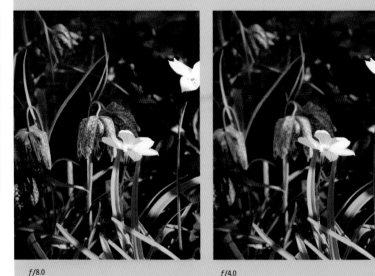

$f/8.0$ $f/4.0$

In this example, the image on the left was shot with an aperture of $f/8$, which gives greater depth of field (a deeper range of focus) when compared with the image on the right, which was taken using an aperture of $f/4$. Notice how the flowers in the background are more blurred.

APERTURE & EXPOSURE

Of the three variables—shutter speed, aperture, and ISO—aperture tends to be the one that trips new photographers up. Shutter speed is intuitive enough: if you increase your shutter speed from 1/200 second to 1/400 second, you get half the amount of light going into your camera. ISO is similarly easy to grasp: go from ISO 400 to ISO 800, and it doubles the sensitivity of the sensor, and your picture becomes twice as bright.

Aperture is more confusing—how come bigger numbers are smaller apertures? And how are you meant to remember all of this?

What do *f*/stops mean?

Apertures are measured in *f*/stops. To be honest, until you hear it explained you could be forgiven for thinking the *f*/stop scale doesn't make any sense. For a start, *f*/2.8 is a pretty irregular number; but also, why would *f*/2.8 be a larger aperture opening than *f*/4.0?

The reason is because *f*/stops are fractions; specifically, an aperture opening is a fraction of the focal length of your lens. So, if you have a 100mm lens set to *f*/4, what you are really saying is that the aperture opening in the lens is 1/4 of 100mm. Let's do the math: 1/4 of 100mm is 25mm—or about 1 inch. This fraction is obviously the reason why *f*/4 is a larger aperture than *f*/8: if you get a 1/4 of a cake, you're getting more than if you're getting 1/8 of a cake.

The best aperture to use

Many of the examples you'll see throughout this book use either a very large aperture, or a very small aperture. Truth is, your lens is sharpest somewhere in between these two extremes. Similar to exposure, the "right" aperture to use is the aperture that achieves what you are looking for with your photo.

How does aperture affect a photo?

Your camera adjusts the aperture by increasing or decreasing the size of a hole inside your lens. Making changes to the size of the aperture affects two aspects of the image: the exposure, and depth of field.

Depth of field & aperture

Aperture is the principal control on your camera that determines depth of field (how much or how little of the image is in focus) although, as we shall see later, other factors also come into play. This is a crucial setting you can use for a lot of different creative effects. If you are taking portraits in a messy environment, for example, using a large aperture will give you a shallow depth of field, enabling you to isolate your subject from the background.

The opposite is also true—small apertures give you a bigger depth of field, which you can use for good effect when you want a lot of your image in focus.

The limits of aperture

When you are taking photos, remember that you need to think about your exposure. If you're taking photos with a very small aperture, you get an extensive depth of field, However, you also reduce the amount of light entering the camera, and you need to compensate for this somehow.

You can adjust for a small aperture by using a slower shutter speed, or a higher ISO setting, but this comes with its own problems: slow shutter speeds means that

← Taken with a 50mm lens at *f*/4.0, 1/200 second, and ISO 800, this image is so sharp that you can almost count every single hair on the model's head.

→ By using a large aperture (small number), this street photograph focuses on the main subject: the smoking girl with the bunny ears. If the photo had been taken with a small aperture, the mass of people in the background would have been very distracting.

THE *f*/STOP SCALE

At first glance there appears to be little logic to the *f*/stop scale—the numbers 2.8, 4, 5.6, 8, 11, and so on, certainly don't appear to follow any obvious pattern. There is a logic, though, but be warned: if you try and decipher what these numbers actually mean, things can potentially get even more confusing.

The problem is, as soon as you try and look for an answer you'll start to encounter sentences such as "The aperture is proportional to the square root of accepted light, and thus inversely proportional to the square root of required exposure time, such that an aperture of *f*/2 allows for exposure times one quarter that of *f*/4." (http://en.wikipedia.org/wiki/Aperture#Maximum_and_minimum_apertures)

This is pretty impenetrable to most of us, but thankfully you don't actually need to know the underlying machinations of the *f*/stop scale to take a photograph any more than you need to know how an internal combustion engine works to drive a car. All that's important is that you appreciate that each full *f*/stop represents a halving or doubling of the light allowed through the lens, and that the smaller the number, the bigger the hole (and therefore the more light is allowed through).

↑↑ A larger *f*/number (smaller aperture opening) is required if you want greater depth of field.

↑ Shooting at *f*/22 meant that everything in this photo was in focus, but a 30-second exposure was needed.

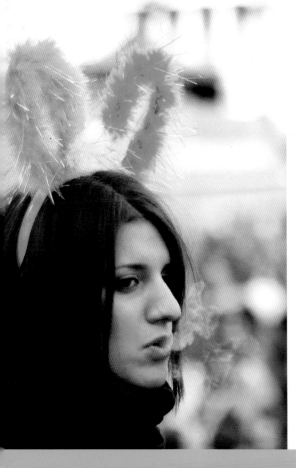

you have to start to think about using a tripod, and very high ISO settings can cause digital noise.

Conversely, very large apertures have their own challenges. When you're taking photos with a wide aperture, your depth of field is limited—ideal for street photography or portraiture, for example, when you want to focus on one thing. But there might be an issue, as most high-end cameras have a minimum shutter speed of 1/4000 second, or 1/8000 second. If you are taking photos in broad daylight it is possible that you will start hitting the limits of your photographic equipment. Even at the slowest ISO and the highest shutter speed, your photos could come out over-exposed when shooting at the largest aperture you have available. If that happens, all you can do is to darken your scene (by blocking out some light, or using a neutral density filter on the front of your lens), or select a slightly smaller aperture.

SHUTTER SPEED & EXPOSURE

While aperture gets to affect the depth of field, shutter speed has a couple of tricks up its sleeve all of its own. The most obvious effect changing the shutter speed has is that it controls the brightness of your exposure, just like the aperture does.

The creative side of shutter speeds has everything to do with motion, but to explain how it works we're going to have to take a look at how an exposure works.

Stopping motion

Your camera is basically a light-recorder that records light for the entire duration of an exposure. So, if your shutter speed is 1/1000 second, your camera records the light for 1/1000 of a second; if your shutter speed is 1 second, it records light for 1 second.

This duration becomes relevant when you are photographing something that moves. A car moving at 40 mph, for example, moves about 0.7 inches in 1/1000 of a second. In most circumstances, this movement is so slight that it will appear that the car is completely still when photographed. If you photograph it using a shutter speed of 1/4000 second, it moves just 0.17 inches, resulting in an even crisper car in your photograph. In other words, you can use fast shutter speeds to freeze the motion of moving objects.

Illustrating motion

You can also do the opposite, of course. If we go back to the car driving at 40 mph and photograph it with a shutter speed of 1/60 second, it moves nearly 12 inches during the exposure. This is a more significant distance, and it means that your car will probably look blurry. In some photos this can be a problem, but in others it can be used to create interesting effects. It all depends on what you are trying to show.

Thinking about motion

It's a good idea to keep movement in mind when you're taking photos, as there are lots of different types of movement that affect your images. You can have movement in the photo, of course, and you can "freeze" the motion by using a fast shutter speed, or make it "flow" by using a slower shutter speed. It's not just your subjects, though: keep in mind that your camera can also move as you're taking a photo.

If you're in a moving car, you'll have to use a shutter speed that's fast enough to compensate for the movement of the camera—but as shutter speeds get longer, you're going to have to start considering a tripod or other support to keep your camera steady.

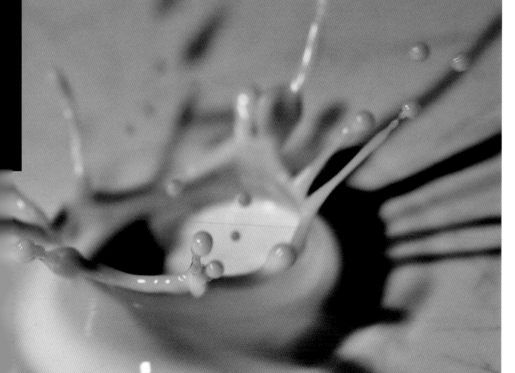

← Capturing a droplet as it hits a surface takes a lot of patience—and a very fast shutter speed.

As a rule of the thumb, if your shutter speed is longer than your focal length (in other words, if you are shooting with a 50mm lens, and your shutter speed is slower than 1/50 second, or if you have a 100mm lens, and your shutter speed is slower than 1/100 second), it starts getting hard to get images that aren't blurry, due to "camera shake." If you take a lot of photos like that, get a tripod, and use it!

↑ Because the motorcyclist in the foreground didn't move much, he appears to be standing still. The 2.5-second exposure was enough to turn the cars moving in the background into streaks of light, however.

↓ Camera movement can give some pretty cool effects, even if nothing in the scene itself is moving.

33

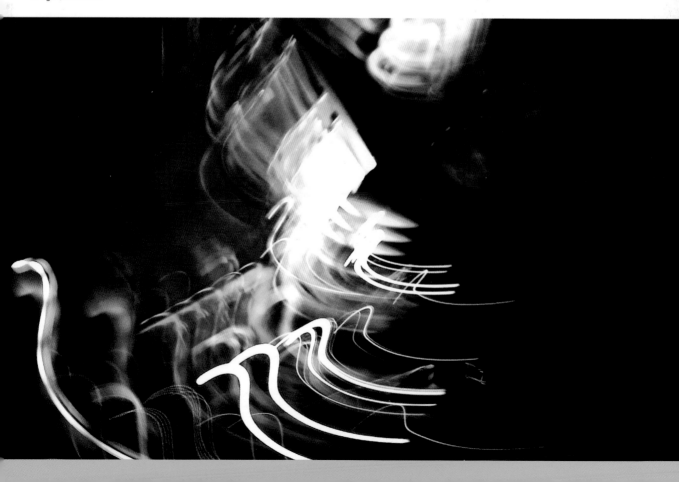

GET CREATIVE WITH SHUTTER SPEEDS

By applying what you know about shutter speeds, you can start developing ways of using shutter speed to your advantage to create awesome photographs. Since we're talking about shutter speed, there are basically two things you can do: freeze or show motion, in various ways.

Waterfalls

It's a completely clichéd shot, but waterfall photos can be beautiful, both when frozen in time so you can see every little droplet in the waterfall, and when photographed with a long shutter speed.

To find out how long an exposure you need, you can either use some very complicated mathematics... or good old trial and error. Start with a 1/20 second

exposure, and adjust from there. Alternatively, set your camera to "Aperture Priority" (A or Av) and choose a small aperture—around $f/11$ or similar will do—and see what results you get.

Panning shots

You've seen how a moving object in the frame can come out blurred, but what if you want the moving object sharp? It takes a little bit of practice, but you can use a technique called "panning" to get some rather eye-catching shots. Cars, cycles, and runners look particularly good in panning photos.

To get a panning photo right, it's easiest if your subject is moving perpendicular to the camera. Stand with your toes facing where you want to take the photo, and turn

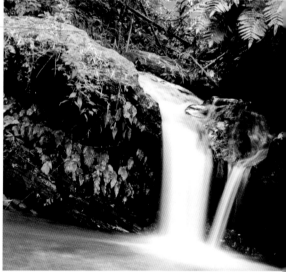

←↑ If the water moves faster, you don't need to slow down the shutter speed as much. In the shot on the left, taken at 1/13 second, the waterfall has an obvious speed to it, while the people in the foreground remain still.

your upper body from the hips toward where your subject is coming from. As it is moving by, keep it neatly in the same spot of the frame, and slowly press the shutter button. Keep turning with it all the way.

Again, finding the right shutter speed is a game of trial and error, but for cars and motorcycles, start at about 1/30 second, and adjust your shutter speed depending on the effect you're going for.

Zooming shots

Anything that's moving can be turned into a long-shutter speed shot, but of course it's possible to introduce movement yourself by moving the camera. Another way of getting movement is to zoom your lens in or out while taking a photo. This technique is

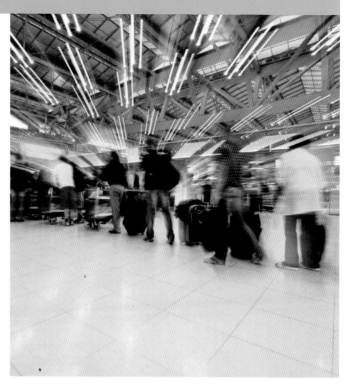

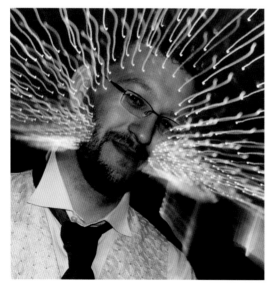

dependent on having a camera that can change its zoom while you're taking a shot—most CSC and SLR cameras will let you do this easily enough.

To get a zooming shot, you'll need a tripod or a sturdy surface to place your camera on. First, take a meter reading and focus the camera by half pressing the shutter button, and then start zooming in (or out) very slowly. Press the shutter button all the way, and keep zooming as smoothly as you can. You get the best result with zooming shots when there are plenty of light sources in the frame, as they will create a cool streaky effect.

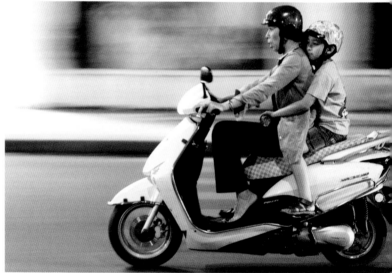

↖ This photo was shot handheld, using a shutter speed of 1/3 second while zooming and using a flash to "freeze" the model's face. It looks pretty crazy, but it's definitely a fun effect to experiment with.

↑↑ By putting your camera on a tripod and zooming in while the shutter is open, you can get a *Star Wars* hyperspace-style feeling of speed.

↑ By moving the camera to keep the subject in the same place of the frame for 1/25 second, the motorbike appears sharp, while the rest of the world whizzes by.

FOCUS & DEPTH OF FIELD

If you've taken any photos before, you've probably stumbled across the problem of a photo being grossly out of focus. Don't worry, it happens to everyone from time to time.

There's actually quite a lot that can be said about how you can determine whether a photo is in focus or not, but ultimately, it's quite subjective. Some photographers are not bothered by a photo being slightly fuzzy, while others only want the sharpest of sharp photos.

What is "in focus"?

On a theoretical level, there is always one distance away from you that is perfectly "in focus." If you focus your lens at the tip of your subject's nose, then that part of their body—and everything else that is the same distance away from your camera—will be in perfect focus.

Beyond the distance from your camera where things are "in focus," there is a gradual drop off closer to, and further away from, your focusing distance. How fast this drop-off is, is described as "depth of field." If the sharpness drops off rapidly, it means you are taking photos with a "shallow" depth of field; if the drop off is more gradual, you have a "deeper" depth of field.

↑↑ This photo was taken at $f/1.4$, and you can see how only part of the text is in focus. The "T" is pretty sharp, but the "I" and "N" are already quite fuzzy. As you can see, the background (a busy record store in East London), is completely out of focus.

↑ By shooting at $f/32$—a very small aperture indeed—all the buildings in this shot were in perfect focus.

↓ Another example of pin-sharp focus: The gentleman's nose is sharp, but his ear, which obviously was only a couple of inches closer to the camera as the photo was taken, is blurry, as is the background, which helps to isolate the subject.

FOCUS EXPLAINED

Plane of focus

There is only a very thin sliver of the photo that is in perfect focus.

Area in focus $f/2.8$

Wide Aperture
Your depth of field will be limited.

Area in focus $f/5.6$

Medium Aperture
Your depth of field is slightly larger.

Area in focus $f/11$

Narrow Aperture
You enjoy a deeper depth of field.

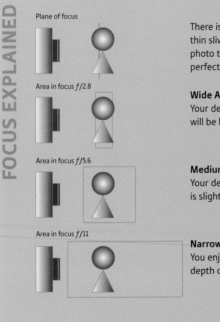

Something being in focus depends on two things: what you actually focus on, and the depth of field you choose. The tricky bit is getting the focus right in the first place.

When focusing, it's often best to aim your camera at an area of contrast. Many photographers focus using the center focus point, as this is the most sensitive point on most cameras and therefore the fastest way to achieve focus. Here's a popular technique for focusing using the center point:

1. Aim your camera at an area of high contrast in your photo: a detail of a building, a person's eye, or similar.

2. Half press your shutter button. This will cause your camera to focus.

3. Keep the shutter button half pressed, and compose your image the way you want it.

4. When you are happy, press the shutter button all the way to take your photo.

↓ This building doesn't have a lot of definition, which might cause your autofocus to get confused. To help it along, it was focused using the window at the bottom left.

WHAT AFFECTS DEPTH OF FIELD?

There are three factors that determine how wide or narrow the depth of field will be for a particular image. We've already covered the principal control—aperture—in some depth earlier. But to recap, a large aperture (smaller number) creates a very narrow depth of field, while a small aperture (large number) results in a wide depth of field.

The next depth of field determining factor is the focal length of the lens (that is whether you are taking a photo with a wide-angle or telephoto lens or focal length setting): telephoto lenses have shallower depth of field, while wider lenses have wider depth of field. So if you want to isolate a subject from a potentially distracting foreground or background, as may be the case with a portrait for example, using a telephoto focal length setting will help. Conversely, if you want to as much of the scene as possible in focus, as in landscape photography for example, use a wide-angle setting.

The final factor determining depth of field is the distance between the camera and the subject. The closer you focus to the camera, the shallower the depth of field and vice versa.

DEPTH OF FIELD EXPLAINED

Deeper

Subject: farther away
Focal length: wide-angle
Aperture: smaller

Depth of field

Shallower

Subject: close
Focal length: telephoto
Aperture: large

DEPTH OF FIELD IN DETAIL

While it's vitally important to understand that depth of field increases as the aperture gets smaller (at least if you want to be creative with your photography), that isn't the whole story.

For a start, depth of field doesn't extend equally in front of and behind the plane of focus. Instead, the depth of field at any given aperture extends approximately 1/3 toward the camera (from the point of focus), and 2/3 away from the camera, behind the subject.

There is also not a sudden transtition from "sharp" to "unsharp" either: the focus falls off gently. In fact, strictly speaking, sharpness falls off either side of the plane of focus, *regardless* of the aperture setting you use. So only one distance in a photograph is "in focus": depth of field is simply a zone of *acceptable* sharpness.

FOCUS & FOCUSING MODES

We've talked about what affects depth of field, and how you can adjust your focus, but that's only half the battle. Since focusing is such an important part of photography, the camera manufacturers have built in a lot of fancy features to help you along.

Focusing modes

One-shot automatic focus is what most people think of when they think "autofocus." In this mode, when you press the shutter button half way, the camera attempts to focus on the subject your camera is pointed at. When it finds focus, it "locks" the focus until you either take the photo, or you release the shutter button and half press it again. This mode is great for most subjects that don't move a lot.

Continuous autofocus (also known as "continuous Servo" or just "Servo" focusing) is a mode you find on many advanced cameras. Instead of "locking" the focus (like one-shot autofocus), it continuously tries to keep your subject in focus. This mode is best when you are taking photos of quick-moving subjects that come closer and move away from you a lot.

Canon calls it AI focus, Nikon and Sony call it AF-A mode, but it works the same way: "Intelligent Focus" is the half-way house between the two previous modes. For subjects that don't move, the camera uses one-shot autofocus, but if the camera detects movement it switches automatically to continuous autofocus instead and tracks the subject. Generally, the AI Focus mode on most cameras isn't quite good enough to rely on all of the time, so if you know what you want, it's best to select one-shot or continuous autofocus yourself.

Manual focus is what it says on the tin: the camera leaves the focusing up to you. On most cameras, when you are focusing manually it will tell you when it thinks your subject is in focus, either by making a beeping noise, activating a focus confirmation light, or flashing the focusing point that the camera believes is in focus.

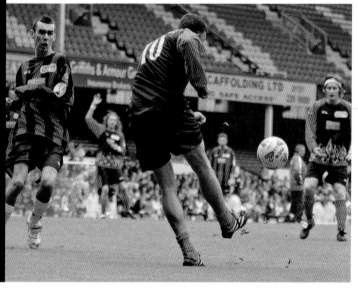

↑ In the fast-moving world of sports photography, continuous autofocus can be invaluable.

→ Dancers move a lot when they do their thing, but since this dancer didn't move toward or away from the camera, one-shot automatic focus was the ideal mode for this photo.

→ When you are working with subjects very close to your camera or when using a macro lens, it is sometimes easiest to use manual focus. Turn your lens to focus as close to the camera as possible, and then move your camera closer or farther away from your subject to focus. Live View is a great tool to ensure your subject really is in focus.

MANUAL FOCUS WITH LIVE VIEW

If you are using manual-focus, particularly for stationary subjects, it's often a good idea to use Live View, and, if your camera supports it, use the "manual focus assist" feature. This means that instead of showing you the full frame you're about to photograph, it shows an enlarged view of part of the image. Using Live View and the manual focus assist makes it a lot easier to focus precisely. It is incredible how big a difference small adjustments to the focus ring on your camera's lens can make. In particular, when you are taking macro photos, the Live View technique can be very useful. Many cameras also superimpose grids of varying kinds over the image when in Live View mode. Here the view shows the scene divided into nine equally sized boxes—a setup that can be very useful, for reasons we'll go into in Chapter 4.

ISO & EXPOSURE

ISO is the only exposure control that doesn't have a huge effect on your photos optically, but—you guessed it—adjusting the ISO isn't completely without side effects.

Until quite recently, the higher ISO values (beyond ISO 800 or so) were useless on most cameras because they would introduce a lot of digital "noise" into the final photos—an ugly-looking grainy effect. These days, things are better, but as a general rule of thumb, if you have enough light, it's a good idea to take photos at as low an ISO as possible—under ISO 800, certainly. This reduces the amount of noise in your image, and keeps the color rendition as true as possible.

↙ Even with a relatively long shutter speed (1/30 second) and a very large aperture (ƒ/1.4), it was still necessary to use ISO 6400 to get the exposure right in this photo. At this ISO setting it can help to convert the image to black and white to deal with the unpleasant-looking clumps of color that come with a noisy image, but it does show that you can take some pretty decent photos using the light from just a single candle.

↓ Taken at ISO 1600, this photo shows that you don't have to worry too much about digital noise: If the subject is pretty enough, a bit of noise doesn't matter.

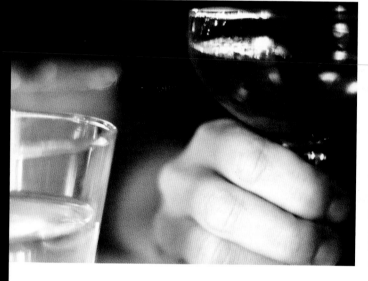

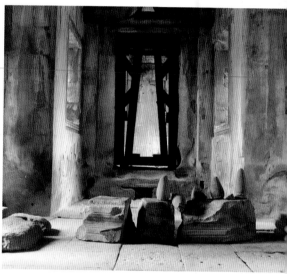

Don't be scared of high ISO

Having said that, current-generation cameras are incredible at dealing with high ISO. On top of that, software like Adobe Lightroom is getting increasingly sophisticated when it comes to filtering out digital noise, too.

All in all, high ISO is one of the areas where new camera bodies are improving rapidly, and with every generation of cameras things just keep getting better. At the very least, it's a good idea to test your camera at various ISO settings. If you don't like the way your photos look at ISOs beyond, say, ISO 1000, the solution is simple: don't use ISO settings faster than that! It's better to find the limits of your personal taste before you embark on an important photo shoot. Noise is most apparent in the dark, shadow regions of an image, so when assessing images to determine your camera's highest acceptable ISO setting, pay particular attention to these areas.

Using high ISO for creative effect

There's not much creativity in low ISO (apart from gorgeous, knife-sharp pictures with a minimum of noise), but you can use high ISO to great effect by introducing digital noise on purpose. "Noisy" pictures can look incredibly gritty and attractive, especially when combined with black-and-white conversions.

When you start taking pictures at higher ISO, it can be beneficial to try to keep your shutter speeds fast if you want your image sharp: long shutter speeds at high ISO tend to generate a lot of digital noise.

← Shot at ISO 12,800, there's a lot of noise in this photo—and yet, it also has a lot of character. Again, converting the image to black and white makes the noise much more acceptable.

↓ By using off-camera lighting and a high ISO (in this case, ISO 6400), it's possible to create some awesome and very creative effects, with a minimum number of external flashes. Of course, there is a lot of noise present in the photo, but the general grittiness of the scene means that the noise doesn't detract too much from the overall "feel" of the photo.

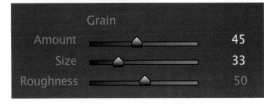

← Many image-editing programs, such as Adobe Lightroom (shown here), offer a Grain filter that artificially introduces "film grain" to an image. Applying this filter can disguise the effects of digital noise and provide a more natural effect.

SHOOTING MODES

A "shooting mode" generally refers to the method your camera uses to select its exposure. Most advanced cameras have four principal shooting modes (known colloquially as the "PASM" modes), a fully automatic mode (marked with a green box, or "auto"), and perhaps a small selection of scene modes (although these won't be present in the highest spec professional bodies).

Preset scene modes

Most compact, bridge, mirrorless, and entry-level DSLRs have a number of "preset" modes. These are semi-automatic modes designed to help you with your photography. In effect, you are telling the camera what kind of photos you are about to take, for example sports photos, portraits, or photos at night, and the camera helps you by using pre-programmed settings, customized for that particular type of photo.

Although scene modes can help the novice photographer capture images in certain situations, they don't do anything you can't do with a little bit of understanding of photography and the PASM modes. Later on in this book, we'll go through the different types of photos you might want to take, the settings at which you need to take them, and the various things you need to think about, and you'll see how you can get so much more out of your camera if you use PASM.

Auto mode

In Auto mode, the photographer has a very limited amount of influence over what the camera is doing. The camera selects the aperture, shutter speed, ISO, focusing mode, and just about everything else. This mode turns your camera into a "point and shoot" camera not that different from a simple compact camera—point at what you want to take a photo of, press the button, and the camera does the rest.

There's nothing inherently wrong with using the Auto mode, but what people photographing in Auto are missing out on is the ability to extract the highest quality image from the scene they're photographing. In Auto mode the camera will do its best to choose the exposure (and ISO and focusing mode) that it thinks will provide the best results based on a database of thousand of images against which it compares the one you're shooting. However, all scenes are unique in one way or another and, as the photographer, only you know what you want the final image to look like—whether you want to deliberately overexpose, blur, or emphasize one element over another.

↑ In sports mode your camera picks a fast shutter speed to freeze motion—but if you know what you are trying to achieve (i.e. freezing motion), you may as well use Shutter Priority, and pick a fast shutter speed yourself.

↓ A photo taken in Amsterdam, with a compact camera set to fully Automatic mode.

→ Program mode is great for fast holiday snaps. There's no need to think—just point and shoot (although you do get the benefit of controlling things a little bit).

↙↙ A popular scene mode found in many cameras is "snow" or "beach" mode. When you use this mode you are in effect warning the camera not to take an overall light reading from the scene as a whole as this is likely to contain large areas of very bright sand or snow, which can trick the camera into underexposing the subject. However, the camera can only use a predetermined adjustment to allow for this, which may not match the actual scene. Learn to use PASM and you'll be sure to get the exposure you want every time.

PASM MODES EXPLAINED

P—Program mode is one step up from Auto mode—and many enthusiast photographers use it on a regular basis. In this mode, the photographer selects everything except the aperture and shutter speed, which the camera calculates for you. If the camera comes up with a combination of the two you don't like, you can usually use a wheel on your camera to change the settings for equivalent exposure: turn one way and you'll see the aperture get smaller and the shutter speed get faster—and vice-versa if you turn it the other way. You can also use exposure compensation to fine tune the image.

S (or Tv)—Shutter Priority is a mode where you dial in a shutter speed (say, 1/200 second), and the camera will automatically select an appropriate aperture setting that provides an "accurate" exposure based on the available light. One situation where you might use Shutter priority is if you're shooting sports and you need a minimum shutter speed to freeze the action, or where you want to use a deliberately slow shutter speed for creative effect.

A (or Av)—Aperture Priority is the opposite of Shutter Priority: you select the aperture, and the camera calculates the shutter speed. Photographers for whom controlling depth of field is more important than freezing action are more likely to use aperture priority. When shooting in Aperture Priority, keep an eye on your shutter speed—if it is very fast without you needing it to be, you may be able to use a slower ISO, which gives images with less noise, or a narrower aperture to extend depth of field. Conversely, if it's very slow, your photos might come out blurry, so you may want to ramp up the ISO or use a larger aperture setting.

M—Manual mode is for the true control-freaks among us. In Manual, you select both the shutter speed and aperture. Your camera will still help you, by using its light meter to indicate whether it thinks you are choosing an exposure that is too dark, too bright, or "correct," but you're free to ignore the recommendation and take your photographs using whatever settings. This gives you total creative control over the camera.

LEARNING TO LOOK

Photographers who have been shooting for a while start noticing that not only are they getting better at handling their camera, but they also seem to be pressing the shutter button more instinctively, and producing a greater number of good photos as a result.

Training your clairvoyance when it comes to photography is really down to being more observant about how things work in general rather than developing an actual sixth sense.

Know your domain

Some things are easy to anticipate—if you have some background information that informs the activity you are looking at. A soccer player who has just snatched the ball from an opposing player is likely to run toward the opponent's goal, and a tennis player about to receive a serve is likely to go stand at the appropriate side of the court. These are illustrative examples of "domain knowledge." By knowing how soccer and tennis are played, you're more likely to anticipate what's going to happen next.

The same thing is true for many genres of photography, whether it's nature, landscape, portrait, wedding, or even street photography. The more familiar we become with a certain subject, the better we are at anticipating its "movement": its pace, nuance, and rhythm. Photograph enough sunrises and sunsets, and you'll learn how often the light can dramatically alter as the sun sinks below the horizon, or how clouds can enhance the colors. Similarly, if you spend enough time observing people in a particular public place, you'll become more familiar with the way they interact with one another within that space. Complete enough portrait sessions and you'll become quicker at noticing how comfortable or otherwise your subjects are in front of the camera, and interact with them so that you are able to capture their essence.

↓ As you spend more and more time photographing specific things or at particular times of the day, you'll become more familiar with how those objects behave or how light changes. Knowing that a tree's branches can scatter the rays of an early morning sun is just one example.

Think before you shoot

Perhaps the most common mistake those new to photography make is using a "scatter-gun" approach. All too often when confronted with a scene worthy of photographing, the temptation is to fire away without really thinking about the images we're capturing. This is partly because it costs nothing to take a photo these days, and partly because we feel that if we take enough shots we're bound to stumble across the image we want to capture.

It is much better though to slow down and spend some time observing the subject, though. This isn't always possible if you're photographing a short-lived or unexpected event, but in most cases photographers usually have time to consider their subject and to spend time assessing it in search of its specific qualities, whether by exploring a variety of shooting angles, changing the point of focus or depth of field, waiting for a change in the light, or shifting the subject's position or posture. You should learn to visualize the image you want to capture and actively seek out that image, rather than reacting to images you've shot in the hope that one of them fits the bill.

↑ A little extreme perhaps, but once you learn to anticipate photographic opportunities you can start considering photos like this: a hummingbird hawkmoth in flight!

EXERCISE

Ask someone to throw a ball against a brick wall a few times, and catch it again. Try to take their picture as they throw the ball, and just as they are about to catch it. It will be tricky at first, but as you learn the "rules" of how your ball-thrower moves, capturing the movement becomes much easier, and the photos rapidly improve.

→ Even when it comes to portrait photography it pays to think about your photography approach. Not all portraits have to be shot at eye level with the camera pointing more or less directly at the subject's face. Using a chair for extra height has provided a different perspective here, which complements the dramatic lighting.

LIGHT & COLOR

At the most basic level light, in all its guises, is the be-all and end-all of photography. Even the word "photography" is derived from ancient words meaning "light" and "drawing."

To make photos, you don't need a lot. You don't need a lens; in fact, you don't even need a camera in its conventional sense! If you look on the internet, there are plenty of tutorials about how you can build your own pinhole camera out of anything from a cigar box to a box van. The one thing you do absolutely need in order to do any sort of photography—is light.

Photography, then, is really the art of drawing with light. The beauty of light is that it comes in every kind of shape, color, and brightness you can imagine; and each different quality and quantity of light will affect your photography differently.

In many ways, knowing photography is knowing, and understanding, light. Where it comes from, how it travels, what it reflects off, and how you "bend" and manipulate it as it passes through your lens and into your camera.

HOW LIGHT AFFECTS PHOTOGRAPHY

If there's no light, there can be no photography—but what is light, exactly? Without going knee-deep into physics, light can be thought of as tiny particles that move very, very fast. In fact, if you could drive a car between New York and Los Angeles at the speed of light, for example, you could drive there and back 75 times in a single second.

In order for something to be visible, it either has to emit light itself (like a light bulb, for example), or it has to reflect light from another source. White light contains the same amount of light at each wavelength. When something is red it means that the item is absorbing all wavelengths except red—the light you see is the light that has been reflected from the item.

Seeing the light

We all accept how important light is to photography, but the next step is to start "seeing" the light.

We'll be discussing the characteristics of light and what they mean to your photos later—but there is something you can start doing right now to gain a deeper appreciation of light. Look around you, and look for shadows. Now look for the object that's casting those shadows, such as a tree for example. Finally, consider the light source that is being blocked by the object. If you spotted a tree, it's likely to be the sun. It feels like a pretty weird exercise, but "tracing" the light like this is very valuable to you as a photographer. As we shall see later, determining the direction of light relative to the camera's position is crucial to how your images will look.

↑ Unbroken sunshine on a clear day free from pollution produces crisp, pure light that is ideal for revealing detail and highlighting form. This is because shadows are strong and distinct, helping to model objects.

↓ Photos taken on an overcast day, have a soft look—no harsh shadows, just lots of beautiful light and subtle colors.

SOFT & HARD LIGHT

There are many different ways to describe light, but one of the most important considerations is the "hardness" of light. How "hard" light is depends mostly on the size of the light source.

A small light source (like a bare light bulb, a flash, or, in relative terms, the sun in the sky) gives hard light, resulting in harsh shadows. A large light source (like light reflected off a large surface such as the ceiling, or the sun diffused by a layer of clouds) does the opposite—the light will be "soft," and the resulting shadows will be much softer as well.

The hardness or softness of light is important in many genres of photography, but people, in particular, tend to look better in softer light. In effect, that means that if someone is standing in direct sunlight, your photos rarely come out well.

There are a few ways around this conundrum: you can add more light (by using fill flash, or reflect some light back onto the subject); you can move your subject out of the sun into the shade; or you can try to soften the light somehow.

⬆ Taken just before a heavy rainfall at around noon under a thick layer of clouds, the light in this image is so soft and diffused that you can't really see any shadow cast by the bike at all.

➔ In direct sunlight, you get hard light and hard shadows. Half the face and body of this skateboarder disappears in dark shadows, and the skateboard's shadow is also very dark and clearly defined.

LIGHT QUALITY

Despite what many aspiring photographers assume, it's not the case that more light is the same thing as better light. Far more important than how much light you have available is the "quality" of light. By quality, we mean mostly the softness, direction, and color of the light: If these things are working, it doesn't necessarily matter that the light isn't very bright.

Let's look in more detail at what affects the quality of light. We've looked at "soft" and "hard" light and how this is determined by the size of the light source: a small light source resulting in hard light, and a large light source providing softer lighting. Another way of thinking about light sources is whether they're directional or non-directional. An unbroken sun, a spotlight, and a flash are examples of directional light. They are relatively small, easy to identify as the light source,

and cast distinct shadows; the more clearly defined the shadows, the stronger the lighter source.

Non-directional light is hard to pinpoint precisely because it is often very large, as in an entire sky completely blanketed by cloud. Other, less vast examples of non-directional light sources include large softboxes that are used in studios for portrait or product photography, or even the light reflected off a pale wall or ceiling. Non-directional lighting tends to be soft, diffused light that casts no shadows. And as with so many issues surrounding lighting and photography there are numerous examples of lighting that falls somewhere between the two.

Both directional and non-directional lighting have their photographic uses. Let's look at directional lighting first.

↑ Frontal lighting is excellent at showing outline and shape, and colors are usually saturated. In this image the frontal lighting is slightly off-axis creating short, but deep shadows.

→ Taken with a flash and a diffuser, this photo is an excellent example of frontal lighting. The photo looks quite two-dimensional.

The directions of light

Directional lighting can come from an infinite number of directions, but essentially there are three directions that clearly impact on photographs: from the sides, from the front, and from behind. Each different direction of light has a unique effect. This is important when you are taking photos in a studio setting, but it's equally wise to keep in mind when you are outside, or in a situation where you are less likely to be able to adjust the light source.

Remember that even if you can't do anything about the light itself, nothing is stopping you from altering the angle you are taking photos from.

Frontal lighting

Frontal lighting, as the name implies, is light that hits the subject from the front—in other words, when the light source is coming from roughly behind the camera.

Frontal lighting can look quite good for certain subjects, especially if you want to show off an object's details. Most product photography uses frontal lighting; and if you're taking photos of buildings, they tend to look best if the light hits front-on too. The downside of frontal lighting is that it does have a tendency to make things appear a bit flat and two-dimensional.

RELATIVE POSITIONS

It's worth bearing in mind that the direction of light is relative in two key ways: relative to the position of the camera and, in a more subtle sense, relative to the orientation of the subject. Although the lighting direction is always described in terms of how it's striking the subject—in other words a frontally lit object remains a frontally lit object no matter what position the camera is in—in real terms, altering the position of the camera allows us to capture differing lighting on the subject. For example, the images below were taken within a few minutes of one another. In the top image, with the sun behind the camera, we get a very different sense of the shape of the rock formation when compared with the image below it. There's very little shadow (ignoring the shadow in the foreground) and, as a result, the rock formation appears relatively flat. In the bottom image, the light is still striking the formation at the same angle, but by moving position we have in effect turned a frontally lit composition into a side-lit one. Shadows are much more apparent and we get an entirely different understanding of the shape of the formation. In a similar way, with the sun directly overhead, horizontal surfaces are frontally (or back) lit, while vertical surfaces are side lit, with each form of lighting capable of emphasizing differing aspects of the subject.

Side lighting

Side lighting is one of the most common lighting setups for portraiture—and just about every other genre of photography as well. With the light coming slightly from the side, you add a sense of depth and drama to an image.

There are lots of different ways to achieve side lighting, and there are lots of directions of light that could be said to come from the side.

In addition to direction, remember to consider the color (covered later in this chapter) and softness (covered earlier) of the light as well. Hard side lighting can give you some very dramatic effects, whereas softer light is better for beauty shots, where you're trying to make the model look as gorgeous as possible.

Side lighting is also favored by landscape photographers for the modeling effect it has on the contours of the land. Gentle peaks and troughs are exaggerated by the shadows thrown by such lighting, and the image usually contains pleasing gradations of tone that prevent a dull, uniform appearance.

Backlighting

If anyone has ever told you anything about photography, it was probably "always shoot with the sun at your back." In a way, they told you two things: use front lighting, and avoid backlighting. It's true—for most photos it's very challenging to capture a good shot when the light is coming from behind the subject. There is one particular technique, however, where backlighting comes in particularly handy, and that's if you want to create a silhouette. There are many ways to create a silhouette image, but the key trick is to set your exposure so the bright background comes out beautifully, while the dark foreground is allowed to be underexposed.

Rim lighting

When the light is coming toward the camera, as in backlighting, but slightly off to one side, you may find that the light reflects off the edges of the various objects in the image creating a glowing rim of light. This form of off-axis backlighting is known as "rim" or "edge" lighting, and it can create truly atmospheric photos. How much, and the way the edges glow, is determined not only by the power of the light source, but also by surface texture. Objects with a hard surface, such as metal will produce a narrow, intense glow, while objects with a softer edge will create a diffuse glow.

← Low sun off to one side can create atmospheric landscape photos, characterized by long, raking shadows, and areas of light and shade that inject drama into an image.

↓ A lot more subtle, but the most important light in this image is from above and to the left of the model.

↓ Back lighting can be used in portraiture, but if your subject is only lit from the rear, it can be hard to see who they are.

Mixing & matching light

The examples in this section are all a little bit extreme—in reality you are probably going to get a mix of light. Even in a scene where the sun is coming from the side, some of the light is probably going to be reflected off the ground, buildings, and other things in your surroundings. In a studio, for example, you might use several light directions at once in order to make the picture come together perfectly.

The challenge when dealing with different light sources stems from the fact that all the light sources are likely to be of different intensities (reflected sunlight is obviously less bright than light directly from the sun). Plus there will be varying degrees of softness, as well as different color temperatures from the various light sources.

→ Rim, or edge, lighting is a particular form of back-lighting in which edges glow with reflected light. The glow is a mild form of lighting flare, but if used with care, it can add atmosphere to an image.

So far in our discussion of light quality we've talked principally about hard and soft light and direction, and only briefly mentioned another key component: quantity. As camera technology progresses, we are able to use higher and higher ISO values with acceptable amounts of digital noise. The result is that it's possible to do exciting things in any number of low-light situations. In fact, improving technology has given us the flexibility to capture an entire range of moods using the same available light. We've always had the ability to turn dark lighting into something brighter and airier by overexposing through either a long exposure or wide aperture (a technique used to create bright high-key images), but recent improvements in high ISO capture mean this ability is more powerful and flexible than ever before. Whereas in the past the need to avoid using high ISO settings meant long exposures (therefore ruling out freezing many even relatively

↑ In portraiture, as in all other genres of photography, the quality of light is paramount. In this photo, due to the diffusers that were being used with the flash, there wasn't a great deal of light to work with. In fact, as with the picture of the cat, an ISO setting of 6400 was used to ensure the image was free from motion blur.

slow-moving objects in poor light), today, with ISO settings of 12,800 producing acceptable noise levels, it's possible to use shutter speeds in dim light that are fast enough to freeze most human movement. Conversely, remember that controlling light works the other way. By deliberately underexposing a scene (through the use of a fast shutter speed or a narrow aperture), you can turn bright conditions into dark ones, to create a moody "low-key" image.

Your camera vs. your eyes

When it comes to the quality of light, it's worth bearing in mind that your eyes sometimes interpret scenes very differently from your camera. This goes two ways: sometimes, you may find yourself in lighting situations that look fantastic to you, but that are extremely elusive when the time comes to capture them; other times, you see something, point your camera at it, and find that the photo is a lot more interesting than you remembered the scene being.

The disparity comes from the differences between the way your eyes "read" a scene and the way in which your camera sees it. Being able to see the way your camera sees comes with experience, and you can only get this by learning as much as you can about photography and taking as many photos as you can.

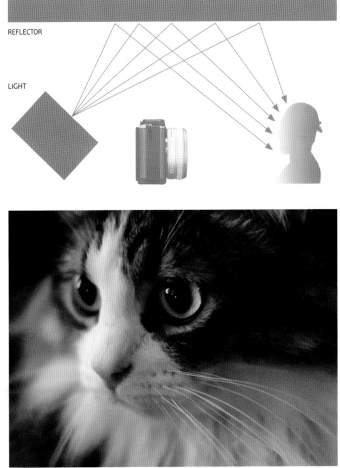

↑ This photo is lit with a 500W halogen shop light, aimed at the ceiling. Bouncing the light off the ceiling produces a similar light as that of very large softbox; soft, gentle diffused light devoid of any harsh, unflattering shadows. Although the light output was weak, using a higher ISO ensured the image was correctly exposed, while a wide aperture, as well as helping with the lack of light, also produced an attractive shallow depth of field. The end result is a beautiful portrait, which could be turned into an effective high-key image with judicious use of the Curves command in an image-editing suite.

↑ This photo was taken in the very weak light at the break of dawn. By using a wide aperture (f/1.4) and a high ISO (ISO 6400), it was still possible to capture the scene successfully. There wasn't a lot of light—but the little light that was available was beautiful.

BASIC STUDIO LIGHTING

As already intimated, the various aspects of quality of lighting—hardness, direction, and quantity—apply just as much to studio lighting as natural lighting. Here we're going to concentrate exclusively on studio lighting, as for many the holy grail of lighting is the ability to control it in a studio environment.

You may have seen it in the movies or on TV: the photographer directing a beautiful model around, with lots of impressive-looking lights hanging in all sorts of places in the studio. With perfect final results, of course.

Studio lighting might seem horribly complex, but it's not actually all that difficult to do yourself. Here we're going to look at using small portable flashes, but the theory behind working with strobes remains the same no matter whether you have powerful studio flashes or smaller, more portable off-camera flashes.

Break it down

The best way to start building a lighting setup is to consider your lighting situation light-by-light. It makes sense to start with the main light. In this example, we're going to use direct flashes (i.e. without any diffusers or softboxes).

1. Using a single flash, our friend HappyHead comes across as very moody indeed. This is perfect if that is the look you are going for, but for a more balanced lighting, we'll need to try something else.

2. A second light (shown here on its own) is added. It is largely designed to "lift" and brighten the shadow caused by the first light.

← Although natural lighting can produce beautifully lit portraits, it's less flexible than artificial, studio lighting. With studio lights it's possible to conjure up every mood imaginable, from bright and uplifting, to dark and reflective.

3. If we take a look at both flashes firing at once, we see that they balance each other out nicely—a pretty good start start to our portrait. Again, this is a perfectly acceptable lighting setup, and one that's used regularly.

5. Now that you have a decent flash setup, all three can be set to fire at the same time. The flashes help each other out in creating the ideal lighting situation.

4. However, the background is too dark, so a third strobe is added that turns the background pure white. This flash on its own creates a good silhouette photo.

6 Having perfected the lighting setup with a figurine, it's time to replace the doll with a real, live person. Take a close look at this photo: the lighting setup is exactly the same as the one used for HappyHead.

USING FLASH

Creating images using just the ambient light of your surroundings is all very well, but there will be times when a little extra illumination is desirable. This could be to even out the exposure of an otherwise backlit subject, or for creative effect; either way, the simplest way to achieve this is to use flash. Most cameras feature a built-in flash, which is either fixed on the front of the camera (mostly fixed-lens cameras), or available as a pop-up unit on top of the camera (most interchangeable-lens cameras). Some cameras also have a hotshoe connection so you can fix an external flash to the camera. Compared to other forms of lighting, flash is relatively "simple" because the exposure is usually calculated automatically by either the flash or by the camera.

TTL & manual

There are two ways to control flash exposure: you can either leave it to the camera to decide the required level of flash or you can take control yourself.

The automated method uses a system known as through-the-lens or TTL flash control. Different camera manufacturers use variations on this theme: Canon, for instance, uses a proprietary system called E-TTL II, while Nikon uses iTTL, but the two are fundamentally similar. When using TTL exposure, a pre-flash is fired. The camera analyzes how much light from the pre-flash has been reflected back toward the camera, and this information is used to adjust (if necessary) the main flash exposure. The flash and the camera shutter are then fired together to take shot. This whole process takes a fraction of a second (it's so quick that you're unlikely to see the pre-flash) and TTL systems are generally accurate. They can, however, become unreliable if the scene or subject that you're photographing is especially bright or dark.

HOT OR COLD? A hotshoe connects the flash electronically to the camera (it has a "hot" connection). The electronic connection is used to trigger the flash and, with modern flash systems, to determine the correct exposure. If you fit an external flash to a bracket or stand that has no electronic connection then you are fitting it to a "cold shoe"; the flash can only be fired via a cable connection to the camera or by using a wireless trigger system.

The alternative to TTL flash is to set the flash exposure manually. This requires more thought (and is easier to get wrong), but the results are more consistent than when using TTL. Manual flash exposure mode is set on the flash itself, or from the flash menu of the camera. You can use the guide number of the flash (see box) to work out the aperture needed to correctly expose your subject at a given distance from the flash. Alternatively, you can calculate the effective distance of a flash at an a particular aperture setting. The equations used are Aperture=GN/Distance and Distance=GN/Aperture respectively, but there are numerous apps available that will automate these calculations for you.

Flash output

If you're using manual flash then the flash's output is controlled in one of three ways. The first is that the amount of light the flash discharges can be altered. This is achieved either by altering the power setting or by applying flash exposure compensation. At a 1/1 power setting the flash discharges the maximum amount of light possible when it is fired, but at 1/2 power the flash duration is halved (halving the amount of light emitted). At 1/4 power the flash duration is halved again, and so on.

A second way of altering the flash exposure is to adjust the aperture used by the camera: the smaller the aperture, the shorter the effective range of the flash will be.

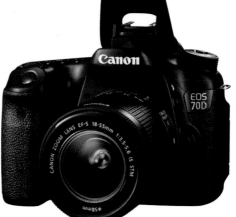

→ Built-in flash tends to be weak compared to an external unit. However, it's better than nothing. Some cameras have built-in optical wireless flash capability. In these cameras the built-in flash is used to trigger an external flash unit.

→ External flash units come in a variety of shapes and sizes, with specifications to satisfy every user: this is Canon's top-of-the-range 600EX-RT and Nikon's entry-level SB-400. When it comes to choosing a flash you don't need to stick with your chosen brand, though— there are many third-party alternatives that are just as well specified, and these are often significantly cheaper. You just need to make sure that the flash is compatible with your camera.

The most important specification of a flash is its power output. For built-in and hotshoe flashes this is usually given as a guide number or GN: the higher the GN, the more powerful the flash is. The GN of a flash tells you the effective range of a flash (in either meters or feet) at a given aperture and camera ISO setting. Built-in flashes tend to have low guide numbers compared to external units (and are therefore less powerful). As the GN of a flash alters as the camera's ISO setting is increased, most camera and flash manufacturers use ISO 100 as a fixed reference. In the past, the GN was essential in helping to determine the aperture needed to correctly expose the subject you wanted to photograph with flash, but it is now rarely used as anything more than an indication of power.

Finally, increasing the ISO extends the effective range of the flash. The effective range increases by 1.4x for every 1-stop increase in ISO.

Sync speed

Strangely, the one exposure control that has no effect on flash is the shutter speed, although when choosing a shutter speed it cannot be faster than the "sync speed" (also known as X-sync). This is the fastest shutter speed that exposes the sensor in its entirety, which means that the flash is recorded: if the sync speed is exceeded the flash will not illuminate the entire image correctly, resulting in part of the image being obscured by a dark bar. The sync speed varies between camera models, but is generally around 1/150–1/250 second (your camera manual should specify the sync speed). Modern camera systems generally won't allow you to use a shutter speed that is faster than the sync speed when you're using a built-in flash or an external flash fitted to the hotshoe, but you do need to be aware of the sync speed if you are using wireless, off-camera flash.

↑ Being aware of the camera's sync speed is important when you are using your flash away from the camera. In this image the camera's sync speed of 1/200 second was exceeded, resulting in an underexposed vertical bar at the right side of the frame.

→ A hotshoe allows an external flash to be attached to the camera, or a TTL cable or wireless trigger for off-camera flash. Although the hotshoes on most cameras look similar, each brand uses its own proprietary system of electronic connections, so you should never use a flash designed for one system on another.

FLASH CONTROL

Basic exposure control isn't the only option available when shooting with flash: by adjusting settings such as curtain synchronization you can modify how your flash behaves during exposure.

↑ This image was shot during the day in relatively bright light. Because of this, a shutter speed higher than the sync speed was required. The solution was to use high speed sync and keep the flash close to the foreground subject, just outside the image space.

Curtain synchronization

The burst of light from a flash is far shorter in duration than the sync speed. This gives you a choice: should the flash fire at the start of the exposure, or should it wait until the end of the exposure before firing? The first is known as 1st-curtain shutter sync, the second as 2nd-curtain sync. Which you choose makes little visual difference unless your subject is moving horizontally across the image space. In this instance, when 1st-curtain sync is selected the light from the flash will freeze the subject's movement at the start of the exposure. Any subsequent movement will be recorded as a blur in front of the subject. With 2nd-curtain sync selected, the light from the flash will freeze the subject's movement at the end of the exposure. Any movement happening before this will be recorded as a blur behind the subject. The effect of 2nd-curtain sync usually looks more natural, but there's no harm in experimenting to see which effect you prefer.

Slow sync

A common problem with images illuminated by flash is uneven exposure, when the subject is exposed correctly by the flash, but the background is grossly underexposed. This occurs because the background is further away than the effective range of the flash.

Increasing the ISO or opening the aperture won't necessarily help in this situation because you may then overexpose your subject, so the solution is to extend the shutter speed. This won't affect the flash exposure, but it will mean that the background is correctly exposed by the available ambient light. Known as slow sync flash, this technique is particularly effective at dawn or dusk. However, the shutter speed may drop to a point where camera shake becomes a problem, so you may need to use a tripod or rest your camera on a solid surface.

Another potential problem occurs if your subject moves during the exposure. This can create a double-image of your subject: one sharp (where the subject has been illuminated by the light of the flash), the other blurred (where your subject has been illuminated by the ambient light only). In this situation it's a good idea to ask your subject not to move until you give the signal to, rather than when the flash has fired.

Red-eye reduction

The closer the flash is to the lens, the greater the risk of a phenomenon known as "red-eye" when you photograph people or animals. Red-eye is caused by light from the flash entering the subject's eyes through the pupil, bouncing off the retina, and back out toward the camera. In doing this the light picks up a red tint from the blood vessels of the subject's retina, and it is this that creates a distinctly demonic "red-eye" look. To compound the problem, flash is often used in low light, when your subject's pupils are at their widest.

Red-eye reduction works in a rather simple way. A pre-flash, or auxiliary light, is fired a second or two before the main flash to force your subject's pupils to close: as the pupil is smaller less light enters their eye, so the red-eye effect is reduced. This is a very effective system, but not a subtle one—you'll certainly lose the element of surprise, which may be important for creative reasons. Some people also instinctively blink straight after the pre-flash, often as the main flash fires to make the final exposure. The alternative is to remove red-eye using your editing software.

High-speed sync

Generally, the sync speed of a camera isn't a limitation: in low light (when flash is used most often) the shutter speed will be far lower than the sync speed. However, if you're using flash in bright conditions—as a fill light for instance—or you want to use a wide aperture, the sync speed can be a frustrating restriction. Fortunately, some external flashes offer a mode known as high speed sync (it's generally not an option when using the built-in flash), which allows you to use any shutter speed up to the camera's maximum. There is however a catch, though: to allow this the flash pulses light over the duration of the exposure, essentially becoming a continuous light source. As a result, the effective range of the flash will drop dramatically, so you may find it necessary to keep your subject much closer to the camera (or the flash if it's being used off-camera) than you would otherwise.

↑ For this shot a slow shutter speed was combined with 2nd curtain sync and panning the camera to create a sense of movement. The brief burst of flash ensured- that the subject was clear in the photograph.

↓ Slow sync flash is particularly effective when the ambient light levels are low. This shot required a shutter speed of 1/2 second to expose the sky correctly.

FLASH TECHNIQUES

Used as a primary light source, the direct light from a built-in flash or hotshoe-mounted unit is rarely attractive: it's a hard, frontal light that casts short, dark shadows. It doesn't have to be like this, though, as a few simple techniques can radically alter the quality of light emitted by your flash and quickly improve the appearance of your flash-lit images.

Fill flash

Backlighting your subject is ideal if you want to create a silhouette, but if you don't you can use flash as a fill light. Fill flash is also useful for reducing the prominence of shadows, particularly under people's facial features (such as the nose and chin) in photographs taken outdoors on a sunny day. The exposure for fill flash is usually handled with few problems by a camera's TTL flash exposure system, provided the sync speed isn't exceeded. Using the camera's Program mode simplifies using fill flash too: by adjusting exposure compensation and flash exposure compensation you can adjust the relative brightness of the flash-lit subject to the background. A combination of negative exposure compensation and positive flash exposure compensation is a simple and effective technique for darkening the background relative to the (flash-lit) foreground.

Bounce flash

Having a flash built into a camera is better than no flash at all, but most of the time fitting an external flash is a better option. There are several reasons for this. As already described, external flashes tend to be far more powerful than built-in flash. Another good reason is that a built-in flash is at a fixed position on the camera (usually close to the lens pointing straight toward the subject), whereas a well-specified external flash will sport a head that can be angled either horizontally, vertically, or even both. This is particularly useful when it comes to using a technique known as "bounce flash."

As noted, on-camera flash typically creates a frontal lighting scheme with dense, hard-edged shadows, but bounce flash will reduce—or even eliminate—these two problems (and usefully prevents red-eye as well). To use bounce flash you angle the flash head upward or sideways toward a reflective surface. This could be a ceiling or wall above or to the side of the subject. For more control (or if you don't have a handy ceiling) you could also use a reflector that fits to the flash head (some flashes feature built-in reflectors) or is held above or to the side of the flash head, angled toward the subject. In all cases, when the flash fires the light bounces from the reflective surface back toward the subject. In doing this the light spreads out, making it far softer and more aesthetically pleasing than if the flash was used directly.

↑ Fill flash is invaluable when shooting in high-contrast conditions. In this shot flash has been used to lighten the front of the soccer player, which otherwise would have been unacceptably dark.

← The simplest type of diffuser fits directly onto the flash head, to spread and soften its light.

There are a few potential issues when using bounce flash. If the surface the light is bounced from has a color tint, then the light will pick up that tint, which could add an unwanted color-cast to your subject (although you could deliberately add color this way for effect). The second problem is that the flash-to-subject distance is increased, so underexposure is more likely if your flash isn't powerful enough, or if you use too small an aperture or too low an ISO value. This means you either need a powerful flash to start with, or accept that you might have to need a wider aperture and/or higher ISO setting than you would like.

Flash diffusers

An alternative way of softening the light from a flash is to fit a translucent diffuser to the flash head. The light from the flash passes through the diffuser, which spreads and softens it.

Flash diffusers are available in a number of different forms. The simplest type is a white plastic cap that fits over the flash head. This type of diffuser is typically bought to fit a specific external (hotshoe) flash, although diffusers are available that can be used with built-in flash, and they go some way to overcoming the limitations of built-in flash. However, a similar (and cheaper) effect can be achieved by taping tissue paper over the flash.

A more effective solution is to use an umbrella (or "brolly") or a softbox. There are two types of brolly available; translucent "shoot through" brollies that act in the same way as a diffuser, with the flash being fired through them, and silvered brollies that act in a similar way to a reflector, bouncing the light back onto your subject. Both types are used with the flash mounted on a stand, away from the camera.

Softbox diffusers come in a variety of sizes, some of which can be attached directly to an external flash, even when it is fitted to a camera. Larger soft boxes, like brollies, require the flash to used off-camera and mounted on a stand. In both cases a softbox works like a shoot-through diffuser and the larger the softbox, the softer the resulting light.

With all types of diffuser there is a certain amount of light loss, so the higher the GN of your flash, the more effective and versatile it will be.

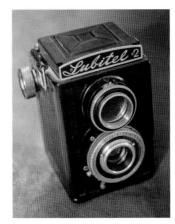

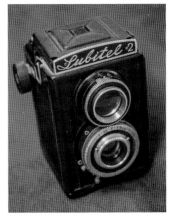

↑ This shot was created using an external flash pointing directly at the subject. The result is disappointing, with uneven exposure across the frame, distracting bright areas, and a loss of detail in the shadows.

↑ However, angling the flash head upward and bouncing the light from a white ceiling onto the subject makes a big improvement, with a better spread of light across the image.

↓ Fill flash is ideal for when you want to photograph a backlit subject without them appearing in silhouette.

63

OFF-CAMERA FLASH

↓ Taking a flash off-camera to create side lighting immediately adds a sense of shape and texture to a subject.

The frontal light from a built-in flash may be useful when you want to fill in the shadows on a subject, but it isn't always ideal. By taking your flash off-camera you'll have more control over the direction of the light from your flash, and by extension more creative control over the images you create.

Cable

The traditional way to use a flash away from the camera is to connect the two via a cable. There are two systems currently in use, the simplest (and longest-standing) being a "PC" connection. Both the camera and the flash must have a PC socket (which stands for Prontor-Compur—it has nothing to do with computers!) either built-in or in the form of a hotshoe adapter. The camera and flash are then connected using a PC sync cable: when an exposure is made an electrical signal is transmitted down the sync cable to fire the flash at the correct moment.

The major drawback to using a PC connection is that no exposure information is shared between the flash and the camera, so the flash exposure must be set manually. Another drawback is that it's all too easy to exceed the sync speed of the camera without realizing (the camera doesn't "know" that a flash is attached and so will not restrict the shutter speed range automatically).

An alternative, and arguably more sophisticated, cable-based system requires the use of a proprietary TTL cable. One end of a dedicated TTL cable is fitted to the camera's hotshoe and the other end is attached to the flash, effectively extending the electronic signal from the hotshoe to the flash and maintaining full TTL control.

Wireless

Whichever cable-based system is used, there is one significant limitation: both are restricted by the physical length of the cable. A more convenient method of firing off-camera flash is to use a wireless system, which also has the benefit that there are no wires to trip over.

There are two types of wireless system: optical and radio. An optical system uses infrared light to trigger an off-camera flash (or multiple flashes). The trigger can be either a wireless-enabled built-in or external flash, or a dedicated infrared transmitter attached to the camera's hotshoe. The trigger flash is referred to as the master flash; the flash that's triggered is the slave. Some infrared wireless systems allow the use of TTL exposure, making off-camera flash exposures as straightforward as using the camera's built-in flash, but the master and the slave must be able to "see"

FLASH-TO-SUBJECT DISTANCE When calculating the correct flash exposure you set the aperture according to the flash-to-subject distance, and this holds true even when you are using a flash off-camera. Even though the flash may be some distance from the camera, this distance is irrelevant to flash exposure: it's always the distance from the flash to your subject that you need to measure and take account of.

each other. Maintaining line-of-sight between the two is therefore very important. Infrared signals also have a limited range, and while this is generally further than would be practical for a cable, it is not always ideal.

By comparison, a radio wireless triggering system is far more robust in terms of the positioning and distance of the camera and flash combination. This is because a radio wireless system uses a radio transmitter attached to the camera's hotshot that communicates with a receiver attached to the foot of the external flash. A drawback to radio wireless is that no TTL information is transmitted between the camera and flash, so flash exposures must be set manually, and attention paid to make sure you don't exceed the sync speed.

↑↑ As soon as you start using flash away from the camera you can transform the look of your photographs, taking them from a snapshvot to stunning shot in one easy step.

↑ As your confidence and experience with flash grows you can add more flash units to your setups to create an entire "studio on location."

← Successful flash photography often involves combining several techniques. This image was created using slow sync, flash exposure compensation, and off-camera flash together.

WHAT IS COLOR?

All colors have three characteristics: hue, saturation, and luminance. The hue is what most people understand as "color," such as red, purple, orange, or green. Saturation expresses how vivid the color is—or how much there is of the color. Luminance describes how bright the color is—a color with a high luminance is very light (baby pink is an example of a color with high luminance), whereas a color with low luminance is a darker color. Burgundy, for example, could be described as a "red color with medium saturation and low luminance." Or, as you would really say, "dark red."

For the purposes of photography, color becomes important in two ways: the color of things, and the color of light. Everything you take a photo of will have some degree of color. In portraiture, the people you photograph have a color, the things they wear have

a different color, and so on. Because we're used to walking around looking at things all day, we're quite used to the way this aspect of color works. Remember that pure white light contains all the colors of the rainbow. If you are looking at a ball that you perceive as red, it means that the ball has absorbed all colors except red—and that it reflects the red back into your eye.

Where it can become confusing is when we introduce colored light. In the previous example, if we take all reds out of the light (by placing a blue filter on our light source), then the ball will look black.

Remember that you can adjust the color of light at two stages: at the source of the light, or with a filter in front of your camera. Once you've taken your photo, you can further adjust the colors in your photos on your computer.

← There is an almost infinite number of colors in the world around us, or at least, far too many for us to measure. However, when it comes to digital photography and computers, it's possible to put a figure on the number of colors we can see—a typical computer screen can display 16.8 million colors, for example. This is certainly a sufficient number to accurately represent the colorful world around us.

↗↗ The original color photo has a lot of reds and blues in it.

↗ Using a red filter on the lens (and shooting in black and white) means that the blues of the sky don't register, and turn a dark shade. As far as the camera is concerned, there is no light in that part of the photo.

→ If a blue filter is used instead, the blues come back, but the camera doesn't "see" the red areas. This means that the red brickwork gets a lot darker, whereas the sky is much brighter.

RGB PRIMARIES

The primary additive colors of red, green, and blue are fundamental to our perception and understanding of color. They are the colors recognized by the color-detecting organs of the eye—the cones—and which together make up all the millions of colors of the visible spectrum. As we'll discover, these colors crop up time and time again in the world of digital photography. A color image, for example, is captured by a camera's sensor (which is unable to differentiate between color) thanks to a color filter made up of a grid of millions of red, green, and blue cells that sits over the sensor. Without such a filter digital cameras could only record black-and-white images.

Additionally, when it comes to editing colors and creating black-and-white images using image-editing software, we'll see how the primaries of red, green, and blue—along with the secondary colors, cyan, magenta, and yellow—play a very active role.

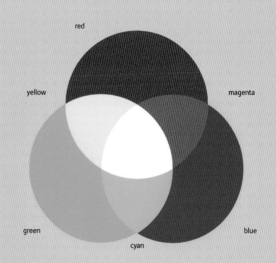

← By using a blue or red gel on the flash illuminating the background, you can change the look of a photo completely. Because the background in this image is white, it reflects all light hitting it. As a result, red light caused by the red gel makes the background appear red, while the blue gel produces a blue background.

COLOR & WHITE BALANCE

White balance is one of those topics that gets discussed to death on internet forums and websites. It can be alarming to learn just how much can be said about the subject, so you'll be pleased to know that you don't actually have to know all that much about white balance to make it work for you.

What is white balance?

The reason that white balance exists at all is because our brains and cameras work slightly differently. Our brains are truly astonishing at interpreting different situations, and determining what "white" is.

By definition, "pure gray" is a color where all the colors of the rainbow are represented in equal brightness. Out in the real world, this happens rarely. The color of the sun changes throughout the day: it's warmer—or more red—in the morning and evening, and cooler—more blue—in the middle of the day. Artificial light also comes in a variety of different color tones.

Your brain compensates automatically for these shifts in color in an attempt to keep things neutral, but your camera has a fixed response. However, the good news is that your camera's white balance control can be adjusted for the different colors of light, by mixing the colors so that whites appear white. In automatic white balance, if your camera discovers the picture is too cool, for example, it can mix the colors differently, adding in more reds and removing some blues, which results in a well-balanced image.

Color temperature & color cast

When it comes to white balance, there are two possible problems with your images, which are generally referred to as "color temperature" and "color cast."

Color temperature is what tints the photo toward blue ("colder" temperatures) or red ("warmer" temperatures). Color casts come in different guises, but casts affecting your photos will usually be magenta (a pinkish cast) or green. White balancing your photo fixes both temperature and cast issues at the same time.

← A typical white balance menu seen on the back of a camera. Most cameras feature these white balance settings: Auto, Sunny, Shade, Tungsten, Flash, and Custom.

↓ The image in the center is correctly color balanced, while the surrounding images show possible white balance and color cast issues. Top left has a cyan color cast. Top right is suffering from a "cold" color balance. Bottom right has a green color cast. Bottom left is too "warm."

JPEG & Raw

Your camera stores your images as digital files. On most cameras, this is either as a JPEG (the same file format that is used on the internet a lot) or as a Raw file.

There are many reasons why it's better to shoot Raw, and white balance is one of them. In short, by shooting Raw, you are taking the burden of decision-making away from your camera, and putting it where it belongs: in your own hands. When you're a photographer, being a control freak is perfectly acceptable!

→ This would never happen to your eyes, but your camera can be fooled. In this case, the camera was set to a manual white balance for indoor photography, which is why this image of Norman Jay came out looking very blue.

USING A GRAY CARD

There are any number of shooting situations where the lighting might result in an unpleasant color cast because the camera was unable to set the "correct" white balance—one in which whites appear white. Mixed artificial lighting is one such occasion. When the ambient lighting doesn't neatly fit into one your camera's white balance presets, such as Tungsten, Fluorescent, Cloudy, and so on, you can set white balance manually, using a gray card.

Gray cards are inexpensive plastic cards available from most camera suppliers. To set a custom or manual white balance, place the card in the same location as where you're going to be shooting. Fill the frame with the gray card, or use the spot metering setting, and take a photo. Next navigate to the Set Custom or Manual White Balance command and confirm the image you want to use to set white balance. When you take the next photo in the same location and with the same lighting the camera will now know which tones to set as mid gray, and all the other colors in the image will be recorded accurately.

When it comes to getting colors right in image-editing software, you'll stand a much better chance if you shoot Raw. Most of today's image-editing software can convert Raw files, and most has some form of white balance control. Below, we show you how to set white balance using Adobe Lightroom.

Using trial & error

Sometimes, if you can't find a neutral gray in an image, the White Balance Selector isn't going to be of any help. Use the drop-down menu, and select Auto. If they are available, you can choose a preset such as "sunny" or "tungsten." If your photo looks better that way, you can fine-adjust from there.

If that didn't work, you have to roll out the big guns and adjust manually: Slide the Temp(erature) and Tint sliders back and forth to see what gets you closest to your intended outcome. It's not a very scientific approach, but it usually does the trick.

What if you can't balance the image?

There are a few lighting situations where it's impossible to get the white balance of an image perfectly neutral. This could happen, for example, if you are taking photos in artificial light where there is only (for example) red light, such as at a concert. If that happens, you may have to live with the image not being "color correct."

Alternatively, if you're ready to give up, you can always convert the photo to black and white instead: after all, no color means no color balancing!

Mixed light sources

In many lighting situations you'll find that you have a series of difa restaurant, lit by candle light, with a light-bulb above the table, some halogen spotlights in the background, and fading sunlight outside. These are all different colored light sources, so unless you're going to do some extremely high-tech photo retouching, you'll never get them all to look the same.

The best you can do with mixed light sources is to set the white balance for one of them, so at least part of your photo looks "natural"—and consider the rest of the photo a mood-lit background.

To correct or not to correct?

As counterintuitive as it may sound, there may be occasions when you don't want to correct a color cast caused by inaccurate white balance. The most obvious example is the red glow of a setting or rising sun. We've become so accustomed to the red tint caused by a low sun that to correct it to make it a "more accurate" colder blue color seems to lose the power of the shot. But of course it's all subjective—there's no right or wrong, just what you want to convey with your image.

Pick a target neutral:

R 68.9 G 68.0 B 68.8

SET WHITE BALANCE

1. Load your photo into Adobe Lightroom, and enter Develop mode so you can make changes to the image.

2. Press the White Balance Selector eyedropper (or just press "w" to quick-select it).

3. Find an area of your photo that you believe should be a neutral gray; click on it with the White Balance Selector.

WB:	Custom⬦
Temp	5227
Tint	0

ACKNOWLEDGEMENTS

This book couldn't have happened without a huge amount of help and advice from some rather fabulous people. Big thanks to the team at Ilex for all their encouragement, and an extra special thanks to Steve Luck, Chris Gatcum and David Taylor for their invaluable help in getting this book made.

For Ziah

PICTURE CREDITS

iStockPhoto: 4BL, 5BR, 57BR, 61B, 65T, 65BR, 76B. 80B, 81BL, 88L, 88R, 88B, 95BR, 98, 99T, 100R. 104L, 105TL, 105TR, 105B, 109BR, 110B, 116T, 116B, 117B, 118L, 125, 127T, 131;

ShutterStock: 56BL, 63B, 119T, 119B, 120T, 120B, 121B, 122L, 122R0 , 123L, 123R, 126, 127B, 129T,

PASM modes 22, 42, 43
pet photography 108–9
phase-detection autofocus 12
pheed 143
photo-sharing sites 142, 143, 144, 146, 148–9, 166, 168
Photomatix Pro 137
Photoshop 150
 focus stacking 138, 139
 HDR imagery 137
 panoramas 135
 spot editing 163
Photoshop Elements 72, 150
Photoshop Touch 147
Picasso, Pablo 78
pin-cushion distortion 139
pixel-editing software 150–1
Pixlr Express 147
Pixlr-o-matic 147
point-and-shoot cameras 10, 11, 42
Polaroid camera 26
portrait photography 45, 98, 100
 artificial light 102–3
 black and white 133
 children 65, 116–17
 detail 105
 families 118–19
 framing 93
 glasses 102
 lighting 52, 54, 57, 90, 91, 100–3
 movement 104
 natural light 100–1
 props 102
 studio shots 104–5
 viewpoint 101, 102
 weddings 121
preset scene modes 42
prime lenses 18, 20, 21
print quality 149
prints 149
privacy issues 107, 148
Program mode (P) 22, 43

ranking photos 156
Raw format 15, 22, 23, 152–3
 black-and-white conversion 164
 color 69, 70, 71
 editing apps 147
 lossless editing 152–3
 night photography 125
 panoramas 134, 135
 quality 153
 travel photography 115
 wedding photography 121
 workflow 151
red-eye reduction 61
repetition 88–9
reportage 120, 121
rim lighting 52, 53
rule of thirds 84–5, 101

Samsung Galaxy 144
Saturation slider 72
self-critique 79, 168–9
sensors 17, 21, 67, 136
 cleaning 17
 crop sensor camera 21, 125

Four Thirds 19
 size 10, 11, 12
Servo focusing 38
Shadow slider 159
shadows 48, 50, 51, 52, 53, 56, 136
 night photography 125
 portrait photography 62, 100, 101, 102, 103, 118
 soft/hard 49, 62
sharing images 142–3, 148–9
sharpening 152, 156, 161
 output sharpening 166
shooting modes 42–3
Shutter Priority (S/Tv) 22, 43
shutter speed 14–15, 28, 29, 40, 83, 111
 Bulb mode 15
 child photography 116
 exposure and 32–3
 fast 29, 104, 106, 108, 123, 131
 illustrating motion 32
 long 28, 32, 34, 40, 78
 night photography 124, 125
 panning shots 34–5
 panoramas 134
 short 28, 32
 slow 15, 29, 30–1, 61, 82, 114, 124
 smoke 131
 sync speed 59, 60, 61, 131
 using creatively 34–5
 water droplets 131
 waterfalls 34
 wildlife photography 123
 zooming shots 35
side lighting 52
silhouette 52
SIM cards 145
smart cameras 10, 144–5
smartphones 10, 142–3
 apps 142, 143, 144–5
 editing apps 146–7
smoke 130–1
Snapseed 146
Snaptastic 147
snow mode 43
social media 142, 143, 144
softbox 62, 63
Soften Skin 162
Sony 12, 15
spot editing 156, 158, 162–3
still-life photography 126–7
 food 128–9
stopping motion 32
storage 167
street photography 106–7
 black and white 133
 legal issues 107
sunlight 48, 49, 100–1
superzoom cameras 16, 17
symmetry 88–9
sync speed 59, 60, 61, 131

tablets 144, 145, 146, 147
telephoto lens 18, 19
 aerial perspective 90
 architecture 110
 child photography 116
 family photography 119

street photography 107
travel photography 114
wildlife photography 18, 19, 122, 123
3G 144, 145
TIFF file format 152
tilt-shift lens 111
tone mapping 136, 137
Touchnote 149
tracking progress 168–9
travel photography 114–15
 editing apps 146, 147
Triggertrap 145
tripod 22, 23, 31, 83, 99, 118, 131
 food photography 128, 129
 macro photography 113
 night photography 124
 panoramas 134
 wildlife photography 123
 zooming shots 35
TTL cable 59, 64
TTL flash 58
Twitter 144

umbrella 62, 63, 103
underexposure 26, 29, 77, 95, 101, 159
uploading images 10, 143, 144, 148–9

Vaseline on the lens 37
verticals 87
Vibrance slider 72–3, 161
video mode 15
viewfinder 14
 electronic 10, 11, 14
 optical 11, 12, 13, 14
viewpoint see angle of view

water droplets 131
waterfalls 34
watermarking 148, 166
web-cams 169
wedding photography 120–1
white balance 68–71, 72, 152, 158
white card 103, 130
Whites slider 159
Wi-Fi cameras 10, 144–5, 155
wide-angle lens 17, 18
 architecture 110
 child photography 116
 food photography 129
 portrait photography 101
 travel photography 114
 wildlife photography 122
wildlife photography 18, 19, 122–3
wireless local area network (WLAN) 144

YouTube 144

Zeiss 15
zoom lens 17, 18, 20–1, 35
 bridge cameras 11
 wedding photography 121
zooming shots 35

output 58
portrait photography 102, 103, 104
red-eye reduction 61
smoke 130
sync speed 59, 60, 61, 64, 65, 131
techniques 62–3
TTL flash 58
water droplets 131
wireless 58, 59, 64
flash photography 23, 50
Flickr 143, 146, 148, 166, 168
Flock 143
focal length 10, 16, 18, 20, 33
 child photography 116
 depth of field and 37
 night photography 125
 travel photography 114
 wildlife photography 123
focus 77, 82
 A1 Focus 38
 autofocus 38, 77, 123
 continuous autofocus 38
 depth of field and 36–7
 focusing modes 38
 "in focus" 36–7
 Intelligent Focus 38
 Live View 14, 39, 125
 manual 19, 38, 39, 113, 131, 134, 138
 panoramas 134
focus ring 19
focus stacking 113, 138–9
food photography 128–9
foreground
 focus 138
 foreground/background contrast 90, 99
 lighting 102
Four Thirds sensor 19
Fracture 149
framing 92–3
freeze motion 32, 42, 43
frog's eye view 81
frontal lighting 50, 51

gift ideas 149
global editing 156, 158–61
Google+ 143, 144, 146
GPS 144
Grain filter 41
gray cards 69

hand-held shots 35, 76, 83
 panoramas 134
HDR Efex Pro 137
HDR imagery 136–7
High Dynamic Range (HDR) 136
Highlights slider 159
histograms 27
horizon 99
horizontals 87

image sizing 166
image stabilization 83
imaging chips 26
implied lines 87
Instagram 142, 143
Intelligent Focus 38
interchangeable-lens cameras 12, 16–17, 58

iOS devices 143, 146
iPhones 143
ISO settings 15, 28, 29, 30, 40–1, 43, 62, 83
 child photography 116
 flash 59
 high 31, 40, 54
 low 40, 99, 111
 night photography 125
 travel photography 115
 wedding photography 121

JPEG format 15
 color 69
 compression 152
 editing apps 147
 panoramas 134, 135
 processing 152
 quality 153
 travel photography 115

keywording images 154–5

landscape photography 17, 83, 98–9
 aerial perspective 90
 framing 92, 93
 panoramas 134–5
large format prints 149
large sensor compacts 10, 11
LCD screen 10, 14, 27, 115
leading lines 86, 92, 99, 101, 111
 still-life photography 127
learning to look 44–5
legal issues
 copyright 148, 154
 street photography 107
Leica 161
lens mount 14
lenses 12–13
 close-up lens 112, 113
 fisheye 110
 fixed focus 10
 image stabilization 83
 interchangeable 12, 16–17
 large sensor compacts 10
 macro lens 108, 112, 113, 131
 manual focus 19
 nifty-fifty 114
 prime lenses 18, 20, 21
 street photography 106
 tilt-shift 111
 vibration reduction 83
 see also telephoto lens; wide-angle lens; zoom lens
light/lighting 46, 48
 backlighting 52, 53
 background/foreground 102
 catch light 102
 colored light 66
 continuous lighting 102, 103
 depth and 91
 directional lighting 50, 51, 100
 edge lighting 52, 53
 family photography 119
 flash see flash
 food photography 128, 129
 frontal lighting 50, 51
 hard light 49, 50, 52

low light 15, 54, 82
mixed sources 70
non-directional lighting 50
off-camera lighting 41
portrait photography 52, 54, 57, 90, 91, 100–3
quality 50, 55
rim lighting 52, 53
side lighting 52
smoke 130
soft light 49, 50, 52, 55
source 48, 49, 50, 71, 101
still-life photography 127
studio setups 56–7, 103, 130, 131
sunlight 48, 49, 100–1
wedding photography 121
Lightroom 40, 72, 151, 152–3, 169
 black-and-white conversion 164–5
 exporting photos 166
 global editing 159, 160
 Grain filter 41
 white balance 70, 71
 workflow 154–7
Live View 14, 39, 125

macro extension tubes 112, 113
macro lens 108, 112, 113, 131
macro photography 17, 112–13
manual control 10, 11, 22
Manual mode (M) 22, 23, 43, 134
Masking slider 161
maximum aperture 18
megapixels 15
memory cards 114, 115, 121, 123
metada preset 154
mirror lockup 124
mobile phone cameras see smartphones
monochrome shooting 133
movement
 illustrating motion 32
 pet photography 108, 109
 portrait photography 104
 wildlife photography 122
Mozy 167
multimedia messaging service (MMS) 142
MySpace Shot 80, 81

national parks 122
negative space 85
nifty-fifty lens 114
night photography 124–5
Nik Software 146
Nikon 20, 58, 145, 152
noise
 digital noise 31, 40, 41
 reduction 40, 116, 161

Oloneo 137
Olympus 152
optical stabilization 19
optical viewfinder 11, 12, 13, 14
output sharpening 166
overexposure 26, 27, 28, 77, 95, 101, 153

Paintshop Pro 72, 73, 150
panning shots 34–5
panoramas 134–5

INDEX

AI Focus 38
abstracts 130–1
Adjustment Brush 162
Adobe see Camera Raw; Lightroom;
 Photoshop
aerial perspective 90
AI Focus 38
algorithms 137
Android devices 10, 143, 144, 146
angle of view 80–1
 architecture 111
 bird's eye view 80
 eye-level 80, 117, 121
 food photography 128
 frog's eye view 81
 landscape photography 115
 low angle 81, 115, 117, 121
 pet photography 108
 portrait photography 101, 102
 wedding photography 121
animals
 pets 108–9
 wildlife 18, 19, 122–3
aperture 14, 28, 29, 30, 43, 83
 depth of field and 30, 31, 37, 83
 food photography 128, 129
 large 28, 31, 100, 101, 128, 129
 limits of 30
 small 29, 30, 31, 99, 100, 111
 variable 28
Aperture Priority (A/Av) 22, 34, 43, 106, 116
 night photography 125
 panoramas 134
Apple Aperture 151
apps see smartphones
architecture 110–11
Auto Cloud Backup 144
auto exposure bracket (AEB) 136
Auto mode 29, 42
Autodesk 147
autoexposure bracketing 77
autofocus 38, 77, 123
Automate Photomerge 135

backlighting 52, 53
background
 background/foreground contrast 90, 99
 focus 138
 lighting 102
 smoke 130
 still-life photography 127
 street photography 107
 wildlife photography 123
backing up 155, 156, 166–7
barrel distortion 139
batteries 114, 115, 121, 123
beach mode 43
beanbag 114
bird's-eye view 80
black-and-white conversion 40, 41, 132, 160,
 164–5
black-and-white photography 132–3
Blacks slider 159
blowing up photos 149
blur 32, 33, 76, 77, 82–3
bounce flash 62
bracketing 77

breaking the rules 85, 94–5
bridge cameras 10, 11
brolly see umbrella

cable 59, 64
cable remote systems 144, 145
Camera Raw 152–3
camera shake 33, 76, 83, 124
CamRanger 145
Canon 20, 22, 58, 144, 145, 152
canvas printing 149
catch-light 102
CDs 166
centering 84
Charge-Coupled Devices (CCD) 26
child photography 65, 116–17
cityscapes 110–11
Clarity slider 73
clipped blacks 26
close-up photography 112–13
color 66
 abstracts 131
 adjustments 160
 black-and-white conversion 40, 41, 132, 160,
 164–5
 droplets 131
 JPEG format 69
 muted 72–3
 neutral 72–3
 night photography 124, 125
 Raw format 69, 70, 71
 RGB primaries 67
 vivid 72–3
 white balance 68–71, 72, 152, 158
color cast 68
correcting 70
color temperature 68
compact camera 10, 11, 14, 22, 123
 superzoom 16
compact system cameras (CSCs) 12, 13, 140
Complementary-Metal-Oxide-Semiconductor
 (CMOS) 26
continuous shooting mode 109, 116, 118,
 136
Contrast slider 159
controls 14
converging verticals 110
copyright 148, 154
Corel Paintshop Pro 72, 73, 150
creativity 78–9
crop 158–9
crop factor 18, 19, 100
crop sensor camera 21, 125
curtain synchronization 60
curves 87

depth 90–1
depth of field 29, 43, 55, 90–1, 100
 aperture and 30, 31, 37, 83
 focal length and 37
 focus and 36–7
 food photography 128
 macro photography 113
 shallow 113, 116, 128
 too shallow 83
 travel photography 115
 water droplets 131

desktop imaging software 150–1
DeviantArt 148
diagonals 87
diffusers 62, 63
digital noise 31, 40, 41
Digital Photo Review 15
digital SLR (DSLR) 12, 13, 140
 crop sensor 100
 HDR imagery 136
 nifty-fifty lens 114
 preset modes 42
domain knowledge 44
downloading images 154
Dropbox 143, 167
droplets 112, 131
DVDs 166, 167

edge lighting 52, 53
editing 10, 168, 169
 apps 146–7
 panoramas 134–5
 workflow 154–7
electronic viewfinder (EVF) 10, 11, 14
export location 166
exporting photos 156, 166–7
exposure 26, 77
 adjustments 159
 controlling 28–9
 equivalent exposures 29
 histograms and 27
 ISO settings and 40–1
 manual 138
 night photography 125
 overexposure 26, 27, 28, 77, 95, 101, 153
 shutter speed and 32–3
 underexposure 26, 29, 77, 95, 101, 159
 variables 29
exposure compensation 77
Exposure slider 159
external hard drives 156, 167
eye-level 80, 117, 121

f stops 18, 28, 29, 30, 31, 34
 scale 31
Facebook 142, 143, 144
family photography 118–19
file compression 152
file naming/renaming 154, 166
file settings 166
fill flash 62, 63, 101
film grain 41
filters 66
fisheye lens 110
fixed-lens cameras 10–11, 58
flash 14, 37, 56, 57, 58–9, 91
 bounce flash 62
 built-in 14, 58, 59
 cable 59, 64, 145
 control 60
 curtain synchronization 60
 diffusers 62, 63
 fill flash 49, 62, 63, 101
 guide number (GN) 58, 59
 hotshoe 59, 63
 manual flash 58, 131
 night photography 125
 off-camera 14, 64–5, 130, 131

shutter speed
The time the shutter (or electronic switch) leaves the sensor open to light during an exposure.

SLR (Single Lens Reflex)
A camera that transmits the same image via a mirror to the sensor and viewfinder, ensuring that you get exactly what you see in terms of focus and composition.

soft-box
A studio lighting accessory consisting of a flexible box that attaches to a light source at one end and has an adjustable diffusion screen at the other, which softens the light and any shadows cast by the subject.

spot meter
A specialized light meter, or function of the camera light meter, that takes an exposure reading from a precise area of a scene.

sync cord
The electronic cable used to connect camera and flash.

telephoto lens
A photographic lens with a long focal length that enables distant objects to be enlarged. The drawbacks include a limited depth of field and angle of view.

TIFF (Tagged Image File Format)
A file format for bitmapped images. It supports cmyk, rgb and grayscale files with alpha channels, and lab, indexed-color, and it can use LZW lossless compression. It is now the most widely used standard for good-resolution digital photographic images.

TTL (Through The Lens)
Describes a metering system that uses the light passing through the lens to evaluate exposure details.

umbrella
In photographic lighting, umbrellas with reflective surfaces are used in conjunction with a light to diffuse the beam.

wide-angle lens
Type of lens with a short focal length. A wide-angle lens is characterized by its wide angle of view (hence the name).

white balance
A digital camera control used to balance exposure and color settings for artificial lighting types.

zoom
A camera lens with an adjustable focal length, giving, in effect, a range of lenses in one. Drawbacks include a smaller maximum aperture and increased distortion over a prime lens (one with a fixed focal length).

filter

(1) A thin sheet of transparent material placed over a camera lens or light source to modify the quality or color of the light passing through.
(2) A feature in an image-editing application that alters or transforms selected pixels for some kind of visual effect.

focal length

The distance between the optical center of a lens and its point of focus when the lens is focused on infinity.

focal range

The range over which a camera or lens is able to focus on a subject (for example, 0.5m to Infinity).

focus

The optical state where the light rays converge on the film or CCD to produce the sharpest possible image.

frontal light

Light that hits the subject from behind the camera, creating bright, high-contrast images, with flat shadows and less relief.

f-stop

The calibration of the aperture size of a photographic lens.

grayscale

An image made up of a sequential series of 256 gray tones, covering the entire gamut between black and white.

golden hour

The hour just after sunrise or just before sunset, named after the warm quality of the sunlight. This is usually a great time to take photos.

halogen bulb

Common in modern spotlighting, halogen lights use a tungsten fillament surrounded by halogen gas, allowing it to burn hotter, longer, and brighter.

HDRI (High Dynamic Range Imaging

A method of combining digital images taken at different exposures to draw detail from areas which would traditionally have been over or under exposed. This effect is typically achieved using a Photoshop plugin, and HDRI images can contain significantly more information than can be rendered on screen or even percieved by the human eye.

histogram

A map of the distribution of tones in an image, arranged as a graph. The horizontal axis goes from the darkest tones to the lightest, while the vertical axis shows the number of pixels in that range.

HSB (Hue, Saturation, Brightness)

The three dimensions of color, and the standard color model used to adjust color in many image-editing applications.

hue

The pure color defined by position on the color spectrum; what is generally meant by "color" in lay terms.

ISO

An international standard rating for film speed, with the film getting faster as the rating increases. ISO 400 film is twice as fast as ISO 200, and will produce a correct exposure with less light and/or a shorter exposure. However, higher-speed film tends to produce more grain in the exposure, too.

LCD (Liquid Crystal Display)

Flat screen display used in digital cameras and some monitors. A liquid-crystal solution held between two clear polarizing sheets is subject to an electrical current, which alters the alignment of the crystals so that they either pass or block the light.

megapixel

A rating of resolution for a digital camera, directly related to the number of pixels forming or output by the CMOS or CCD sensor. The higher the megapixel rating, the higher the resolution of images created by the camera.

midtone

The parts of an image that are approximately average in tone, falling midway between the highlights and shadows.

modeling light

A small light built into studio flash units which remains on continuously. It can be used to position the flash, approximating the light that will be cast by the flash.

noise

Random pattern of small spots on a digital image that are generally unwanted, caused by nonimage-forming electrical signals.

pixel (PICture ELement)

The smallest units of a digital image, pixels are the square screen dots that make up a bitmapped picture. Each pixel carries a specific tone and color.

ppi (pixels-per-inch)

A measure of resolution for a digital image.

RAM (Random Access Memory)

The working memory of a computer, to which the central processing unit (CPU) has direct, immediate access.

Raw

A digital image format, known sometimes as the "digital negative," which preserves higher levels of color depth than traditional 8 bits per channel images. The image can then be adjusted in software—potentially by three stops—without loss of quality. The file also stores camera data, including exposure meter readings, aperture settings, and more. Each camera model creates its own kind of Raw file, although the majority are supported by software such as Adobe Photoshop.

resolution

The level of detail in a digital image, measured in pixels (e.g. 1,024 by 768 pixels).

RGB (Red, Green, Blue)

The primary colors of the additive model, used in monitors and image-editing programs.

rim-lighting

Light from the side and behind a subject falling on the edge ("rim") of the subject.

saturation

The purity of a color, going from the lightest tint to the deepest, most saturated tone.

shutter

The device inside a conventional camera that controls the length of time during which the film is exposed to light.

GLOSSARY

aperture
The opening behind the camera lens through which light passes on its way to the image sensor (CCD/CMOS).

artifact
A flaw in a digital image.

aspect ratio
The ratio between the width and height of an image. Traditional television has an aspect ratio of 4:3; 35mm film is 3:2; and widescreen television is 16:9.

autoexposure
Letting the light meter in the camera determine which shutter time and aperture should be used for a given scene.

autofocus
When using automatic focus, the subject in front of the camera lens is brought into focus by letting the camera determine when the subject is sharpest.

bayonet fitting
A quick-release fitting to attach a lens to a camera; found on most interchangeable-lens cameras.

backlighting
The result of shooting with a light source, natural or artificial, behind the subject to create a silhouette or rim-lighting effect.

bit (binary digit)
The smallest data unit of binary computing, being a single 1 or 0.

bit depth
The number of bits of color data for each pixel in a digital image. A photographic-quality image needs 8 bits for each of the red, green, and blue channels, making for a bit depth of 24.

bracketing
A method of ensuring a correctly exposed photograph by taking three shots; one with the supposed correct exposure, one slightly underexposed, and one slightly overexposed.

brightness
The level of light intensity. One of the three dimensions of color in the HSB color system. See also Hue and Saturation.

byte
Eight bits. The basic unit of desktop computing. 1,024 bytes equals one kilobyte (KB), 1,024 kilobytes equals one megabyte (MB), and 1,024 megabytes equals one gigabyte (GB).

catchlight
A catchlight is a small dot of white in somebody's eye—it gives your model a "glint" in the eye that often makes a photo look more natural than if it were omitted.

CCD (Charge-Coupled Device)
A tiny photocell used to convert light into an electronic signal. Used in densely packed arrays, CCDs are used as imaging sensor in most compact cameras.

channel
Part of an image as stored in the computer; similar to a layer. Commonly, a color image will have a channel allocated to each primary color (e.g. RGB) and sometimes one or more for a mask or other effects.

cloning
In an image-editing program, the process of duplicating pixels from one part of an image to another.

CMOS (Complementary Metal-Oxide Semiconductor)
alternative sensor technology to the CCD.

color temperature
A way of describing the color differences in light, measured in degrees Kelvin and using a scale that ranges from dull red (1900K), through orange, to yellow, white, and blue (10,000K).

compression
Technique for reducing the amount of space that a file occupies. There are two kinds of compression: lossless and lossy. While the first simply uses different, more processor-intensive routines to store data than the standard file formats, the latter discards some data from the image. The best known lossy compression system is JPEG, which allows the user to choose how much data is lost as the file is saved.

contrast
The range of tones across an image, from bright highlights to dark shadows.

cropping
The process of removing unwanted areas of an image, leaving behind the most significant elements.

depth of field
The distance in front of and behind the point of focus in a photograph, in which the scene remains in acceptable sharp focus.

diffusion
The scattering of light by a material, resulting in a softening of the light and of any shadows cast. Diffusion occurs in nature through mist and cloud cover, and can also be simulated using diffusion sheets and soft-boxes.

digital zoom
Many cheaper cameras offer a digital zoom function. This simply crops from the center of the image and scales the image up using image processing algorithms (indeed the same effect can be achieved in an image editor later). Unlike a zoom lens, or "optical zoom," the effective resolution is reduced as the zoom level increases; 2× digital zoom uses ¼ of the image sensor area, 3× uses $^1/_9$, and so on. The effect of this is usually very poor image quality.

edge lighting
Light that hits the subject from behind and slightly to one side, creating flare or a bright "rim lighting" effect around the edges of the subject.

extension tube
A mechanical device that allows a lens to be held securely in place a distance away from the camera body.

file format
The method of writing and storing information (such as an image) in digital form. Formats commonly used for photographs include TIFF and JPEG.

fill-in flash
A technique that uses the on-camera flash or an external flash in combination with natural or ambient light to reveal detail in the scene and reduce shadows.

fill light
An additional light used to supplement the main light source. Fill can be provided by a separate unit or a reflector.

2 What can you do to improve it? Now that you have a little list of issues with a photo, you can think about your toolbox: do you have the knowledge and the equipment to solve the problem? Usually equipment is rarely the problem—so it's a case of applying what you know about light, lenses, and camera settings to try to find a solution to your challenges.

3 If you improve on point 2, will that fix point 1? The final point in the three-point plan is to analyze whether the solutions you've come up with are good enough to save the day. Sometimes you'll find that you've done everything in your power and knowledge to make a photo work, but it just doesn't want to play nice. Honestly? It happens. But the great news is that the focused approach you've chosen throughout these three steps means that you've gone through a process of self-critique that will help both these and future photos.

↙ Looking at your old photographs is a good way to remind yourself how far you've come as a photographer.

↑↓ A photo taken with the web-cam on a computer(!) was never going to be anything to write home about. But it had a certain something—and after a bit of editing in Lightroom, the end result is a vaguely usable photo.

169

TRACKING PROGRESS

One thing common to many photography students is that they don't believe they're making any progress. Usually the problem isn't that they're not improving, but that they're so involved in their photography that they don't recognize the huge leaps they're making.

It's important to always keep learning, of course, but it's equally important to stand back and see how far you've come. Look at your photos on Flickr or wherever you keep your old work. It doesn't matter if you show them to the world, or just set them to "private" so only you can see them; the point is that the linear nature of Flickr means you can go back in time quite easily.

Every now and again—and especially when you're feeling you're not progressing—take a look at the photos you took six months or a year ago. You'll spot mistakes or decisions in your old photos that you would never have made today. You'll remember why you liked a photo, but you'll suddenly spot something you overlooked the first time around. That does two things: If you can fix the problems in post-production, you can go back and

improve your old photos. And even if you can't, you've just noticed something you didn't notice before. That probably means that you have a new perspective, new skills, and new knowledge. Fabulous: you see you've improved more than you thought!

Self-critique

There are bound to be days when you feel that a recent photo or set of photos you've made isn't what you ideally want to be producing. Here's a three-step plan to help you learn from these moments.

1 What are you unhappy with? Can you put into words what you feel should be better in your photos? Are the issues mostly technical, or do you feel that it's a lack of inspiration that's getting in the way of your dream photos? It's important to be quite clear about what it is you don't like.

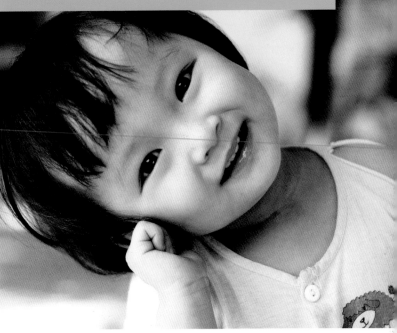

↑ This dialog box is your highway to getting your photos out into the world. It's boring, but important.

↗ Fact: without sharpening, this photo wouldn't be as cute.

can be replaced, your photographs themselves are irreplaceable, so it really is important to make yourself backups before the worst happens.

Choose how to back it up

When you're at home, backups are relatively simple. Buy a couple of external USB2/3 hard drives, and save all your photos to both drives. Keep one at home, and leave another drive somewhere safe—at your parents, at work, or in a safety deposit box. Basically, anywhere that isn't your house.

A recent development is online backup solutions that are fully automated and can sync with your computer. In addition to the drives mentioned above, look at Mozy (bit.ly/mozhome); a fully automatic backup service. There's also Dropbox (bit.ly/drop-welcome) which is a similar service. They both work very well. Have a look at both, and see which one you prefer.

Check your backup integrity

Remember that you have to be sure that what you are backing up is actually working: there's no use in taking a backup of a corrupted file. Obviously, you can't check every file for integrity every time, but what you can do is ensure that you keep older backups, too.

Imagine discovering that you've deleted a folder of important pictures by accident. If you only keep the most recent snapshot of your pictures folder (as it were), you'd be in real trouble. With a sensible backup strategy in place, however, you should be able to dig out an older backup of your photos folder, and then you'll be able to restore those photos.

For important shoots (like weddings, for example), it's a good idea to burn them to DVD immediately. That way, you know you will always have a backup somewhere that cannot accidentally be overwritten or deleted.

Think about where you store your backups

It's important to think about how you are storing your backups. Remember that you're backing up for all sorts of reasons: if your computer breaks, an external hard drive is handy. But what if someone breaks into your house?

It's a good idea to keep a hard drive connected to the network hidden away in the attic. That way, a casual burglar is unlikely to run off with it, so even if your computer is stolen, you don't lose your photos.

In addition, keep a backup on an external drive at a friend's or relative's house—it's low-tech, and the backups may be fairly old every time you swap the drive over, but it's better than not having an extra backup. Finally, set up some online backups.

And finally...try recovering the backup

The best thing that might happen to you is that you go your entire life without ever having to restore a backup. Nonetheless, it is an extremely good idea to try it anyway.

If you're unable to restore your backups (perhaps there's a problem with the backups? Maybe the restore feature of your favorite backup package isn't working?), you may as well not make a backup at all: they're only useful if you actually can use them should the worst happen.

EXPORTING & BACKING UP

Taking photos is a lot of fun, and editing them makes them even better, so that's fun too. But what's the point in taking good photos and editing them to perfection if you're not going to do anything useful with them?

The great thing about Lightroom is that you can create different export preferences to export your photos in the best possible, most efficient way. For example, there are export preferences set up for emailing photographs (low resolution), sending images to Flickr (medium resolution), making postcards (medium-high resolution, with sharpening for matte printing), and for use in books (full resolution, with a low amount of sharpening-for-print enabled). In your Export dialog, you'll find the following options:

Export to allows you to choose whether you want to export to CD/DVD (great if you need to give someone a set of image files in full resolution) or to hard disk (best for everything else). You can also download a lot of different export plugins; to Facebook, Flickr...you name it. Do a quick Google search for Export, Lightroom, and your favorite photo sharing service, and you'll probably find a suitable plugin.

Export Location is where you choose where you export your photos to. You can export everything to a folder on your desktop, but you can also set up photos to export directly to a specific folder somewhere else.

File Naming is good if you want your files to change names as you export them. For photos to upload online, you can include key words in the file names, for example, or you can include things like "-web" or "-fullsize" at the end of file names, which is handy if you want an easy indicator of how big your files are.

File Settings is where you choose your file format. There are quite a few to choose from—but in general, you'll want DNG (Digital Negative) if you want to edit your files more at a later date and JPEG for everything else. Because this is the very last step of your image-editing process (and because you're keeping your Raw files in your Lightroom library. This is the only time where it doesn't really matter that you're using a "destructive" file format.

Image Sizing is where you choose the output size of your files. This is perfect for stuff like Facebook: You don't want to upload your photos in full resolution there, so here you can make sure they are "resized to fit" 1000x1000. This means that the files are resized to fit in a 1000px by 1000px box.

Watermarking is where you can choose to embed a watermark into the photos you're exporting. Not everybody likes this method, but if you want to reiterate to the outside world that your photos are indeed yours, it's not a bad idea to overlay a copyright notice on your images. You can easily use a text- or image-based watermark on your exported photos.

When you're happy with your output settings, you can either use the new settings once, or save them as a preset by clicking "add" and giving your preset a name.

Sharpening for the right destination

Output Sharpening is an output setting many people overlook, but it's very important indeed. The issue is that photos that are unsharpened can look rather fuzzy by the time they reach their final destinations.

In the past, there was a lot of guessing involved with how much you should sharpen your photos, but Lightroom is making the process a lot easier, by giving you some simple presets: Sharpen for Screen, Sharpen for Matte prints, and Sharpen for Gloss prints, each with three levels of sharpening—Low, Medium, and High.

It's difficult to illustrate how much of a difference these export settings can make in a book, so try it yourself. Export a detailed photo without sharpening, then sharpen-for-screen in each of the three amounts of sharpening. Your unsharpened photo will look dull compared to the three others.

How much sharpening you apply depends on your personal preferences—but experiment with this setting, because that final little bit of extra sharpness can make your photos pop out of the screen in an absolutely incredible way.

A word about backups

Let's open with a little anecdote. Once, a photographer moved house. After all the boxes had been carried into the house, both he and his housemate were exhausted, so they decided to pop out for some food to relax for the rest of the evening. In the 20 minutes they were gone, somebody broke into the apartment, and stole everything—every single box. All his clothes, his computer equipment...and his backups, too.

Sure, having all your possessions stolen is a little bit extreme, but when you think about it, there are a lot of things that could happen: fire, thieves, water leaks—anything. While your camera and computer equipment

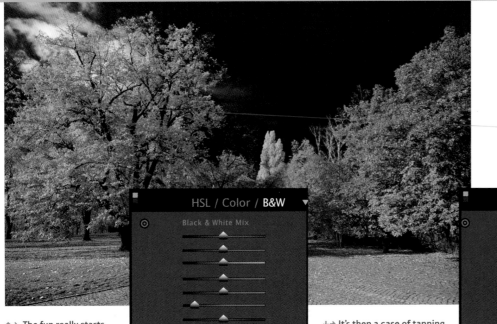

↑→ The fun really starts, however, when you start delving into the black-and-white conversion controls. With a strong blue sky, turning down the blue channel creates a powerful black background.

↓→ It's then a case of tapping into the other colors in the image to get the effect you are after. For this conversion, the yellows and greens were adjusted to create as much contrast as possible in the leaves and grass.

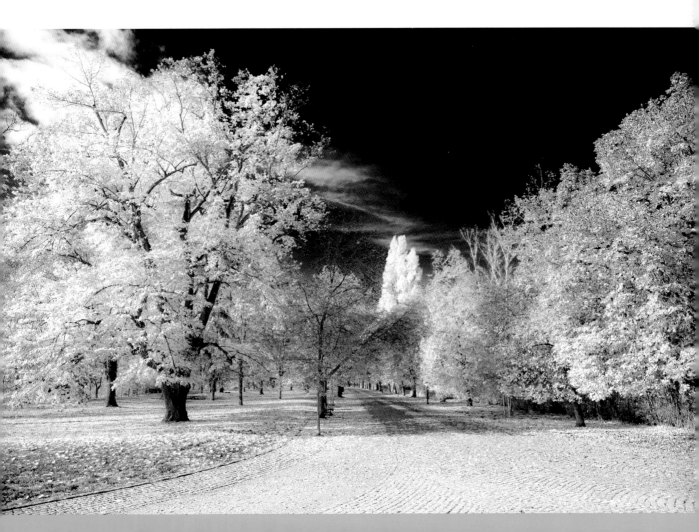

BLACK & WHITE CONVERSION

We looked at black-and-white photography earlier in Chapter 5. There, we discussed why black and white was still so appealing to so many photographers, and what compositional tools to look out for when making black-and-white images.

Having made the original image (in Raw ideally), the next stage is to convert the image from color to black and white. Even if you've used your camera's black-and-white mode, when you come to open the Raw file in your image editor it will have retained the original color information captured at the time of shooting.

There are a number of good black-and-white conversion techniques, but what they all rely on is the ability to target and then alter the color tones to create the monochrome version.

In this example we're going to use Lightroom to make the conversion, but almost all recent image-editing software, both pixel-editors and workflow software provide access to the principle color channels in an image. Controlling these channels allows you to fine tune your black-and-white conversion.

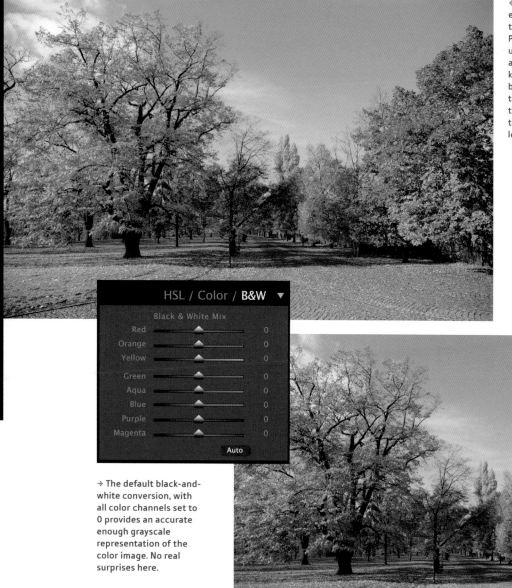

← Although pleasant enough as a color image, this photograph of a park in Prague, Czech Republic is unlikely to attract much attention. However, knowing how powerful the black-and-white conversion tools at our disposal are, the contrasting colors of the blue sky and the yellow leaves could have potential.

→ The default black-and-white conversion, with all color channels set to 0 provides an accurate enough grayscale representation of the color image. No real surprises here.

↑ If you want to remove larger objects, such as people, you'll need to switch to a pixel editor. Here two figures are spoiling an otherwise nicely lit shot of a famous Berlin landmark, the Bismarck Memorial in the Tiergarten.

↑ For greater control, turn to the Clone tool. This allows you to choose the area you want to copy, rather than letting your software decide.

Fill	
Contents	
Use: Content-Aware ⬍	OK
Custom Pattern	Cancel
Blending	
Mode: Normal ⬍	
Opacity: 100 %	
☐ Preserve Transparency	

↑ Photoshop has a number of clever retouching tools and methods. Drawing around an object and filling the selection using the Fill tool's Content-Aware option can often produce the desired result.

→ The finished image, and not a figure in sight. What you clone (and when) is up to you, but there are some moral implications.

162

SPOT EDITING

Once you've concluded your global edits, it's time to get to work on spot edits. Most photos can benefit from the odd edit here and there: people have blemishes, objects get scrapes and dust on them, and landscapes are occasionally littered with garbage. If it's spoiling your photo, get rid of it!

Effect: Soften Skin ⬍
Amount ————————————— 100

← The model in this portrait has one or two pimples and small patches of dry skin. This close level of spot editing is achievable using Lightroom tools.

↑ To fix the areas of dry skin select the Adjustment Brush tool and choose Soften Skin from the pull-down menu. Brush over the area to smooth it.

↓ In In a matter of moments the pimples are removed and the dry skin smoothed away. A gentle application

of "Soften Skin" over the rest of the model's face completes the portrait.

↑ The pimples are quickly banished using the Spot Removal tool. With the tool in Heal mode, simply adjust the tool using the "[" and "]"

keys to fit neatly over the spot and click. Use the Clone setting to replicate another area of skin.

Noise reduction & sharpening

One of the things that keeps improving all the time—both in-camera and in computer software—is noise reduction algorithms. A few of the steps we took earlier in this workflow made the noise in the picture more visible—especially the adjustments made to the exposure and brightness.

So, in order to pull the noise back down a little, some noise reduction was applied. The noise-reduction settings are quite powerful, but if you try to filter out too much noise, your photo will come across as fuzzy; experiment to see what works best for your photos. Use the Masking slider to restrict the algorithm to edges of the image, leaving flat areas of tone unaffected.

Sharpening is something you have to do quite carefully, and it's usually best to save this step until the end of your workflow, when you export your images. Having said that, some cameras are distinctly "soft" before you've sharpened the images a little; Leica's M8 and M9 cameras, for example, are fantastic cameras indeed, but unless you sharpen the photos, you'd be forgiven for thinking they weren't.

Sharpening advice varies a lot from camera to camera, so play with the settings a little, or do a quick search online to find out which settings other people are using.

→ Here, the Vibrance setting has been increased, and add a touch of Saturation added. You can be stronger handed with the Vibrance setting as it only increases colors that won't become oversaturated.

Presence		
Clarity		0
Vibrance		+40
Saturation		+3

Color adjustments

Next, it's time to make any color adjustments. These were discussed in Chapter 3, so leaf back and get those adjustments in place now.

There are a lot of creative options available in the Basic panel in the Develop mode in Lightroom; you can create selenium or sepia tones, for example, or make black-and-white conversions. It's worth playing around with the settings, because if it all goes horribly wrong you always have the "reset" button at the bottom right of your photo to undo everything in an instant.

You can use the crop tool to crop and rotate your image. For this particular photo, we're going to do both. Crop in slightly and rotate to straighten the hand rail by moving the cursor to one corner and dragging the image up or down to rotate it.

Exposure adjustments

The next step is to take a closer look at the exposure—is your photo slightly under- or overexposed? Because this photo was shot in Raw, it means there's a lot of extra data to work with compared to shooting a JPEG so slight under- or overexposure is not a problem, as that can be fine-tuned. The best way to adjust exposure is to work your way down the sliders.

The Exposure slider does exactly what you'd expect it to—if your photo is a little underexposed, you can increase your exposure here, and vice-versa. Here, the image has been brightened.

The Contrast slider provides greater separation between light and dark tones—essentially, light tones become lighter and dark tones become darker. This can give an image a little more punch.

The Highlights slider adjusts the lightest parts of the image; The slider was moved to the left to darken the photographer's bright shirt.

The Shadow slider controls the dark tones in the image. Moving the slider to the right opens up shadow regions to reveal more detail.

The Whites slider controls the very brightest elements of the image, and determines the white point. Here the slider was used to make the flashes even brighter.

Finally, the Blacks slider adjusts the very darkest parts, essentially setting the black point. Making sure you have small areas that are entirely black and completely white in your image provides a richer overall tone.

↑ The crop tool initially overlays a grid that divides the image into nine equal areas—just like the rule of thirds. When you move the cursor to a corner of the image to rotate it, a smaller grid appears, which makes it easier to check horizontals are straight.

↓ Using the exposure controls in Lightroom's Basic panel allowed the previously underexposed image to be brightened, while at the same time ensuring the image retained good contrast and a complete range of tones from black to white.

159

GLOBAL EDITING

Photo editing is generally split into two different disciplines—one is "global edits," the other is "spot edits." As the names imply, the difference lies in how much of the photo you edit at once.

Global edits are edits that you apply to a whole photo at once. Contrast, color balance, sharpening, noise reduction, cropping, and exposure corrections are all examples of global edits. For various reasons, most photographers tend to do global edits to their photos before they do spot edits, mostly because some adjustments that are applied to the photo as a whole can negate the need for local edits.

It may sound a little drastic, but the truth is that most photos benefit from a couple of tweaks in order to really stand out.

White balance

The first change needed on a lot of photos is a color tweak—we looked at this in Chapter 3, but let's take another quick look at changing white balance.

Pick the white balance tool and move the cursor around the image. As you do so you'll see the RGB percentages alter. Look for an area where the percentages are quite even and click on it.

Crop

Now that the photo is white balanced, it's easier to see what you have to work with. With this image, the next step is to crop and straighten it. Select the Crop tool or press "R" to bring it up. You now get a grid with the image split into nine equal-size parts. Yes, that's the rule of thirds you're seeing—isn't that useful!

WB: Custom

Temp 2850

Tint +28

Pick a target neutral:

R 24.4 G 24.0 B 23.3

↑ This image was shot at the entrance to an airport. The artificial lighting has given the image an orange cast. Selecting a neutral area has resulted in a much more accurately colored image.

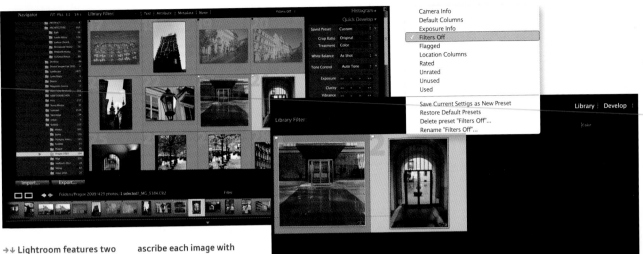

→↓ Lightroom features two ways of categorizing images. You can either flag them as picks or rejects, and then go back and further refine your initial selection. Or you can ascribe each image with a number. Again, you can then go back and further sort images by the assigned number, using Lightroom's Filter options.

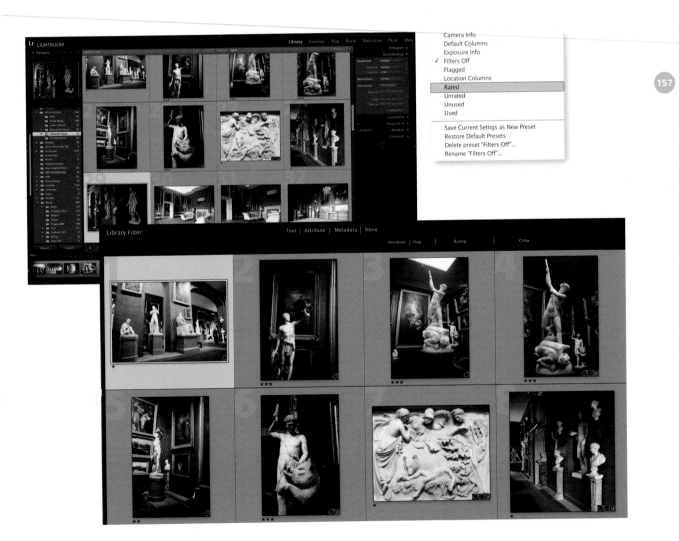

Ranking your photos

Ranking photos means giving them a rating from one to five, in order to help you decide which photos you are going to take a closer look at for editing.

Depending on how you take photos, you may be able to skip this step: If you've just been on a leisurely stroll and taken the odd photo here and there, it's easier to just dive straight in and do your editing.

If you've just done a studio or travel shoot, however, you might have taken several hundred photos. The last thing you want to do is to spend an hour editing a photo, only to discover that a photograph shot a couple of frames after is much better.

In Lightroom, the star rating system works well for this. Pressing X will mark a photo as "rejected," but it's usually best to reserve this for photos that are technically flawed. If it's grossly over- or underexposed, or out of focus, no amount of editing can save the photo, so reject it—and later delete the image files. For everything else, press one of 1–5 on your keyboard. Use 1 and 2 for acceptable photos, 3 and 4 for ones that warrant another look, and 5 for photos you think have potential for greatness.

An alternative to the star rating system is to flag images, either as picks (press P) or rejects (press X). Whichever system you use you can later use the Filter options to show images that you've selected.

Global & spot editing

We'll look at the actual editing process a little bit later in this chapter, but once you have ranked your photos, it's time to do the global edits, and then the spot edits, to your photographs.

Sharpening & export

The final steps of the process are usually done in a single step: exporting and sharpening. It's important to know that nearly all digital photos need to be sharpened as the very last step before you export them—the reason for this is that the amount of sharpening depends on the media (Web? Magazine? Canvas prints?) and size you're going to use them at. There's more on sharpening later in this chapter. Finally, export your files to the destination you want.

Backup again!

Before you close Lightroom, do a last backup. Lightroom will prompt you to do weekly backups anyway, but it's a good idea to make a separate backup of your photos after you've edited them. There's no point in doing all that work only to lose it all if something bad happens to your computer.

←↑ External hard drives come in all sorts of shapes, sizes, and colors. The two most important considerations are the size of the drive (1 terabyte is likely to be sufficient) and the speed of the connection; USB 2 or USB 3. All USB 3 devices will work on USB 2 compatible computers, but there's no point having faster connectivity if your computer isn't equipped with it.

File Handling

Render Previews Standard

☑ Don't Import Suspected Duplicates

☐ Make a Second Copy To:
/ Users / steveluck / ... Download Backups

File Renaming

☑ Rename Files

Template Date – Filename
Custom Text
Shoot Name
Start Number
Extensions Leave as – is

Sample: 20130521-IMG_001.DNG

Apply During Import

Develop Settings None

Metadata Steve Luck

Keywords
LANDSCAPE, Italy, summer, Tuscany

Destination – +

☑ Into Subfolder Ilex Photo Guide

Organize By date
Date Format 2013/2013-05-18

New Mac 49.4/ 297 GB
▼ Users
 ▼ steveluck
 ▼ Pictures
 ▼ Photos
 📁 Abstract
 ▶ 📁 ARCHITECTURE
 📁 Boarding
 📁 Borders_A
 ▶ 📁 Dorset Stream Fair 2011
 📁 Exhibition pix
 ▶ 📁 Kids
 ▶ 📁 Landscape
 ▶ 📁 Lesson Files–PScs 1on1

Auto Import Settings

☐ Enable Auto Import

Watched Folder: < not specified > Choose...

Destination

Move to: /Users/steveluck/Pictures Choose...

Subfolder Name: Auto Imported Photos

File Naming: IMG_0001.DNG

File Naming: Filename

Information

Develop Settings: None

Metadata: None

Keywords:

Initial Previews: Minimal

Cancel OK

↑ As an increasing number of cameras are Wi-Fi enabled, programs such as Lightroom feature dialog boxes that allow you to tell the software where to look for new images.

→ Lightroom's File Handling panel instructs how images are imported and how they are tagged. Here you can ensure all your images have copyright information, all the appropriate keywords embedded, and filenames that make it easier to search.

Street Photography, New York. If you're in a hurry, tag the photo with "TO-TAG," then you can simply search for TO-TAG at a later date for additional keywording.

Once you've done your general keywording, you are already well on your way to making your photos easier to find, and depending on how many photos you take, you may decide to leave it at that. If you want more fine-grained search options, however, you can go through your most recently imported photos to add additional keywords. Words like "boy," "child," "male," "funny hat," "motorcycle," or "landscape" can come in useful later—or the name of the person or brand of product in the photos, and so on.

Time for a backup!

Now that you have all your photos keyworded, it's time to start thinking about making a backup. Lightroom makes this easy for you: simply select all the images you just imported, and from the File menu, choose Export as Catalog. This exports the whole photo shoot—digital negatives and all—to one handy place.

We'd propose that handy place to be an external hard drive that you only use for Raw files, before you've started editing them.

THE EDITING WORKFLOW

It's a very long time since photography was about taking a photo, handing the film over to a developer, and getting some prints. After the digital photography revolution, a lot of photographers have stopped seeing "opening the envelope" as the end of the photographic process. In fact, many now see photo taking as the very beginning of the workflow.

When photographers talk about "workflow," they generally mean everything that happens after they've pressed the shutter. It covers the whole process from downloading your photos to your computer through to their final destination, whether that's Facebook, Flickr, postcards, or a gallery wall.

In the example given here, we are going to walk through the workflow using Adobe Lightroom. The same steps would apply no matter what software you use; it's just the interface and menus that will be slightly different.

Downloading your images

It's a great idea to use a card reader of some sort to get the photos off your camera. Some computers have built-in card readers that are generally very good, but you can pick up a card reader online relatively inexpensively.

It's easiest to import the files directly into Lightroom. Insert your memory card, and Lightroom pops up with its import dialog box. Here, you can add additional EXIF data, such as your copyright information and keywords, and you can rename your files as well.

File handling

Before Lightroom starts to import any images, go to the File Handling panel at the right of the screen. Here, there are some important options that will help you locate, manage, and tag your images much more efficiently later down the line.

File Renaming: We recommend always renaming your files using DATE—FILENAME. This means that all your image file names will be unique, which can save you a lot of time. You can send low-resolution JPEGs to a potential client, for example, and if they decide they want to use a high-resolution version of a file, you can simply type the file name into the search box in Lightroom. Because the file names are unique, the correct file shows up right away.

Apply During Import: Here you'll notice a Metadata pull-down menu. Clicking the Edit option will bring up the Metadata option. Create a metadata preset with all your copyright information (name and contact details) and save this. Now, whenever you import any images, with your preset selected in the Apply During Import option, you know your files will be tagged properly. Remember to include your email address in case somebody wants to license the photos for use.

At this point, you can also choose to apply Develop Settings. If you want to turn a whole batch of photos into black and white, for example, you can choose a developing preset here.

Keywording your images

If keywording sounds like a bit of a chore, then we have to admit that you're probably right. The thing is, Lightroom has a very fast and efficient search engine built in—but it can only search metadata. If you remember that you took a photo of a yellow frog at one point, but you can't remember where or when, you could spend hours going through all your photos. If you've keyworded the photo with "Yellow" and "Frog" all you have to do is type in "yellow frog" in the search box, and it'll pop up immediately.

At import, it's good to get into the habit of keywording your photos with everything the photos have in common. After a session of street photography in New York, for example, you could tag your photos with Travel Photography, Travel, North America, USA,

← A convenient way of downloading images from a memory card to the computer is via a card reader. You can leave the card reader permanently connected to your computer, which saves having to connect your camera every time you want to download photos.

and create a "change" file that keeps track of your edits in a separate place, instead of applying the changes to your Raw file. Then, when you are happy with your changes you can export the image as a JPEG or TIFF (keeping the original Raw file and the option to change it again at a later date).

Quality

However, the best thing about shooting in the Raw format is that you are retaining much more image information. JPEGs are 8-bit images. Without getting too technical, this essentially means that a JPEG image can contain 256 levels of red, green, and blue, or 16.7 million colors in total (256×256×256).

This sounds like a lot until you realise that when you shoot Raw, the image is saved as a 12-bit file, and can be opened in editing software as an even larger 16-bit file. This gives you 65,536 levels per color channel (RGB), providing 281 trillion colors.

This is far more than we can detect with the human eye, but it is incredibly useful when it comes to editing the image. Having an image with a greater bit depth means you'll get fewer ugly-looking artifacts, such as banding and noise, when you make dramatic adjustments with your editing software.

↓ This image of Prague was poorly taken. The sky, although not quite blown out entirely, is overexposed Fortunately the camera was set to capture in Raw+JPEG so we have a lot of image data to draw on when darkening the sky.

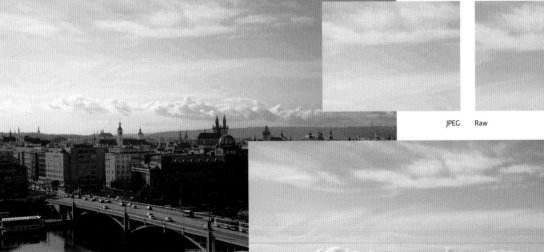

JPEG Raw

↑ When attempting to fix the overexposed sky in the JPEG version unattractive discoloration and banding soon becomes apparent, as shown in the detail of the sky. With the Raw file, however, it's possible to adjust the exposure in the sky and darken it, and still achieve a smooth, accurately colored sky.

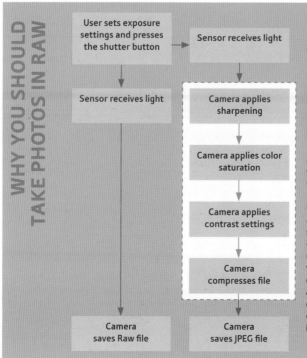

RAW FORMAT

How your camera records images

There are three main file formats used for digital photographs: JPEG (also known as JPG), TIFF (also known as TIF), and Raw. JPEG and TIFF are standard file formats, but Raw is a proprietary file type developed by the camera manufacturers. (Canon's Raw files are called CR2; Nikon's are NEF; Olympus' are ORF; and so on).

To understand the difference between the different file formats we have to take a look at how the camera records a photo. It all starts with the exposure: your shutter speed and aperture determine how much light hits the sensor; the image sensor records the data it finds, and multiplies the light captured by the ISO setting. If you are shooting at ISO 200, for example, the light measured by the imaging chip is multiplied by two.

This is the raw data that is passed through to the processor inside your camera. Now, if you are taking photos in Raw, this data is simply saved to a file. If you are taking photos in JPEG, the camera processes the raw data, applying sharpening, white balance, and any color/contrast settings. The problem is that as soon as the camera applies sharpening, it cannot be "unsharpened" without a reduction in quality. Similarly, once white balance has been applied to a file, that white balance is "locked in." However, until the camera processes your photo, it exists in a state where everything is possible.

File compression

The TIFF file format is generally used to store images. It takes the "rendered" or "processed" image in its entirety, without compression—which means that you still lose some flexibility, but your photos are as good as they can be, without compression artifacts. TIFF files are "lossless," so you can open, save, and close them a million times without seeing any image degradation.

JPEG files, on the other hand, compress the files in addition to processing them. JPEG compression can be very good indeed, but no matter how you look at it, it is a "lossy" file format. This means that you lose data every time you save a file—so you lose a little bit of quality every time you open, save, and close a JPEG. It may not be noticeable; but if you've gone out of your way to invest in a high-end camera, do you really want your files to degrade as you're working on them?

Lossless editing

So, Raw files are brilliant because they don't "render" your photo; you can do all the edits that your camera would have done on your computer after the fact. Sharpening, contrast, white balance, and so on—it can all be done in software with greater control

The other great Raw-editing trick is the ability to perform lossless editing. Software such as Adobe Camera Raw and Lightroom open up your Raw file,

WHY YOU SHOULD TAKE PHOTOS IN RAW

User sets exposure settings and presses the shutter button → Sensor receives light

Sensor receives light

Camera applies sharpening

↓

Camera applies color saturation

↓

Camera applies contrast settings

↓

Camera compresses file

Camera saves Raw file

Camera saves JPEG file

As this diagram shows, the key difference between Raw and JPEG is what happens in the camera, after an exposure has been made.

With a Raw file, the "raw" data recorded by the sensor is saved directly onto the memory card. Any subsequent processing that is needed—such as changes to the exposure, color, contrast, or sharpness, for example—is performed using Raw conversion software. This allows you to make non-destructive changes before the image is output as a TIFF or JPEG file, but it does mean that you have to process your images to get the best from them—and that takes time.

Conversely, a JPEG file is processed in-camera so any changes (sharpness, saturation, contrast, and so on) are "embedded" in the file when it is saved onto the memory card. The file is also compressed (using "lossy" compression) when it is saved to the memory card. The result is that any further editing of a JPEG is "destructive," in that it will affect the image directly and can degrade the quality. However, the advantage is that JPEGs can be ready for printing or uploading to the internet straight from the camera.

Non-destructive editing

Instead of changing the pixels directly, the second type of imaging software makes changes through a series of instructions or parameters. All changes and adjustments you do to your images are kept in a separate file, and your original files are left untouched. This means that you can experiment to your heart's content. If it all goes horribly wrong, you can always press the Reset button or go through an unlimited number of undos. These undos remain available even after you quit the program, so you can always go back if you regret a choice made earlier on in the editing process. If only real life was like that!

Raw workflow

This type of non-destructive software, of which Adobe's Lightroom and Apple's Aperture are the two best-known examples, developed as a means of editing and processing large numbers of Raw files with the minimum of fuss. As "workflow" software, each takes on your whole photography workflow, including downloading your photos to your computer, tagging them so you can find them later, viewing, editing, and exporting them, and making backups. For event photographers, such as those shooting weddings, the ability to tag, process, and output a large number of files quickly and easily without jumping between programs is a real bonus.

Which software?

Which type of software is right for you depends ultimately on what type of images you produce and the level of editing you want to get into. With pixel-based editors, because you can alter each individual pixel, you have ultimate control over the content of the image. So if you want to assemble photomontages, or you're into special effects or creating adverts with text on them, then you'll need a pixel-based editor.

This level of editing isn't possible with non-destructive editing software. Although it's now possible to undertake a certain degree of local adjustment with Lightroom and Aperture, removing objects or blending two or three images together isn't possible. However, for many photographers, editing at a pixel level isn't necessary and a non-destructive workflow software is a better answer.

151

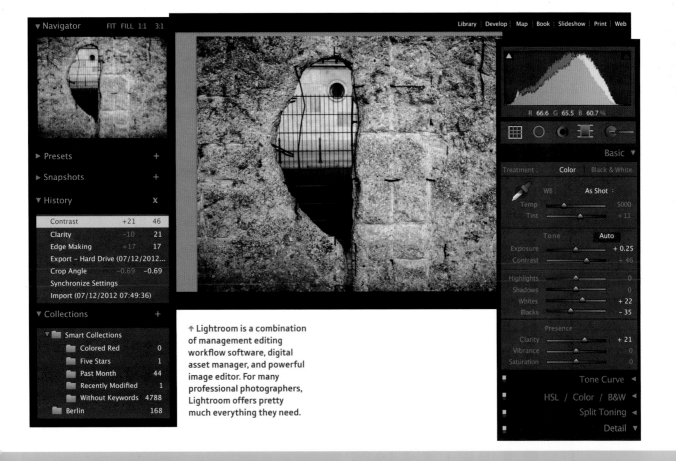

↑ Lightroom is a combination of management editing workflow software, digital asset manager, and powerful image editor. For many professional photographers, Lightroom offers pretty much everything they need.

DESKTOP IMAGING SOFTWARE

There are a lot of different desktop image-editing packages available out there, ranging from free, via entry-level software, to packages that will set you back by as much as a brand new camera body.

You may have heard of Photoshop before. It's a fantastic software package that has become the industry-standard for image and graphics editing and production. With Photoshop you can do just about anything to a photograph, even to the point of recreating it pixel by pixel should you so wish. It's still one of the most flexible image-editing programs available—but that flexibility comes at a price. Not only is Photoshop prohibitively expensive for many, but it also has a very steep learning curve, and beginners are often scared away by this.

There is a cheaper version of Photoshop out there as well. Named Adobe Photoshop Elements, it's a stripped-down version of its bigger brother. It's easier to learn, and offers pretty much everything a photographer needs.

Comparable in terms of functionality and price to Photoshop Elements is Corel's PaintShop Pro. Like Elements, PaintShop Pro is structured so that you can organize, edit, and share your images in a sensible, logical workflow.

What all these packages have in common is that any editing you undertake is applied to the image itself; in other words the pixels themselves are changed, be it their color, brightness, or saturation values. Because you can edit right down to individual pixel level, it's possible to merge images together to create photomontages, add text, or clone out unwanted objects, as well as making broader, less localized changes to overall contrast and brightess. The ability to work down to pixel level has resulted in this type of software being referred to as pixel-editing software.

↑ With some image-editing software, such as Photoshop Elements and PaintShop Pro it's possible to change the actual pixels that make up the image. In this way you can clone out unwanted details from a photo, as demonstrated in these images.

images for viewing on screen, but if you want to edit some images on the move, then upload them to the cloud either for final editing or for printing to perhaps 10x8 inches, make sure the app is capable of crunching images large enough for this size of print. In a similar vein, if you're a serious travel photographer or similar who needs the ultimate image quality while doing an initial edit on a tablet, you may find that working with Raw files is either not possible, or extremely slow. Many of the apps that claim to support Raw are actually working on the JPEG sidecar file that is attached to the Raw file. If working on Raw files is a critical part of your workflow when in the field, choose your app with care.

There are many mobile editing apps to choose from, so check to see which ones are right for your needs. Check the specifications to see the size and type of file they can work with, how much control you have over specific areas of an image, whether or not the app supports layers, text, and other filter-type effects. Many users will just want simple controls and filters that enhance an image with one press of a button and help them upload the image to sharing site. Other users will be looking for something that provides far lot more control and offers a near-desktop editing experience.

↑ Snaptastic is for users who want a simple interface and only need a few key effects. Despite being a simple app to use, there is a good level of control and it's quick and easy to share images.

147

← Autodesk's Pixlr Express and Pixlr-o-matic have won a lot of fans. The apps provide a vast array of filters, borders, and effects. Both apps are great fun to play with, although serious users may want to use them in conjunction with another app that offers more flexible control.

→ Photoshop Touch is Adobe's mobile version of its powerful image-editing software. Although the app doesn't support Raw files or provide the level of control available in the desktop version, it does support layers and the interface is surprisingly familiar—Photoshop users will feel instantly at home.

EDITING ON THE MOVE

With an increasing number of people photographing on the move and the improved functionality of smart cameras, it's no wonder that there is also an increasing number of image-editing applications designed specifically for use on a smartphone or tablet. Although many of the apps are designed to be intuitive to use—with some apps settings are controlled by swiping the screen, for example—they do allow for a good-level of control. While this may not be comparable to a desktop image-editor, may be sufficient for travel photographers who have to send images across the world for publication, or for sports photographers who need to get images to editors quickly. This also encourages serious photographers to get things right in-camera, as editing parameters are curtailed.

What to look for

When considering which app you want for your tablet or smartphone, there are some key issues to consider. The most obvious is: is the app compatible with your operating system? Most apps are now available in Android and iOS versions, but it's worth checking. The second issue to look out for is the size and type of image files the app is capable of dealing with. Some apps will only be able to work on relatively small file sizes. This isn't a problem if all you want to do is post

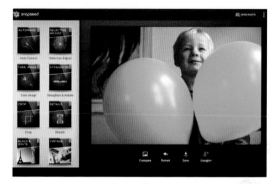

↑ Nik Software's Snapseed has been a popular mobile editing app since it was first launched. It provides a good combination of control, primarily via finger swipes, and one-stop filters. The software also provides good integration with Google+.

3G

Takings things one step further than Wi-Fi are cameras that feature 3G. 3G (third generation) is a mobile phone standard that enables 3G devices to connect directly to the internet with broadband speed. 3G-enabled smart cameras, therefore, don't need a Wi-Fi hotspot or mobile phone to upload photos and videos to the web. The drawback to 3G is that as the devices require a SIM card, and there's an additional data-transfer cost involved whenever images are uploaded. The question really will be whether you need both a smart phone and a 3G-enabled smart camera?

Firing apps

The other benefit of having a Wi-Fi-enabled camera is that users have access to numerous apps that allow them to control their cameras via their mobile phones or tablets. The flexibility and complexity of these apps varies enormously, ranging from the most basic, which simply fire the camera's shutter, to those that allow you to control the camera's aperture, shutter speed, and other settings, and which you can set up for time lapse or HDR photography. Other apps will fire the camera following a loud noise, detecting movement, or after recognizing that faces are present in the frame.

Additional devices and accompanying apps allow you to utilize Wi-Fi to tether a camera to a smartphone or tablet. The majority of the camera's settings can then be controlled by menus on the tablet. Images are then captured by the camera and then made available for review on the tablet.

→ Triggertrap is a cable remote system on steroids, enabling you to use your Android or iPhone smartphone to trigger your camera in a number of creative ways. Originally users had to attach the master device controlling the app via a cable to the camera, but now the app can be used wirelessly with the master device connecting with dongles plugged into the camera via Wi-Fi. The app can be set to fire a number of cameras as long as each is fitted with a dongle.

→ A number of Nikon's DSLR cameras become Wi-Fi enabled when used with the company's wireless mobile adapter. Using this adapter you can connect the camera to a smartphone, tablet, or computer.

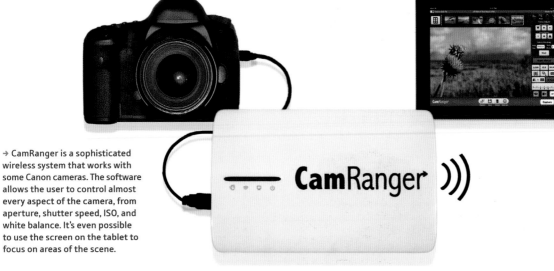

→ CamRanger is a sophisticated wireless system that works with some Canon cameras. The software allows the user to control almost every aspect of the camera, from aperture, shutter speed, ISO, and white balance. It's even possible to use the screen on the tablet to focus on areas of the scene.

SMART CAMERAS & APPS

As the cameras on mobile phones have improved, so encouraging a massive growth in online photo (and video) sharing, camera manufacturers have reacted by developing cameras that share some of the same connectivity found in mobile phones. Their hope is that rather than only using their smartphones to take and instantly upload images to the web, people will recognize the superior-image quality and capabilities of a smart camera, while still having the ability to upload images almost wherever they are.

Wi-Fi cameras

The means by which most wireless-enabled cameras connect with other devices and to the internet is through a Wi-Fi connection. Wi-Fi technology utilizes radio waves to transfer data—in this case image data—and replaces the need for ethernet, USB, or other types of cable by creating a "wireless local area network" (WLAN). Wi-Fi enabled cameras, such as smartphones and tablets, can connect to the internet through Wi-Fi "hotspots" found throughout large towns and cities, and in many hotels, bars, restaurants, and cafés, all over the world.

Such Wi-Fi connectivity can be exploited by cameras in a number of ways. A key use is to upload images directly from the camera to photo-sharing and social media websites such as Google+, Flickr, and Facebook. Although uploading images this way is not as quick (or secure) as using cable, for those traveling, uploading vacation shots via Wi-Fi hotspots is certainly convenient.

If there's no Wi-Fi hotspot available, an alternative way to upload images from the camera is to first send them to a mobile phone. With most cameras, syncing the first time with a phone can take a few minutes, but once done the camera will usually remember the phone and vice versa, and photos and videos can be uploaded to the internet or sent via email.

As well as uploading images to photo-sharing sites or emailing them directly to friends and family, users can also upload their images to a number of cloud storage networks. The advantage of this is knowing that, once uploaded, images are stored safely and can be wiped from the memory card to make more space available.

↑ Being a fully-fledged Android device, the Samsung Galaxy allows you to access the internet directly either via Wi-Fi hotspots or on a 3G/4G network. This means you can download photo-related apps (beyond the ones that are already installed on the camera) and upload images and video directly to photo-sharing and social media websites such as YouTube, Facebook, and Twitter. The camera also features an Auto Cloud Backup and Share Shot feature so you can save your images to the Cloud or share them instantly.

↑ Canon's EOS 6D was the first DSLR with integrated GPS and Wi-Fi connectivity. The first feature will tag your photos with location data allowing you to place images on a digital map when downloaded. With the second feature you can connect the camera to a smartphone, tablet or computer so you can share images or control the camera using a remote firing app.

↑ Pheed is a more recent sharing site, that allows users to share audio and video as well as still images. The concept behind pheed is that members can charge other members to access their content.

↓ Flock's unique selling point is that it identifies images taken at the same time, in the same place by a particular group of friends or a family and then creates a single image folder with all the images taken by the various phones. Flock utilizes Facebook and other services to identify and locate friends and family.

HOW TO SHARE IMAGES

If you have an Android phone and you want to share your images, simply navigate to your image library or gallery and select the image. Somewhere on the screen you'll find a "Sharing" symbol—it will have three points joined by two lines. Click on this button and another screen will appear showing which sharing options you have available. Your options will depend on the software that was initially installed on the device, or other software you have downloaded yourself, such as Facebook, Instagram, and Google+. Select the service you want to use, log in with your name and password, and the image will usually automatically be resized before uploading.

It's just as easy to upload images from an iPhone to Flickr, Facebook, or similar service. Simply click on the service icon, and then a camera icon. You'll be prompted to either take a new photo to upload or to upload one from you image gallery.

↑ Most photo-sharing apps will grind to a halt if you try to upload more that one or two photos at a time. Dropbox is a file sharing application that is available for iOS and Android users. Download the software and you can create folders for various images and choose who has access to what. A clever feature of Dropbox is that you can set it to automatically upload images whenever you shoot them. As with many photo-sharing apps you'll be given a certain amount of free space, but if you need more you'll have to pay for it.

SHARING ON THE MOVE

There has been a gradual revolution in digital photography building since around 2010. Much of it centers around mobile phone technology, online social media, and photography websites, all driving a general desire to share our images with as many people as possible as quickly as possible.

Smartphones

The revolution really started with the development of the smartphone. Early mobile phone cameras were pretty uninspiring, with their low resolution, poor lenses, and slow reaction times making them something of a last resort. Over time, however, camera phones improved and people began to appreciate the potential for capturing acceptable images and either

sending them directly to another phone via multimedia messaging service (MMS), or uploading them via mobile broadband or wireless internet connection to social media and photo sharing websites. Once the link between capturing images on a mobile phone and sharing them via a wireless broadband connection was made it wasn't long before a number of services were launched that not only facilitated the entire processes using just one or two buttons, but also offered a means of enhancing the images before uploading.

The first and most popular service was Instagram, which was launched in 2010, and by April 2012 had over 100 million users. A number of other mobile sharing services and apps have also been released, each aiming to provide a unique experience.

↑ Instagram was the first dedicated photo-sharing app for mobile devices. Its popularity was due partly to its ease of use and connectivity with popular social media sites such as Facebook, but also because images were automatically formatted into a square and users could apply a number of retro style filters that replicated different types of conventional film. Just about any image was instantly a work of art.

CHAPTER 6

SHARING & EDITING

Editing photos used to be a horrible hassle. In the old days, you could spend hours in a darkroom, coming out reeking of chemicals with photos that weren't quite what you had hoped for.

Then computers started taking over. First it was possible to scan your photos in and then digital cameras started changing the game. In the beginning there were digital compact cameras, but DSLRs and—more recently—CSCs quickly took over.

However, being able to bypass the darkroom doesn't mean that photos don't need a tweak here and there. Using modern software, you can make simple (and more advanced) edits to your photographs.

In this chapter, we're going to take a closer look at the digital darkroom: software options, why you should shoot Raw, and how to develop an efficient workflow—as well as the important matter of how to be sure you're always making progress as a photographer.

2. Open the images in Photoshop as one file on separate layers and align them using Edit > Auto-Align Layers... Depending on the lens you're using you may want to select the Geometric Distortion option. This corrects pin-cushion and barrel distortion, but may not ultimately be what you need. It's worth experimenting with this option.

3. With the layers aligned, it's time for the really clever bit. Go to Edit > Auto-Blend Layers... Select Stack Images and check Seamless Tones and Colors to help blend the layers together Again, depending on the image, you may want to experiment with this setting. Photoshop will now automatically blend the layers so that the sharpest details from each image remain visible. The rest of the image is automatically masked out using a layer mask. Photoshop repeats this exercise for each layer.

4. When Photoshop has completed the auto-blending task the preview image will look sharp from front to back. You'll see the layer masks that Photoshop creates during the blending process in the Layers palette, and you can edit these to make any adjustments as necessary.

5. If you're happy with the result, flatten the image and make any final adjustments to the crop, saturation, tone, and contrast.

FOCUS STACKING

As photographers have become more familiar with the concept of merging individual files, whether to exploit a wider dynamic range or to exclude objects, other possibilities have opened up; and software developers have been looking at ways of automating processes to make our lives easier. A perfect example of this is focus stacking. The purpose of focus stacking is to take a number of shots of the same scene using slightly different focus each time. When the images are merged, the final result is a photo that's as sharp as possible from foreground to background. The technique is most appropriate for macro photography, where depth of field is often very shallow. At present, Adobe's Photoshop is the best automated software for focus stacking.

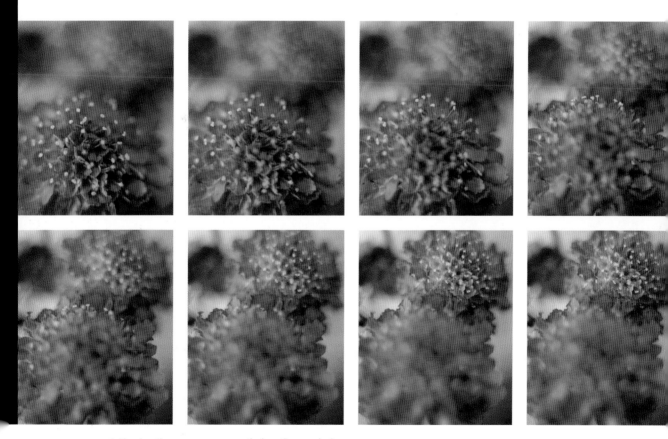

1. The shooting process for focus stacking is simple enough. Set the camera on a tripod and attach a remote shutter release. Select manual exposure and manual focus. Compose your shot, set the exposure, and test that you can get the foreground and background in focus by turning the focus ring on the lens. Once you're happy that you can achieve full focus throughout the shot, focus at the front and take a shot. Now turn the focus ring slightly to set another focal plane, and take another shot. Repeat this exercise taking shots at different focal planes, and finishing with the background in focus.

Process: ● Tone Mapping
○ Exposure Fusion

Method: Details Enhancer

Strength ——————————— 10

Color Saturation —————— 39

Luminosity ——————— +10.0

Detail Contrast ————— +10.0

Lighting Adjustments Medium
 Natural Surreal
Lighting Effects Natural + Surreal +

▼ HIDE MORE OPTIONS

Smooth Highlights ————— 39

White Point ————— 0.595%

Black Point ————— 0.000%

Gamma ——————— 1.52

Temperature —————— -3.7

▼ HIDE ADVANCED OPTIONS

Micro-smoothing ————— 2.0

Saturation Highlights ———— 0

Saturation Shadows ———— 0

Shadows Smoothness ———— 0

Shadows Clipping ———— 0

☐ 360° image

Reset: Default ↕ ↓
Preset: Custom

Save and Re-import

All

Creative 3

Enhanced

Soft

Soft 2

2. Open the source files using any one of a number of HDR programs, such as Photomatix Pro (shown here), HDR Efex Pro, Oloneo, or Photoshop, to name a few. The software will align the images and create a single HDR file. You can then use the software to tone map the image to produce the finished file.

3. Most programs offer a number of tone mapping algorithms and controls that allow to you to experiment with the look you want to achieve, ranging from naturalistic to hyperrealistic.

137

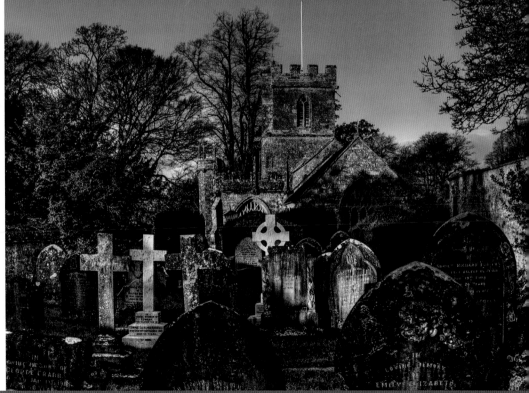

4. Applying strong tone mapping settings can degrade the image. The most obvious sign of tone mapping is evidence of haloes around bright areas or objects. Adjust the software controls to minimize such effects, while attempting to get the look you want. Be warned, though: it is easy to get carried away, so be clear about your intentions.

HDR IMAGERY

In digital photography, High Dynamic Range (HDR) imagery describes recording a tonal range that exceeds the dynamic range the camera's sensor is capable of capturing in one shot. All sensors are restricted to recording a certain range of brightness, from the darkest shadows to the brightest highlights. This varies from camera to camera, but the best DSLRs have a range of about 11–12 stops. The dynamic range of a typical sunny day will greatly exceed this, even excluding the sun. In other words, with only one shot the photographer has to decide whether to expose so that all the highlights are exposed accurately (that is, not overexposing to pure white) or expose to allow for the shadows (that is, not underexposing so the shadows become pure black).

With HDR imagery it's possible to combine a number of different exposures of the same scene— which together cover the complete dynamic range—to create one single HDR file that contains the same range of tonal information.

Tone mapping

When a number of exposures are combined to make a single HDR image file, the dynamic range of the file exceeds the dynamic range of the vast majority of computer monitors, not to mention paper or other media, and so the tonal range contained in the file cannot be reproduced in full. To combat this, the file undergoes a process known as tone mapping. Tone mapping adjusts the tones and color values of individual pixels by analyzing the pixels around it. In other words, contrast can be adjusted locally within specific areas of an image to recreate the effect of an HDR image. The result is that all the tones from the scene being reproduced in a file that can be viewed on a normal monitor or printed. It's the local tone mapping process that gives HDR images their unique appearance. Applying strong tone mapping not only crams a wide range of tones into one image, it can also be used to enhance textures and colors for a hyperreal effect.

1. Shooting a series of images for HDR is straightforward with today's digital cameras. What you're trying to achieve is to capture the range of tones in the scene. The easiest way to do this is to set your camera to auto exposure bracket (AEB), and continuous shooting and take as many shots as necessary to record the tonal range. The number of shots a camera will take automatically while in AEB varies, but most will cover a range of around 6 stops in either three, five, or seven frames, which together with the sensor's existing dynamic range will cover most high contrasting scenes. For best results shoot with the camera attached to a tripod, but this isn't essential as the HDR software will align images very successfully.

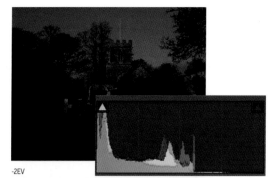

-2EV

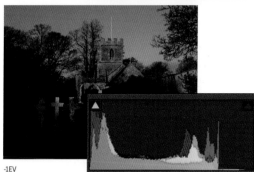

-1EV

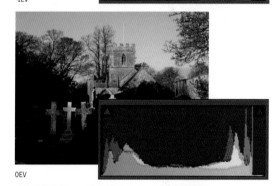

0EV

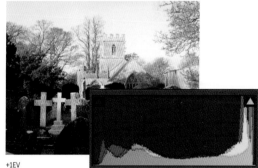

+1EV

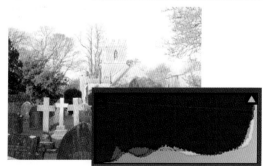

+2EV

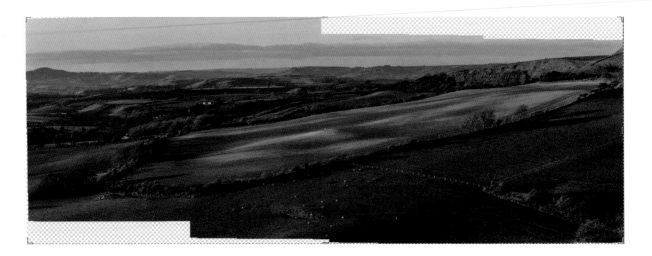

4. Some editing software, such as Photoshop, will automatically merge the Raw files to create the panorama. Simply navigate to the files and select Automate › Photomerge. The software will match up the images to create a composite that you will then need to crop and flatten.

5. You can edit the resulting file to adjust contrast, colors, brightness and so on, and then save as a JPEG. Alternatively, edit the Raw files before you begin, but ensure the same adjustments are made across all the files before you save them as individual JPEGs and create the panorama composite.

SHOOTING PANORAMAS

Before the advent of digital photography, creating panoramas was beyond the realms of most amateur photographers, as the equipment needed was prohibitively expensive.

Today, there are numerous of ways of achieving high-quality panoramas. An increasing number of cameras have a dedicated panorama mode. When selected, the user pans the camera across the scene being photographed to create a large single panorama photo. Although this is a convenient way of getting a panorama, most cameras will only do this when shooting in JPEG. For the ultimate quality panorama, you're still better off shooting individual frames in Raw and stitching the files together using an image-editing program.

1. When shooting horizontal panoramas, shoot in the portrait format in order to get more foreground and sky in the final image.

2. For ultimate sharpness, shoot using a tripod as you would when shooting any landscape. However, you can still achieve good quality results shooting handheld, as long as you make sure the shutter speed is fast enough to avoid camera shake.

3. Take an initial exposure reading in Aperture Priority, then set the camera to Manual mode to ensure the exposures are consistent. Focus manually, and shoot the necessary number of frames ensuring a good overlap between each frame.

compositional elements. It's a great challenge and will help you develop not only your black-and-white photography skills, but your photography in general.

One practical tip that will help nurture your eye and provide instant feedback as to what does and doesn't work as black and white is to set your camera to shoot monochrome. That way you can preview images in black and white on the rear LCD screen. Remember to shoot in the Raw format so that you'll have access to the color channels later when editing.

Portraits, street, & documentary

Although much black-and-white photography is associated with fine-art photography, the genre isn't just about exploring tones, line, shape, and so on. There has also been a long tradition of black-and-white photography in portrait, street, and documentary photography. Naturally, this evolved from a time when the only photography was black and white, but even with the advent of color these genres were—and are still—very well represented by monochrome images.

The reasons for this are many, but as discussed earlier, the absence of color on one level allows us to engage more fully with the subject. Without color, the tones—either subtle and soft, or harsh and dramatic—of portraits are more apparent, and can often appear to reveal a person's character better than a color portrait. Perhaps counterintuitively, monochrome street and documentary shots seem to have a greater realism or immediacy to them than their color counterparts. This may hark back to a time when all "serious" photo-journalism was in black and white.

⬉ As photographers develop an interest in black-and-white photography, they become more aware of the ways in which light interacts with the objects and the scenes around them.

⬆⬆ Textures, tones, and the juxtapositon of light and dark objects, together with the overall visual balance of an image will usually be more apparent in a monochrome.

⬆ Black and white lends itself well to street photography and portraiture. Without the distracting influence of color the message is often more clearly conveyed.

BLACK & WHITE PHOTOGRAPHY

For many photographers, black-and-white images are the pinnacle of the medium; the true art of photography. We're going to look in detail about how to convert a digital color image into black and white using image-editing software later on, but here we'll explore why black-and-white images hold such a fascination for so many photographers.

Composition

We are bombarded daily with a constant stream of color imagery, which represents the world around us. Our reality—albeit often a heightened, romanticized version—is in color. Stripped of color we are already one step away from reality when we see a black-and-

white image, so other elements take on greater significance. These elements are essentially the tools of composition—line, form, shape, texture, tone, balance, pattern, movement, and so on. Devoid of the incredibly seductive power of color, a black-and-white image needs to demonstrate these other compositional aids in order to keep viewers interested, and to guide them around the picture.

Block out color

There are essentially two ways of making black and white photos: passively and actively. The passive method involves going through your library of images and doing a quick black-and-white conversion on those

↑ Working in black and white will often force the photographer to explore shapes, textures, tones, and line in a more emphatic way than working in color. Composition rules over content.

that you think have potential, to see if they work as monochrome or not. This method can certainly reap rewards, but it's a bit hit or miss. Far better is the active method in which you will train your eye to look out for scenes and objects that you know will work in black and white: "Learning to see in black and white" is a much-used phrase associated with monochrome photography, but it's good advice. Once you learn how to block out color, you become more sensitive to light and shade, line, texture, and all those other

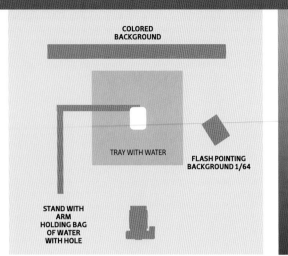

COLORED BACKGROUND

TRAY WITH WATER

FLASH POINTING
BACKGROUND 1/64

STAND WITH
ARM
HOLDING BAG
OF WATER
WITH HOLE

↑ A simple water drop setup uses a dark colored tray with a bag of water suspended above it. The camera is positioned low and angled down toward the water. Set an off-camera flash (at 1/32 or 1/64 power) slightly above the height of the tray and pointing toward a colored backdrop. Set an aperture of f/10, a shutter speed of 1/250 second, pierce the bag, and fire away.

↑ Patience and persistence pays off when photographing water drops. At first you may not feel as if you're getting any good shots, but experiment with different aperture and flash settings, colored backgrounds and water, and soon you'll be getting incredible shots.

Using a sturdy table, place the flash about 20 inches (50cm) to the left or right of the incense burner. Place the black background about 3 feet (1m) behind the incense burner.

Now it's time to take a few shots. Set the camera to focus and expose manually. Set a fast shutter speed (around 1/125 second) to freeze the movement of the swirling smoke, and a narrow aperture (f/8.0) to ensure the smoke is in focus.

Capturing droplets

Photographing droplets as they hit a surface requires a lot of patience. There are numerous ways of achieving beautiful-looking water drop shots, but the description given here is the simplest, and one that requires the least specialist equipment

On a table, place a baking tray or plastic tray half filled with water. Behind the tray, prop up a colored background. The colors of the background will determine the colors in the image, so start off with something bright and colorful. Rig some form of stand over the tray. It can be made of anything; all it needs to do is support a small clear plastic bag filled with water, taped to the stand.

Next place your off-camera flash next to the tray, directed toward the background and synced to the camera with a sync cord. You may want to cover it in plastic film to protect it from any water. Turn the flash to manual and set it to 1/32 power: the lower the flash power, the faster it pops, increasing your chances of freezing really fast water drops.

Now, set the camera on a tripod angled slightly down toward the water tray. Make a small hole in the plastic bag so that water drops consistently into the tray. Again the size of the hole is something you'll want to experiment with. Manually focus on the area where the water is dropping. Zoom in as close as you can; if you have a macro lens it's worth using that. In manual mode set an aperture of around f/10 so that you have sufficient depth of field to make sure the splash from front to back is in focus. Choose a shutter speed to sync with the flash—around 1/250 second (see p90–91). Turn down the lights in the room in which you're working or draw the drapes.

Finally simply start shooting the drops as they hit the water. You'll get into the rhythm soon enough, and the more photos you take the greater the chances of capturing a really great-looking water splash.

Vary color

To get different colors in your droplet images, try adding food dyes to the water. You can even try using different liquids altogether, such as milk. Also, use colored gels in front of the flash, and experiment with different colored backgrounds. For more interesting light effects, replace the background with a sheet of clear acetate and place another flash behind it, synced to fire at the same time as the first flash.

ABSTRACTS

Of course, life on a rainy day isn't all about still lifes. There are opportunities to take photos of moving subjects too, and here we're going to look at two popular subjects: smoke and water droplets—both of which can make for really ethereal and beautiful abstract compositions.

Photographing smoke

The best substance to use when making images of smoke is incense. Burning incense provides a sufficiently dense quantity of smoke and it burns at a consistent rate. It also burns for a long time and produces a pleasant aroma—at least when compared with burning most other things. As well as your camera and incense, you'll need an off-camera flash, and a sync cord to connect your camera to the flash. One end attaches to the camera's accessory or hot shoe; the other to the bottom of the flash. This allows you to place the flash unit wherever you want (depending on the length of the cord). With the cord attached the flash will fire whenever you press the shutter release, just as if the flash was attached to the camera. You'll also need a black background against which you will shoot the smoke. This can be made of anything black, such as card or paper; but black felt is usually best at absorbing light. Finally, cut two narrow strips of card and attach them to either side of the flash with tape. The purpose of this is to ensure the flash produces a very narrow beam of light when fired.

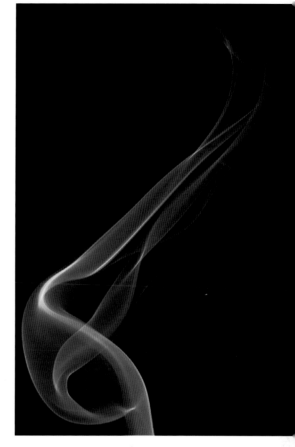

↓ Here's our lighting setup for capturing smoke. The card on the sides of the flash allows light to strike the smoke, but prevents it from entering the camera lens or spilling onto the background.

You can add a reflector or piece of white card on the opposite side to the flash to bounce light back toward the smoke to help it show up better.

↓↑ Photographing smoke can be an exercise in frustration, of course, but the results can look amazing. Adjust your camera, smoke, and flash position and brightness if necessary. If you're doing it correctly only the smoke will show up in your images.

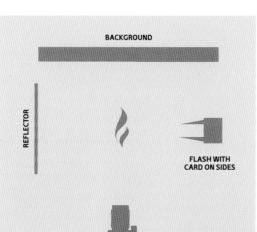

BACKGROUND

REFLECTOR

FLASH WITH
CARD ON SIDES

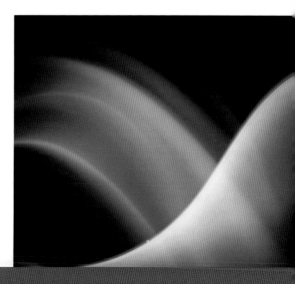

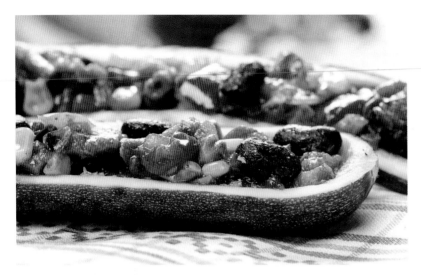

← Shooting outdoors under shade will often provide you with a natural-looking background against which to style your food. Get in close with a wide-angle lens and shoot with a wide aperture, using a tripod to steady the camera.

↓ It's a pretty photo, but not very useful. You couldn't use this on a menu, for example, because the only thing you can identify is the chargrilled tomato.

your dishes. Most food shots really come to life when you add a prop or two, whether it's a fork, a napkin ring, or a glass.

In many ways food is a pretty cruel still-life subject, as it doesn't look good for very long. Pastries start sagging or looking stale, meats turn gray, and greens look sad very quickly in the heat from the other foods. The secret is to set up your shot with an empty plate, or with something that doesn't spoil as easily. Once you're completely happy with your camera settings, lighting, background, and overall setup, all you need to do is to swap the plates and take the photo. Cheating? Not if it's going to help you get the best results!

→ A San Francisco classic: clam chowder in a bread bowl. This was photographed in direct sunlight. The light was blocked from hitting the background, which is why the bread bowl is standing out so well.

FOOD PHOTOGRAPHY

Food photography is a natural progression from still-life photography, and is viewed by many as a sub-genre of still life.

Like still life, food photography looks easy, but is in fact very challenging, with a unique problem of its own—a lot of really tasty food doesn't actually look very good when viewed through a camera lens. You can get a long way by lighting your photos well, however. Artificial lighting works, but you can also just place the plates near a window and exploit the golden rays of the sun to light up your food photos. Natural lighting can often complement the natural simplicity of good food in a way that is very hard to replicate using artificial lights. Sure you can achieve a shot that looks dramatic and colorful with artificial lights, but then the image becomes more about the photography rather than the food. You'll be surprised at how good food can look under soft, diffused, natural lighting.

As with still life, the best way to photograph food is with the camera locked onto a tripod. Not only does this allow for a wide aperture for attractive shallow depth of field, but it also frees up your hands between shots to dress

TOP TIPS: FOOD

Good food photography should convey the flavors, textures, and aromas of the food being photographed to the viewer.

Lighting. Unlike other still-life photography, where dramatic lighting can add impact to an image, food photos should show off the food in an understated, subtle way that accentuates the natural qualities.

Angle of view. By all means experiment with different shooting angles, but most successful food photography is shot quite low to the food.

Enhance the food. Food will often dry and wilt very quickly once served, making it unattractive in photos. A good way to enhance how food looks is to use an atomizer on salad to give it a freshly picked look; other food can look more tasty when brushed with olive oil.

Reference. Look at your favorite recipe and cook books to see what style of photography they use. Using other books as reference will give you ideas as to how to style your food images.

Lens	WIDE	TELEPHOTO
Aperture	SMALL	LARGE
Shutter Speed	SLOW	FAST
ISO	LOW	HIGH

↓ Good lighting is essential to bring out your subject's color and texture, to make it look as mouth-wateringly delicious as possible.

→ Still-life photography can be used to create product photos that illustrate concepts; in this case, spa treatments.

↙ Although many people now consider the classic still life as dated and old-fashioned, it's still a great way to spend a rainy afternoon with your camera. Creating a classic still life is surprisingly difficult: you will need to learn how to arrange, dress, and light your objects effectively so the viewer is taken around the composition and sees it as a single unified arrangement.

↘ Lighting is critical in a still life. It should emphasize the object's form, shape, and texture in a subtle way.

TOP TIPS: STILL LIFE

The secret to successful still-life photography lies in arranging interesting objects in an artistic way and using lighting and camera techniques to show those objects at their very best.

Select your objects with care. Don't use any old collection of objects for your still life. Choose objects that are unified in some way—either through theme, color, texture, age, or shape.

Composition. Good composition is crucial to a successful still life. Arrange your objects in such a way that the eye is lead through and around them. Think about using leading lines, curves, and off-center composition.

Lighting. Make sure your lighting, whether natural or artificial, shows off the form and texture of the objects, and that there are discrete areas of light and shade.

Background. Either use a background that complements the arrangement (such as dark fabric for a classic still life) or use a large sheet of white paper if you want a minimalist, white background look.

Lens	WIDE ———————●——— TELEPHOTO
Aperture	SMALL ———————●——— LARGE
Shutter Speed	SLOW ———————————— FAST
ISO	LOW ———————●——— HIGH

STILL-LIFE PHOTOGRAPHY

Generally, "still life" is the art of taking photos of an inanimate object or a small group of objects that have been arranged in a way that best shows their form, shape, texture, and color. Flowers and fruit are the classic still-life subjects, and were widely represented in oil paintings, but today photographers train their lenses on just about every imaginable subject to create modern still-life images. Professional still-life photographers are usually also good at turning their hands to product photography.

When creating a still life you have a lot of flexibility, with full control over the lighting, the arrangement of the subject, and your camera. This means that still-life photography affords you all the time in the world to labor over creating the "perfect" shot.

A good still life should look so perfect and yet so real that it nearly looks impossible. This means that you have to be careful about what you are photographing.

If you include fruit, for example, spend a bit of time picking the best specimens from the market, and show them from their best side. Many photographers consider product photography their bread-and-butter work. Art photographers tend to dismiss the product crowd as "technicians," but that's a bit unfair—product photographers may not have the creative freedom that, say, portrait photographers have, but on the other hand they do tend to be some of the best technical photographers you'll find. It takes a lot of dedication to make it in the upper echelons of product photography, but that doesn't mean that it's not interesting to give it a go anyway.

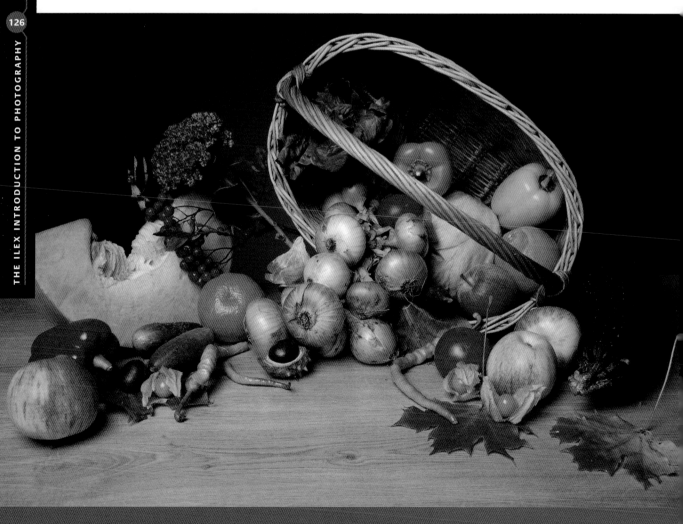

Lens choice & camera settings

If you really want to draw people into your night-time photo then you'll need a decent wide-angle zoom lens, one with an effective focal length of around 16–35mm (10–20mm for a crop sensor camera). Otherwise, unless you can take the photo from a mile away you may miss a lot of the substance from the shot.

Most beginner night-time photographers may feel more comfortable starting in Aperture Priority (A/Av) mode, which will let the camera choose the proper shutter speed depending on your aperture setting. To keep everything in focus an f/8.0 setting is usually ideal, but you can also experiment with smaller apertures (up to f/16) to get great effects. Remember, watch your light meter carefully.

Unless you want to specifically highlight something in the foreground, or are taking a night-time portrait, do not use flash. However, while using flash is generally a poor idea, using a flashlight is a neat way to highlight part of an object, or light an object while keeping others dark. With long exposures you can use your flashlight to "paint" a large object for stunning results. Give it a try!

A low ISO (as in 100 or 200) is key for night photography, as dark areas and shadows are particularly susceptible to digital noise. Remember that as long as you have a tripod you can set the exposure as long as you need to get the right amount of light. In fact, by using exposure times of several minutes, you can get shots that look like they were taken in broad daylight.

If your camera comes with a Live View feature, use it! Live View can be particularly helpful if you like to focus manually, and can help you capture a perfectly focused shot.

Night photography is a demanding form of image making. It'll test you and your equipment to the limit, so try not to leave anything to chance.

Shoot Raw. With so many lighting variables, smooth gradations in tone, and dark areas, you want your image files to be as clean as possible, free from noise, banding, and other artifacts. Shooting Raw will give you the best chance of this.

Plan the shoot. If you can, make a reconnaissance of the area you want to photograph before you go out to shoot. Look for areas that have a good mix of lighting and provide wide, sweeping views.

Stay warm! Remember that in some places it can get very cold when the sun goes down. Make sure you're going to be warm enough when out shooting.

Lens	WIDE	TELEPHOTO
Aperture	SMALL	LARGE
Shutter Speed	SLOW	FAST
ISO	LOW	HIGH

↑ By using one flashlight with a red filter and one with a blue filter, you can "paint" buildings in two different colors at night.

NIGHT PHOTOGRAPHY

If you love sparkling city scenes, starlight skies, or the neat effect of blurred traffic, you'll want to learn about night photography. You will soon find that with a few tricks there are virtually no limits to shooting after the sun goes down.

Although the time for "night" photography is considered to begin at least an hour after sunset, you may want to consider setting up just before sunset in order to capture some excellent sunset and silhouette shots as well. Dusk is also a great time to get photos, and you'll see some amazing colors.

Eliminating camera shake

In most cases, unless you have a flat and stable surface to put your camera on, you will absolutely need a tripod. Consider getting a tripod with a versatile tripod head so you can change the angle of your shot.

Even with a tripod you may find that camera shake is interfering with your photos, likely due to the movement caused by pushing down the shutter button. To avoid this problem, set up your shot and use a timer (two seconds is fine) to automatically take the shot, or get a wireless-remote shutter button.

If you are shooting with an SLR and are still seeing camera shake in your photos, find out if your camera has a "mirror lockup" function. This eliminates the slight shake caused when the mirror is flipped up before the photo is taken. If you're using a mirrorless camera, you're one step ahead already: no mirror, no mirror slap!

↓ Car lights can make strong light trials when you use a slow shutter speed at night. With this particular image a narrow aperture of ƒ/16 was used, which turns strong points of light into star shapes that add to the impact of the image.

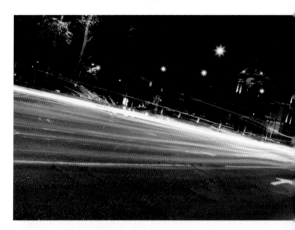

↑ A 30-second exposure made the water under the Golden Gate bridge turn into a tranquil blur just after sunset. The camera was standing on a solid concrete block—Alcatraz.

→ Cities have amazing potential for night-time photos. If you shoot Raw you can adjust the white balance later to cope with the various light sources.

Closer to home

Even more convenient than visiting a national park or forest is photographing out of a window at home. You don't need a big yard or garden to attract wildlife, and depending on where you live you may be able to tempt some quite exotic birds and animals into your yard with feeders and bowls of nuts or other food. Photographing garden birds can be surprisingly rewarding and if you have enough feeders you won't have to wait around for long before you have something to photograph. Always think about backgrounds when placing your feeders in trees. Avoid placing the feeder so that you're shooting against a bright sky or a particularly colorful or busy background.

Equipment

Not surprisingly, the most important equipment you need for wildlife photography is a telephoto lens, or at least a good-quality compact camera with a powerful zoom setting. A minimum effective focal length of 200mm is recommended, but you'll get much better shots with 300–500mm effective focal lengths.

With such long telephoto lenses or settings you'll find it much easier to get sharp shots if you use a tripod; and holding a DSLR with a heavy zoom lens for any length of time can also become quite tiring. Apart from photographing birds in flight, for which you need to pan the camera and lens by hand, the best type of tripod head for wildlife is the ball-head. This permits good movement when you're tracking animals, but can be tightened off quickly when you're shooting.

Other equipment to carry with you includes plenty of memory cards and a spare battery or two. Remember, the more you review your shots, the more battery you use up; so don't be tempted to review every single shot. You may also want to take a small camera beanbag with you. These are useful if you can shoot from a car window, but a beanbag is equally useful if you're shooting from a window at home with a telephoto lens.

Finally, if you're really serious about your wildlife photography, consider buying a lightweight hide. Many parks and forests will have permanent hides from where you can shoot the local wildlife; but if you're out trekking, carrying a hide allows you to set up wherever you want.

Settings

You should always avoid photographing animals against potentially distracting backgrounds, so to help isolate your subject, use a wide aperture. This will also allow you to set a fast shutter speed for freezing action. Depending on the kind of animal you're photographing, a minimum shutter speed of 1/125 second should be sufficiently fast. Naturally, if you're shooting large, grazing mammals then you can afford to go a lot slower. Know what your maximum acceptable ISO setting is. Finally, unless you're using a professional DSLR with a sophisticated autofocus system, set the camera to use the center focus point only. This is the most responsive and you'll know exactly where the camera's focusing.

123

←← Research to find out when is the best time of day to photograph: different animals are active at different times.

← Wildlife isn't just about "big game." You can get great wildlife photos from your kitchen window.

↙ Don't forget insects when you're photographing wildlife. Despite their diminutive size, they often exhibit dazzling colors and amazing body forms. Exchange your telephoto lens for a macro lens if you want to get stunning close-up shots of small insects.

→ Birds are the most popular wildlife subject—they're both varied and attractive. You will need a long telephoto focal length to get close to them, and a great deal of patience, but if you start with garden species and you'll soon be hooked on finding ever more birds to photograph.

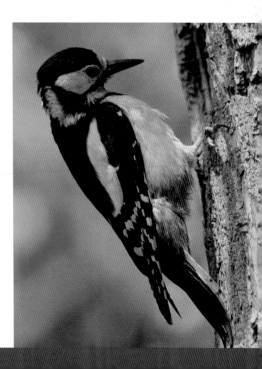

WILDLIFE PHOTOGRAPHY

Wildlife photography, like the subject itself, comes in all sorts of shapes and sizes. For many, true wildlife photography conjures up pictures of elephants strung across the African savannah, or a leopard lying in the branches of a tree. Certainly going on a photo safari to Africa will provide you with the opportunity of taking some breathtaking photos of wild animals in a glorious natural setting, but that's one extreme end of wildlife photography that only a minority are likely to experience.

National parks

A more realistic opportunity, one that's within reach for most of us, is gaining access to a national park or forest. National parks and forests are safe havens for a wide diversity of wildlife, from large mammals, through colorful birdlife, to tiny insects.

One thing common to wildlife photography, whether you're shooting on the African savannah, the swamps of the Everglades, or the highlands of the Cairngorms in Scotland, is that you need a lot of patience and a fair amount of luck. The better prepared you are, however, the greater your chance of getting a winning shot. Time your visit to coincide with the greatest activity in the species you want to photograph. Most national parks are well documented on the internet, and it pays to do your research. Once you've decided when you're going to visit, check with the local visitor center to find out as much as you can about recent sightings and the best places to set up a camera. You may find that you're allowed to set up a hide, which is ideal if you're trying to photograph shy mammals and birds.

Successful wildlife photography involves a great deal of planning and preparation, knowledge, patience, and a few technical pointers.

Anticipation. Although animal behavior and movement may seem almost random at times, experienced wildlife photographers are better at anticipating how an animal is likely to react or respond to any given situation. This skill can only come with experience, but it will also help to make a conscious effort to learn about animal behavior.

Use both eyes. A surprisingly difficult skill to master, but try to keep both eyes open when you're framing your shots through a viewfinder. With one eye looking at the broader scene you'll be able to respond more quickly when animals are coming into shot.

Go wide. Although the majority of wildlife photos you see show one or two animals in close-up, and we've emphasized shooting with a telephoto lens here, don't forget that wide-angle views can be just as spectacular. When confronted with large flocks of birds or even a solitary deer, a wide-angle shot can put the animals into context.

Lens	WIDE	TELEPHOTO
Aperture	SMALL	LARGE
Shutter Speed	SLOW	FAST
ISO	LOW	HIGH

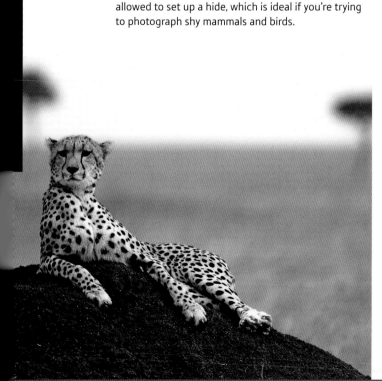

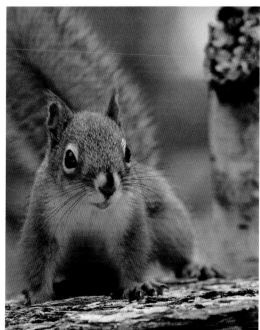

Good wedding photography is about variety, detail, and capturing emotions.

Lighting. It's likely that much of the wedding day is going to be conducted indoors or under shade, where light levels are low. Make sure you know the maximum acceptable ISO setting on your camera and use this with a wide aperture. Shoot Raw for maximum quality if you're going to edit your images later.

Faces. Use a telephoto lens for candid portraits and for picking out details, such as the cake, rings, and bouquet.

Vary your angle. Don't shoot everything at eye-level. Getting down low and finding high points from which to photograph will add variety to your portfolio of images.

Behind the scenes. Keep an eye out for behind-the-scenes action, as well as the main event.

Engage. Talk to the guests as you walk around taking their photos. This will help them relax.

Speeches & reception

With the ceremony over, the bride and groom can start to relax a little. The speeches are a crucial part of the reception, so capture close-up portraits of those giving the speeches, but also keep an eye out for how the bride and groom and other guests are responding. There's usually lots of laughter to photograph. Also keep an eye on children. When kids get bored they can often start fooling around—and shots of cheeky kids always add to a portfolio. Cutting the cake is an important event, so plan where you're going to be when this happens. Try different angles and ask the couple to pose with the knife before making the first cut.

With the speeches finished and the cake cut, the fun really starts. Lots of shots of the first dance are important, as this is often an emotional time. After that just keep an eye open for everyone having fun and fire away!

Equipment

Don't overload yourself with so much equipment that you can't move around easily. A good walkaround zoom lens should cover most of the shots, but if you have a telephoto zoom, use this for discrete portraits; and make sure you have enough memory cards and a spare battery. The secret to good reportage wedding photography is getting in close where you can to capture details and expressions. Vary this with wide-angle shots of the venues and transport. Ask the other guests to pose for informal portraits, and try to have fun. If you're having fun you're more likely to create some memorable images.

in mind where everyone is in relation to the main light sources and position yourself with the light behind you. That way the light will be more even and it'll be easier to set an exposure.

Other couples may not want a photographer around during the ceremony, but may be happy for you to take photos as they're walking back down the aisle. Try to agree what they want beforehand.

Traditionally, the period between the service and the reception is when most formal portraits and group shots are taken. If there's a professional taking these, keep involved and look out for "off-scene" moments as people are preparing to have their photo taken. And if you've any ideas of your own, try these out once the formal shots are out of the way.

→ Remember to take shots of wedding-related paraphernalia as well as the bride, groom, and guests. These help to make a more complete record of the day and create a contextual backdrop.

WEDDING PHOTOGRAPHY

As an enthusiastic photographer, it's quite likely that you may be asked to photograph a friend or relative's wedding at some point. This is a great honor, but also a great responsibility. If you feel you'd like to capture the day but are also concerned that if things go wrong you'll never forgive yourself, you could always suggest that a professional photographer is there for the crucial formal shots—the bride and groom, parents, bridesmaids, and so on—while you act as a roving photographer capturing informal events throughout the course of the day. This will take some of the pressure off, but you should still bear in mind that it's the informal unplanned shots that often give the most pleasure when couples are reviewing their photos.

Reportage

The buzz word in wedding photography these days is "reportage." Reportage or documentary wedding photography aims to get away from the formal portraits of traditional wedding photography and show the wedding in a less structured, more realistic way. Although this is now popular with many young couples, a combination of both styles of photography is likely to cover all bases. If your role is to be the reportage photographer, you need to have access to the bride and groom as they're preparing for the big day. Shots of scattered clothes, hair styling, makeup applying, nervous speech preparation, caterers—the list is endless. Capturing these shots will instantly take the bride and groom back to those anxious moments before the wedding. Remember to get close-up shots showing details, such as shoes, rings, ties, bouquets, and other similar wedding objects.

Pre-service

The important pre-service shots are the transportation, the wedding service venue, and the guests as they arrive. Ask to the chauffeur to stand next to the limo, get shots of the minster bustling around the church, and of laughing guests assembling outside. These are the things that the couple won't be aware of at the time, but will appreciate seeing later.

Service

It's worth discussing with the couple and the wedding officials what photos they want of the service before the day. Individual couples vary. Some may be quite happy to have a photographer visibly taking photos during the ceremony. If that's the case, photos of the groom watching the bride walking up the aisle, the aisle walk, the exchanging of the rings, and so on, are all key moments that you should try to capture. Bear

↑ Informal shots of bridal preparations are popular with wedding photographers.

→ Be ready to capture key moments like the first dance, and keep your eyes peeled and camera ready for the unplanned moments too.

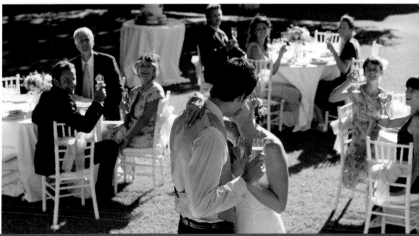

Be prepared! Kids have short attention spans, so they aren't going to be happy with waiting for you to set up a shot, arrange props, and so on. Try to have most of the shot prepared ahead of time.

Don't say cheese! Avoid getting children to put on their "photo face;" it results in inauthentic images. Stay natural, talk to them, be patient, let them relax, and eventually you'll get the shot.

Keep talking. Ask your young subjects what they like doing? What's their favorite TV show? Try to engage them thinking about stuff they like rather than thinking about having their photo taken.

Fewer the better. Politely but firmly ask mom and dad not to get too involved with the shoot; or better still, if the children are happy, to leave you alone while you get on with the photography.

Lens	WIDE	TELEPHOTO
Aperture	SMALL	LARGE
Shutter Speed	SLOW	FAST
ISO	LOW	HIGH

→ Children love to get up to all sorts of fun and games, especially when water's involved. Be prepared to catch a unique moment at any time and anticipate what's going to happen next.

↓ Try photographing children from eye-level or lower to engage with them better. Yes, that probably means you'll be on your knees or stomach for much of the photo shoot.

PHOTOGRAPHING CHILDREN

Kids are fun to photograph, but they are also spontaneous and can be reluctant to follow instructions, so getting great photos takes a lot of patience, a bit of luck, and a fair amount of practice. However, once you get the hang of it—and with the help of the following tips—you will soon be taking fantastic photos of children.

Different approaches

For the most part your photos of kids will be separated into two groups: babies and children. Because babies are somewhat immobile and tend to remain lying down or sitting, it's usually best to start by getting down to their level; so get on your belly for some great shots at their perspective.

With older kids you may have to crouch down to get a shot "on their level," but you also have to be able to move around a bit if you are taking action shots. Generally you will get more candid shots if you can catch them being involved in something rather than trying to get them to smile for the camera. When shooting active kids it can be beneficial to use a burst or continuous shooting mode so you can capture the subject kicking, jumping, or falling down.

Camera settings & lens choice

Aperture Priority mode (A or Av on your camera's mode dial) will let you control depth of field, so you can switch between portrait shots with a fuzzy background and deep shots that give the viewer a sense of what is happening in the photo. Note that a lens with a wider aperture (lower f/stop number) will allow you to let in more light for faster photos.

The best lenses for children's photography will allow you a range of wide-angle and telephoto options, and will give you a reasonable amount of flexibility in low light situations. A long focal length setting (around 200mm) will let you get more candid shots, as you won't be as intrusive, but wide-angle lenses also let you get the whole picture. For portrait photography it can be a good idea to get a nice, bright, prime lens (f/2) with a focal length of around 100–135mm, which will give you lots of light for a blurred backgrounds.

Try to keep the ISO as low as possible to reduce noise, but try to balance that out with a fast shutter speed (since kids rarely hold still). A shutter speed of 1/200 second is good for normal shots—for action shots you may want to increase it to around 1/500 second.

↑ When photographing young babies, try using a wide aperture and focus using the center focus point only and focus on the eye nearest the camera. The wide aperture will create a lovely shallow depth of field that adds a softness to the image that helps to accentuate a baby's inherent quality.

← Giving kids something to do makes your photos come to life, and they'll soon forget you're even there.

Before you set out on your first, and subsequent, photo shoots when traveling, keep in mind the following:

Batteries. Ensure that your camera's batteries are fully charged (get into the habit of charging batteries overnight) and you have sufficient memory cards.

ISO. Check your ISO setting, particularly if this isn't automatically displayed in the viewfinder. As light conditions fall during the course of the day you're likely to increase the ISO sensitivity. It's easy to forget you've done so when you finish shooting, and extremely annoying to discover that you've been shooting with an ISO setting of 800 all the following morning.

Raw or JPEG. If you're going to edit your images using editing software when you get back home, shoot Raw. As you're unlikely to be able to go back and retake any shots that haven't quite worked out, shooting Raw gives you maximum leeway when editing. If, however, you're printing or uploading straight from the camera, shoot JPEG and check that the various settings, such as sharpening, noise reduction, and so on, are as you want.

Camera care. Check the lens and any filters you might use are clean and free from smudges.

Subject

The key to an impressive travel photography portfolio is variety—variety of subject, scale, and view. Don't just shoot landscapes, cityscapes, and sites of interest. The best travel photography should include people. Depending how far afield you are going, bear in mind that not everybody is used to having a camera pointed at them, and that in some parts of the world being photographed can have serious consequences. A little bit of research ahead of your trip goes a long way. Also, it's not hard to understand the universal sign for "Stay out of my face with that camera"—if someone is holding up their hands to stop you from taking a photo, it's best to put your camera away, smile, apologize, and walk on.

In some countries, people will come running to you, eager to be photographed. Sometimes, they'll want a bit of money (one-dollar bills are appropriate as a thank-you nearly everywhere), or they might just want to see their picture on the LCD screen of your camera.

Finally, it's important to keep your wits about you. Many people only have positive experiences photographing random strangers while abroad, but you should always be prepared for a less enthusiastic reception.

Scale & view

As well as the big vistas and sweeping landscapes and cityscapes, look for the detail as well. All countries have innumerable fascinating architectural and other details that make for interesting images—and these are just as powerful at conveying a sense of place as the iconic postcard views.

Try to avoid taking all your shots from a standing position looking straight ahead. Get down low to emphasize the reflections on wet cobble stones or the size of sand dunes, for example, or find a higher viewpoint from which to capture an alternative perspective.

↖ Limited depth of field and a curious-looking logo give a taste of the Thailand flavor in this photo. Small details such as this can bring back memories of a particular place just as powerfully as iconic shots of temples and sweeping landscapes.

← Photographing the people you meet and see while abroad is a key part of travel photography. Always treat people respectfully and smile before taking any photos. Their responses should give you some idea as to how they'll react if photographed.

115

TRAVEL PHOTOGRAPHY

It may seem odd to have a section in this book about travel photography. Surely travel photography incorporates a little bit of everything? There's a bit of portraiture, some architecture, a spot of wildlife photography, and some landscape photos here and there too. But this is exactly why there are some practical considerations to think about before jetting off, which will help you to get the shots you want.

The key to good travel photography lies in preparation. Familiarize yourself with what your destination has to offer photographically. Searching the internet and reading well-illustrated guide books is a good starting point.

Equipment

If you're taking an interchangeable lens camera, a good-quality, medium telephoto zoom lens (with an effective focal length of around 30–150mm) makes an ideal walk-around lens. You'll need the wide-angle focal length for landscapes, while the telephoto end is good for portraiture, architectural details, and street photography. For DSLR shooters, a compact, fast (f/1.8) 50mm lens (known as a "nifty-fifty") is good for low-light shooting. These lenses are relatively affordable, especially preowned ones. If you find 50mm too long for a cropped sensor camera, consider choosing a 30-35mm lens, or a 20-25mm lens for a Four Thirds camera. These are small, lightweight, and fast models, but they are more expensive than their 50mm counterparts.

As you're unlikely to have room for a tripod and remote camera trigger, a beanbag is a useful option. These are small portable beanbags that you can place on a wall or similar support and rest the camera on for stability when poor lighting conditions mean that you have to use a slow shutter speed. You can always rest the camera directly on a wall or other similar support, but a beanbag makes it easier to get the framing you want.

Finally, make sure you have at least two batteries, a charger (and any necessary plug adaptors), and a sufficient number of memory cards to last you.

↑ Only in Thailand would you find someone up to his knees in water, but still toting an umbrella while riding a motorbike...and those are the moments when you're glad you have a camera handy.

→ Good travel photography should capture the heart and soul of a place. To do this you need to train your camera on every aspect of the country you're traveling through: its people, their customs, the landscape, and the memorable architecture.

Use a tripod. When you're getting very close to your subjects, all bets are off when it comes to camera shake. It is simply too easy to move your camera as you're taking the photos, which results in blurry pictures. Considering the magnification you will be working at, any movement to the camera is going to be a problem—so embrace your tripod, and grow some patience. You're going to need both.

Focus manually. When you are working with macro extension tubes you may not be able to use your camera's autofocus. Instead, you will focus by moving your whole camera closer to—or further away from—your subject. It takes a bit of practice, but once you get the knack for it, you'll get the photos, too!

Shoot for shallow depth. The other thing you need to know about macro photography is that you will have extremely limited depth of field. If you get close enough, you may only have fractions of an inch of depth of field, even if you use a small aperture. The only way to get over this is to use a technique called focus stacking (see p138–139).

Lens	WIDE	TELEPHOTO
Aperture	SMALL	LARGE
Shutter Speed	SLOW	FAST
ISO	LOW	HIGH

113

← Use the limited depth of field in macro photos as a creative tool.

↓ At first, you'll worry too much about getting close to think about it, but when you are starting to get to grips with macro photography, remember that the normal rules of photography—such as lighting and composition—still apply.

↗ It takes a steady hand and more than a little bit of luck to photograph a live fly.

→ There are numerous tools you can use to capture macro shots, including a dedicated macro lenses, extension tubes, or close-up lenses.

↘ Can anyone say "extremely limited depth of field?" This is a photo of an ear bud of an MP3 player.

CLOSE-UP & MACRO

We're all fascinated by the unusual views photography gives us that we cannot get any other way. We love using slow shutter speeds to create motion-blurred photos, because it's something you can't see in real life. Similarly, using very short shutter speeds can help you see phenomena that you couldn't see otherwise: a droplet of milk splashing into a bowl, or a horse frozen in mid-leap, there for you to examine in great detail.

Close-up and macro photography opens a magical world, enabling you to photograph tiny things with great detail. Insects, flowers, peppercorns, soap bubbles, electrical equipment—simple everyday objects can all become more interesting when seen through the magnifying power of a macro lens.

Strictly, macro photography (as opposed to close-up) requires a reproduction ratio of 1:1 (that is, the subject can be the same size as the sensor and completely fill the frame), but a ratio of 1:2 is now widely accepted as macro. Anything less than this, such as 1:4 and 1:8, is only close-up.

Although dedicated macro lenses provide optimum true macro quality, they are expensive. Near macro

(1:2 or 1:4 scale) can be achieved much more cheaply with macro extension tubes. These are metal rings with a body bayonet fitting on one side, and a lens bayonet fitting on the other. In essence, what they are doing is moving your lens further away from the lens body. Since there are no optics in here, there's no such thing as a "good" or a "bad" extension tube—setting aside build quality and the camera retaining the ability to auto focus.

When you move the lens further away from your camera body, you lose a bit of light, but your lens can focus closer to your subject. A lot closer. You can stack several extension tubes to get even closer. The result is great close-up photos.

Another low-cost alternative to a macro lens is a supplementary close-up lens. These lenses attach to an existing lens like a filter, and allow the lens to focus more closely on the subject, in the same way that reading glasses correct long sight.

Generally extension tubes work best with lenses with a focal length of 50mm or less, while close-up lenses work better with 100mm or more focal lengths.

Choose your vantage point. The number one rule for photographing buildings and architecture is to not take your shot from too near the base of the structure. If you take a shot from this location, you'll find that your shot is skewed because the base of the building will appear larger than the top. The shot will come out much better if you can take it from a higher point if possible.

Vary your angles. Try a straight shot of your subject, then one at an angle. Each shot will give a different perspective, and you may find that you prefer one shooting position over the other.

Use leading lines to lead the eye. Remember the lesson about leading lines in Chapter 4? You can draw the viewer's eye into the photo by including a pathway that leads up to the structure.

Include people. Sometimes including people can help explain the "story" behind your shot.

Don't forget about the details. While a whole building or city scene may be nice, sometimes the interest is more in the details, so zoom in and see what you come up with.

	WIDE	TELEPHOTO
Lens		
	SMALL	LARGE
Aperture		
	SLOW	FAST
Shutter Speed		
	LOW	HIGH
ISO		

Finally, there are the expensive tilt-shift lenses that are used by some architectural photographers to get the advantages of a wide-angle shot while eliminating distortion. If you really want great, close-up shots of buildings and other subjects, this is the way to go—just be prepared for the hefty price tag!

Camera settings

Depending on the time of day, you may need to reduce your shutter speed, particularly if you are taking the shot at twilight or later, but for deep shots (like cityscapes) you'll need to use a small aperture to keep it all in focus. A lower ISO is better, as this will reduce noise on the photo, so it's a very good idea to invest in a tripod so you don't come home with blurry shots.

When you are setting up a shot, consider the context of your photo and whether you want to include just the subject, or the surrounding space as well. Does the picture make sense if it is just the subject, or does it need space or surrounding buildings to give it some context? You may want to experiment with close-versus-wide shots to see how including space can change the feel of the picture.

111

↓ Be on the lookout for architectural details—these are often just as representative of a city as entire buildings, and introduce a change of pace to a portfolio of architectural shots.

↘ Cities usually have iconic skylines that are readily identifiable. Shoot into the sun to capture strong silhouettes that reveal the city's identity.

ARCHITECTURE & CITYSCAPES

There are so many fantastic buildings, some new, some hundreds (or even thousands) of years old, and so many beautiful cities that it's hard to resist the urge to capture them all. Or, at least, some of them.

By learning the best techniques to photograph buildings, cityscapes, and architectural subjects you can ensure that you end up with shots that truly represent how you feel about each subject. With that in mind, here are some tips to get you started.

Lens choice

All photographers have different lens preferences, and it's no different with architectural photography and city

shots. It's worth experimenting to find out what works best for the kind of image you want. A wide-angle lens is great for shots where you want to fit in the whole subject (such as a skyscraper), or for photographing skylines. Be aware, though, that wide-angle lenses will cause some distortion. A telephoto lens allows you to isolate detail and other areas of specific interest. For many, a good walkaround zoom lens (something along the lines of 20–100mm) is ideal, combining a useful range of focal lengths in a single portable lens.

A fisheye lens is also popular for this type of photography, as it lets you get into the image, which makes it great for street-level-to-sky shots where the photo is surrounded by buildings.

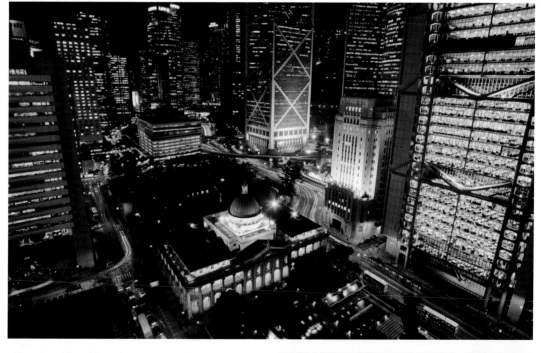

↑ Shooting with a wide-angle lens helped capture this shot of Hong Kong's city lights. It's always a good idea to seek out easily accessible areas that provide a good view of the city. Photographing a city from a good height is always spectacular, but is often more so at night.

→ You may have noticed that when you photograph a tall building, pointing your camera upward to capture the building from top to bottom results in the building appearing wider at the bottom than the top. This is an optical effect known as converging verticals. By using a specialist tilt-shift lens it's possible to ensure the sides of a building appear straight and parallel to one another.

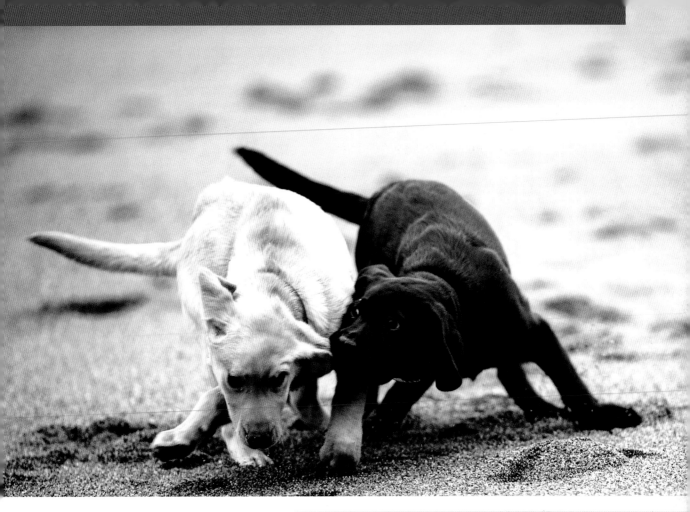

↑ To capture fast-moving pet action, you'll need a fast shutter speed. This shot was taken at 1/320 second, which was just about fast enough to freeze the movement of this puppy fight. The wide aperture setting helps to isolate the two dogs at play.

→ Good framing, good exposure, the eyes perfectly in focus—and a great little action shot of a hamster playing. Who says animals don't have personalities?!

continuous shooting mode (where you hold the shutter button down and the camera takes a burst of shots) to get some great action scenes.

Animals with darker fur, skin, or scales may be more difficult to capture in photo, particularly on a bright day. Play with your exposure levels and see if you can help bring out more of your pet's natural tones. It also may be a good idea to ensure that you have a contrasting background so they stand out more.

Pets are rather like children, and usually pay very little attention to what you want them to do. In order to get a particular shot you are going to have to be very patient. If you are getting frustrated, consider putting the camera down and trying another day, or recruit someone to help you get the right behavior by showing a toy, treat, or calling the animal when you are set up and ready.

PHOTOGRAPHING PETS

Big or small, young or old, four-legged or...other, we all love our furry (and not so furry) friends, so it's no wonder that we are concerned with getting some great photos of them. Photographing animals—even our pets—can be tricky for a number of reasons, however, so here are some tips to help you on your way.

No matter how calm and collected your pet is, they may not respond well to the bursts of light coming from your camera, so natural lighting is a good choice for most pet photography. Preferably take your pet outside for pictures, or at the very least set up your shoot in a room with a large window and lots of light. If you are shooting outside consider waiting for an overcast day, as direct sunlight will cause too many shadows. Alternatively, seek out a large shady area, preferably one in which the lighting is uniform. A tree may look as if it offers lots of shade, but the lighting can be dappled—giving patches of very bright light. The one exception to this rule is if you have an animal with a dark coat, which will need fairly bright sunlight or a flash to help bring out all the blues, browns, and blacks in their coat.

Camera settings & lens choice

Unless they are sleeping, you will need a relatively fast shutter speed to capture a crisp shot of your pet. Combining this with a wide aperture can give you sharp photos with a nicely blurred background, to enhance the importance of your furry pal. Also try using

TOP TIPS: PET

Patience. While you may get your dog to sit/stay for a few minutes, it's unlikely you will have the same luck with your cat, hamster, snake, etc. You will have to be patient if you want a good pet photo, and you may also need to get down to their level for the best shot.

Focus on the eyes. Your pet's eyes communicate a lot about them, and can be soulful, playful, or downright devious. When taking photographs of your pet, have your camera focus in on the eyes first.

Movement. Pretty much anyone can take a decent pet photo given the right equipment, but the truly remarkable pet photos are the ones that not only show off how lovely your pet is, but also give an insight into what they are really like. Running, playing, sleeping, or "getting into trouble" shots all show off a part of your pet's character that few get to see.

Get in close. Pets have a wonderful amount of color and texture, as well as their beautiful eyes that you can capture using a macro lens. However, if you are trying to get some "natural behavior" shots of your pet you may want to stand back and use a telephoto lens or zoom setting instead.

Lens	WIDE	TELEPHOTO
Aperture	SMALL	LARGE
Shutter Speed	SLOW	FAST
ISO	LOW	HIGH

← Although for the most part it's good to photograph pets at their eye level, like all compositional rules, this rule can be broken. Photograph your pet from a variety of angles and you'll be amazed at how it changes your perception of their character.

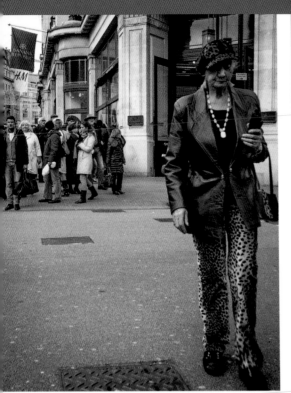

Remember your safety

Some people react strangely to being photographed. In most countries, if you are in a public place you are fully within your rights to take photos. Having said that, if someone seems annoyed or is behaving erratically, it's often better to just shy away rather than start a lengthy discourse about privacy-versus-freedom-of-information-gathering laws on the street.

If you're out and about with your camera, remember that you're a natural target for certain criminals too; they can see that you have an expensive piece of equipment in your hands, and that you're paying more attention to your subject than to your surroundings. If you're going to a particularly shady part of town, consider taking a friend with you—two pairs of eyes are always better than one.

Street photography & the law

Before you run out and take photos on the street, it's a good idea to know what your rights are (and what the law is) where you're taking photos. A quick internet search for "photographer rights" and your country should give you all the info you need.

TOP TIPS: STREET

Some people aren't comfortable with being out and about taking photos. Here's a few tips to get you started.

Find a good background. Aim your camera at a good background, focus on the people who walk by, and simply press the shutter when you see a person who looks interesting.

Seek out street performers. If you're too nervous to take photos of strangers, start out with street performers. They are there to show off, so most won't mind having their picture taken—as long as you drop something into their hat.

Use a telephoto lens. If you use a telephoto lens, you can take your shots from a safe distance.

Lens	WIDE	TELEPHOTO
Aperture	SMALL	LARGE
Shutter Speed	SLOW	FAST
ISO	LOW	HIGH

→ Another obvious choice for honing street photography skills are street performers. They expect to have cameras pointed at them, and the crowds usually make for a good photo opportunity as well. Here, the juxtaposition of the performer's hat sitting over an audience member's head makes for an amusing and fortunate diversion.

↗ You can capture some truly intimate moments on the street.

STREET PHOTOGRAPHY

Street photography is an age-old discipline of photography. It is closely related both to architecture and portraiture, in a way. When you are out taking street photos, you're showing the inter-connectedness between people and places in a way that is quite unique.

In street photography, you're actually quite similar to a wildlife photographer. Instead of lions, elephants, and monkeys, you have jugglers, lovers, and businessmen. Instead of a jungle, an ocean, or a savannah, you have stairways, alleyways, and open spaces.

When photographing people in their natural environment—towns and cities—something beautiful happens: often you reveal more about both the people and the setting you're photographing them in than you could by shooting each separately.

Lens choice & camera settings

There are a lot of different situations where you might give street photography a shot, and it's difficult to give advice that works for every possible situation. However, one thing that's for sure is that people rarely stand still to be photographed. To freeze them in time, you'll need to use a reasonably fast shutter speed.

Once you've decided you need a fast shutter speed (1/250 second works well as a starting point), all your other choices are made for you. A lens with a large maximum aperture is useful, a high ISO is necessary, and your aperture will be whatever it has to be.

Street photography is one of the few times where it's best to use Shutter Priority mode on your camera—a fast shutter speed is the only thing that's important when you're out there.

If you have a lot of light, you can also consider using Aperture Priority: choose a nice, large aperture, and see how your photos come out. Using a large aperture has two benefits: the messy city background is blurred so your photos look better, and the extra light you get helps reduce the shutter speed that's required.

⤓ Street markets provide excellent opportunities for newcomers to street photography. They're often bright, lively places, full of colorful produce. A lone, discrete photographer is easily overlooked amongst the hustle and bustle of commercial activity.

↗ Looking out for interesting individuals is a key element of street photography. Make sure that your camera settings are primed for quick-fire shooting. You can also try shooting at waist level. Not bringing your camera up to eye-level will draw less attention.

Generally, if you're learning about lighting, it is easier to work with continuous lighting because you can immediately see what you are doing. Most hardware stores sell 500w halogen spotlights, branded as "flood lights" or "shop lights." They are cheap, and getting the color balance can be tricky, but they are a great first step into the world of continuous artificial lighting.

Studio and camera-flashes can be harder to get to grips with, because they only illuminate your subject for a fraction of a second. Nonetheless, flash lighting tends to be much brighter, and in the hands of a good photographer, flash is are very effective. You can achieve great results with a single flash unit placed off-camera that is synced with your camera. Remember the flash lessons covered in Chapter 3 and you'll soon be on your way to mastering artificial lighting.

BASIC SETUP

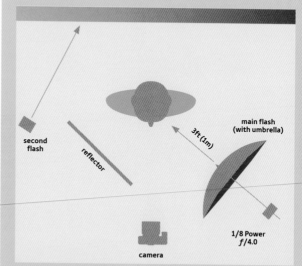

You don't need to spend a fortune to get a simple, but really effective studio-lighting setup. This diagram shows the equipment and where to place it. The main lighting comes from an off-camera flash mounted on a stand. The flash fires through an inexpensive "shoot through" umbrella, which modifies the small powerful light from the flash gun into a much larger softer light source. Place the flash and umbrella slightly above and to one side of your subject, around 3 feet (1 meter) away from them. Experiment with the power of the flash and the size of the aperture and you'll soon be getting professional-looking portraits.

Play around with the position of the flash/umbrella to see how it impacts on your portrait. If you want to balance the light so that there's less shadow use a reflector or white card placed on the opposite side to the flash. Introducing a second, less powerful light source to throw some light on the background will add depth to the image.

This initial lighting setup will provide you with good results, but you don't have to stop there. Adding more lights and reflectors will give you very different results; the important thing is to keep experimenting.

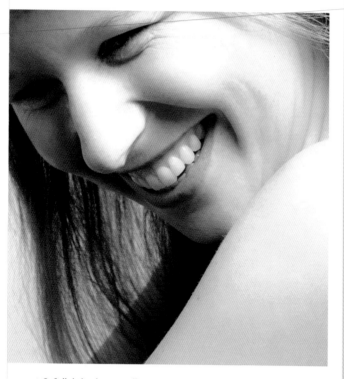

↑ Soft lighting is generally more flattering in portraits, especially for women. For really soft lighting try using a softbox.

103

PORTRAIT PHOTOGRAPHY WITH ARTIFICIAL LIGHT

For many photographers, particularly those new to photography, artificial lighting can be a little daunting. The first active experience many of us have with artificial lighting is pop-up flash—and this is rarely a good experience. Portraits taken with pop-up flash are often washed out, feature ugly black shadows and red eyes, and usually appear flat and two-dimensional. But it doesn't have to be that way.

Artificial light comes in two flavors: continuous lighting and flash lighting. Lightbulbs, flashlights, and floodlights are examples of continuous lighting, while flash lighting ranges from small, built-in flashes to large, high-end studio strobes that require mains power and control packs.

The great thing about taking photos with artificial lighting is that you have full control over what is happening in your frame. Here are some top tips for making your studio shots work out better:

Use a catchlight. By making sure your model's eyes reflect a little bit of light back to the camera, it adds a "twinkle," which makes people look more alive.

Turn-turn. Inexperienced models sometimes have problems looking natural on camera. Have them turn their back, and then when you tell them, turn back to the camera. This movement often helps people relax enough that the photos come out much better.

Use props. If your model has a hobby or a job that involves props (knives for a chef, spanners for a mechanic, a camera for a photographer), encourage them to bring the props to the shoot. Sometimes having something familiar to handle helps make a model look more natural.

Go high. If your model is a little bit on the plump side, taking the photo from slightly above has a slimming effect. Getting the model to look up into the camera also helps reduce any double chins.

Glasses. Glasses can be a problem in portraiture. If possible, consider taking photos using empty frames, or turn your model slightly so your lights aren't reflected in the lenses.

Light the background separately. If you have enough lights, use separate lights for your foreground and background. Make sure none of your foreground lights spill onto your background and the photos will look much more professional as a result.

Have fun with it. Taking photos is fun, and being photographed is likewise. Have some fun with it; it'll show in the final result.

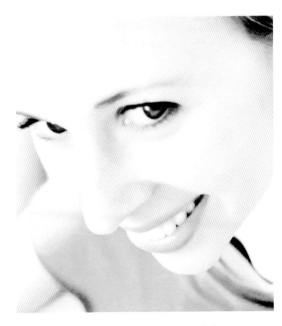

↑ A single flash can give beautiful lighting. If you want more flexibility and control, add more flashes and light accessories.

→ Two 300w halogen spotlights are the source of light in this shot. It's hardly the most impressive studio shot in the world, but this was the very photo where it all started making sense.

Lens	WIDE	TELEPHOTO
Aperture	SMALL	LARGE
Shutter Speed	SLOW	FAST
ISO	LOW	HIGH

← ← A good-looking portrait. A 150mm focal length flatters the proportions of the face, while a large aperture (*f*/2.8) blurs the background enough to isolate the subject—more observant readers might realize she's on a tennis court.

↘ Beautiful soft sunlight spilling in through a window gives you gorgeous, classical portraiture lighting. Don't be afraid to overexpose or underexpose backgrounds. As long as the model's face is exposed accurately, that's all that really matters.

← Using a wide-angle lens to photograph people can cause odd facial distortions. Parts of the body closest to the lens become disproportionately large—this distortion can be used to great creative effect—but be warned, it's probably not going to show the model at his or her most stunningly beautiful!

hits the subject from more angles. You can accomplish this by placing a large translucent diffuser between your subject and the sunlight.

Add more light—Strictly speaking, if we're going to be doing natural light photography, adding more light is cheating, but sometimes there's no other way of achieving the result you are after. It may feel strange to use a flash in broad daylight, but your camera's fill flash feature can help you remove some of the shadows from your model's face.

TOP TIPS: PORTRAITS—NATURAL LIGHT

Shooting portraits outdoors can provide great, natural-looking results but you need to know how best to control and harness sunlight to your advantage.

Research your location. Try to find out as much as you can about your location before the shoot. Where will the sun be when it's relatively low in the sky in the morning and afternoon? What's in the background—apartment blocks, or trees?

Vary your angle of shooting. This applies to all portraits, naturally or artificially lit. Most portraits will work when shot at the subject's eye-level, but shoot from above and below for variety.

Shoot into the sun. Try creating some dreamy, overexposed white backgrounds by deliberately placing your model in front of the sun. Expose for your model's face otherwise you'll end up with a silhouette.

Shoot later in the day. Photographing when the sun is lower in the sky is likely to provide slightly softer, more manageable light, and warmer, richer tones.

Composition. Remember compositional guidelines, such as the rules of thirds and leading lines. Try placing your subject off-center with the eyes a third of the way down the frame. Then try everything else!

	WIDE	TELEPHOTO
Lens		
	SMALL	LARGE
Aperture		
	SLOW	FAST
Shutter Speed		
	LOW	HIGH
ISO		

PORTRAIT PHOTOGRAPHY WITH NATURAL LIGHT

Traditionally, portraits have generally been taken with long lenses—it has been said that 80–135mm lenses are perfect for portraits. The problem with wider-angle lenses is that they can cause distortions. Get too close, and your subject's nose will look huge, or if they have one part of their body closer to the camera than another, it could look strange. Of course, this is something you can explore for effect, but if your goal is to make your subjects look good, it's probably best to opt for a longer lens. Remember, if you're shooting with a crop sensor DSLR you also need to allow for the crop factor of between 1.5x and 1.6x—so a standard 50mm lens becomes an ideal portrait lens of 80mm.

As for camera settings, there are as many options as there are photo models. In some circumstances, an extremely shallow depth of field can look great, so you would need a large aperture. A shallow depth of field is a nifty short-cut to great-looking portraits, so shoot wide open and see if you like the results you get. In other cases, setting a smaller aperture with its greater depth of field allows you to show off the background in the image for context.

Dealing with shadows

Even though there's a lot of beauty in sunlight, that big, bright, burning ball of fire in the sky does have an unfortunate side-effect: it tends to cast very harsh shadows, and people don't look all that great with black swathes of shadow cast across their faces.

Shadows are caused by strong, directional light; the sun is an excellent example of such a light source. There are three ways of dealing with this challenge:

Make the light less directional—This is the easiest way of dealing with direct sun. Take your subjects out of the directional sunlight, and place them somewhere else. The simplest way of accomplishing that is to ask them to go and stand in the shade. If you want to get more high-tech about it, you can use a reflector to reflect some of the sunlight back into their face, which will lift the shadows a little, giving a more even light.

Make the light source bigger—If your light source is bigger relative to your subject, it means that the light

Straighten that horizon. If you're going to include a horizon in your image it is important that it is either straight, or at a significant angle. A slight angle makes your photo look shoddy!

Balance your foreground and background. All photos are very different, so it is hard to say whether you should have the foreground or background as your main focus. As long as it looks right, you're onto a winner. Try compositions with a majority of foreground and background to get a feel for what works best.

Use a small aperture. By using a smaller aperture you get a greater depth of field. Perfect for ensuring that both the foreground and background in your images are in perfect focus.

Use a tripod. A side effect of having to use a small aperture and a low ISO is that your camera will need to use a long shutter speed as well. By using a solid tripod you can ensure that camera shake doesn't disturb your final photograph.

Remember the rules of composition. Not only will this help you to create a balanced image, it will help you to convey the meaning and "story" of your image.

Lens	WIDE	TELEPHOTO
Aperture	SMALL	LARGE
Shutter Speed	SLOW	FAST
ISO	LOW	HIGH

← Beautifully framed and simple in color, this photo is a magnificent example of how rich a story can be told in a simple landscape.

↗ Strong leading lines and a beautiful golden glow make this an appealing landscape shot with much impact.

→ Ensure you have some interesting elements both in the foreground and background of your shots.

PERFECT LANDSCAPES

We wouldn't be at all surprised to find out that landscape photography is the second-most popular photographic genre, after portraiture. Like painters from the Romantic period, both seasoned professionals and amateur photographers turn to the wilds of mother nature for inspiration and expression.

Taking landscape photos can be rewarding, relaxing, and (if nothing else) is an excellent excuse to go for a long walk every now and again. Apart from getting a bit of fresh air, it's also a great way of learning to know your new photographic equipment: the trees won't run away from you, the horizon won't get offended that you're taking its photo, and the mountains are happy to hold very, very still for however long you need to get all your camera equipment and settings right.

Technically, landscape photography is probably one of the easiest disciplines; bring a tripod with you, use a wide lens and a small aperture, and you can't really go wrong.

One thing worth keeping in mind, however, is to use a low ISO. In landscape photography, you have the luxury of time, so use it to take the photos you have dreamt of. The real challenge, then, isn't so much the technical side of the photos as the creative side. It's easy to get a tree in focus, but how you will be able to illustrate the awesomeness of the forest you are standing in is a different matter altogether.

Like anything else in photography, you have to think about telling a story. If anybody is going to give your photo a second glance, there has to be something that can be experienced; it has to resonate with the viewer.

How you speak to someone differs from person to person, so the best place to start is to attempt to tell a story that resonates warmly with you. The lessons learned in the Composition chapter are more important in landscape than in any other genre of photography as they, more than anything else, are the weapons in your storytelling armory.

HOW TO SHOOT ANYTHING

One of the questions most frequently asked of professional photographers is how they took a particular photo of a particular scene. This is a completely normal approach to photography: it's much more fun to learn new techniques while you're experimenting with mastering a particular shot than it is to read pages and pages about apertures, shutter speeds, and other dry theory, after all.

In this chapter, we've collected some really cool photos—along with explanations as to how you can take similar shots. More importantly, we'll be talking you through the theory behind each shot. Sneakily, and without even really noticing—possibly against your will—you'll learn more about photography and develop into a better photographer.

Of course, all the examples and setting shown in this chapter are merely suggestions. If you think you have a novel idea about how you can photograph a particular scene, then there's no better advice than to get your hands dirty and give it a try.

a while. Nonetheless, learning the rules will give you a solid grounding as a photographer, and it will help develop your inner eye faster.

Nobody should ever tell you to "never" do anything. Over- or underexpose to your heart's content; play around with how you focus. And all that stuff about blur in photos being evil? Ignore it and experiment away. The most important thing about photography, after all, is creating compelling images, and if you are able to do that by breaking a couple of rules here and there—all the better!

→ This image was deliberately underexposed by around 2 stops. The background is almost totally black and the foreground very dark. But the important part, the bluebell, is clear and colorful against the black ground, helping it to stand out.

↑ In this shot the subject's eyes are not in focus (gasp!) and it's way too dark (tut-tut!), but it's still a strong photo with a story to tell. It does adhere to some of the "rules" though. It has a rule of thirds-style composition, and it uses dramatic lighting and a limited depth of field to give the impression of depth.

→ No rule of thirds, no leading lines, no nothing! However, the strongly centered design still helps you focus on the subject.

BREAK THE RULES

As you've probably already noticed, this chapter—and in fact much of the rest of the book—is very rules driven. We make no apologies for this. All newcomers to photography will benefit from being pointed in the right direction when it comes to compositional rules. Just as you have to learn how to use a camera if you want to get an exposure that's not too bright and not too dark, so too it helps to learn some rules of composition if you want to make images that hold the viewer's attention. But, by the same token, just as you deliberately ignore the camera's light meter if you want to create an overexposed or underexposed image, you can from time to time also ignore compositional rules for creative effect.

These so-called rules are there to be broken. The key is to do it in a way that makes it obvious that you're breaking a particular rule of photography to achieve an effect, mood, or emotion.

Learn 'em, then break 'em

The reason photography has so many rules is due to the way the human brain processes images. The rules are tried-and-tested methods that engage and elicit the psychological responses we have when we look at photographs to full effect. It can be seen as a bit lazy, following the rules as if we're enslaved by them, but ultimately if you're just starting to find your feet as a photographer, you need to use all the tips and tricks you have available to you to make the best possible photos in as short a period of time possible.

Unfortunately, learning the rules means that you will end up taking the same photos as everybody else for

↓ Who says you should always hold the camera steady? Sometimes we just want to create an impression of the colors, textures, and tones of a scene. An effective way to achieve this is to deliberately pan the camera as you're taking the shot.

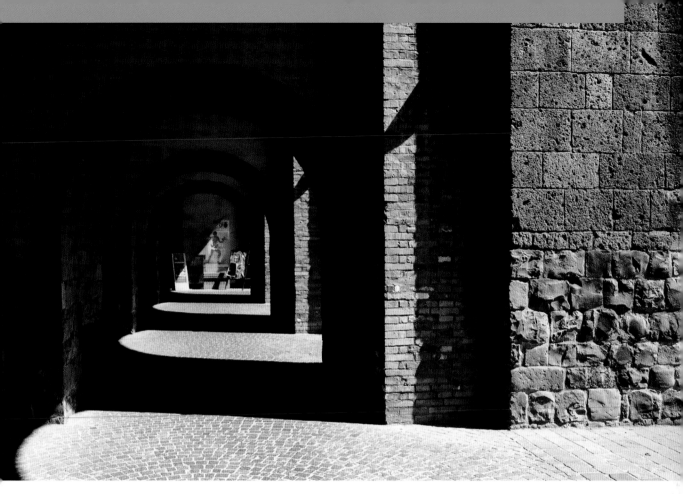

← Framing a landscape scene with trees or other natural objects was a compositional method first used by landscape artists. The technique works equally well in photography. Including some form of frame in the image helps to accentuate the subject and adds context so the viewer has a real sense of where the image was taken from.

↑ Frames can be used to guide a viewer through an image, as in this series of arches. The frame within frame within frame provides strong perspective to the image.

→ You can also use the frame within a frame technique for portraits. Used in this way you won't achieve the same sense of depth as the subject is usually within the frame, but they can help to emphasize the subject and add contextual information.

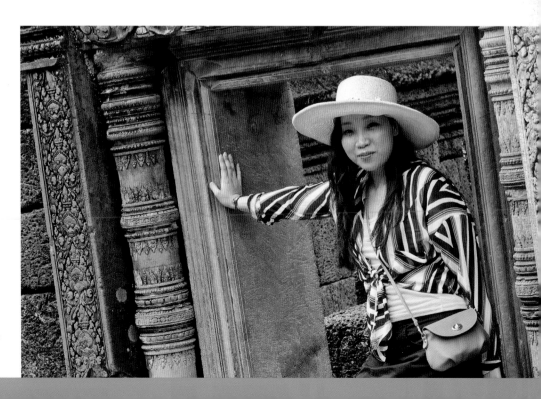

FRAMES WITHIN FRAMES

Leading lines can be a relatively subtle way of leading your viewer's eyes around a photograph. If you prefer a more in-your-face approach—the Las Vegas neon way of attracting attention, as it were—you can introduce another photographic trick.

Framing your images is a sure-fire compositional technique that can add interest to a picture and draw your viewers into the image. The great thing is that there isn't any particular rule that says how or when you can use framing—or how obvious your framing should be. You can be as subtle or as bold as you want.

A great side effect of starting to look for framing opportunities is that it trains your mind to look deeper into your photos. You're sorting through "near," "medium," and "far" from a perspective and compositional point of view, and once you're used to that way of thinking, even if you never take a single "framed" photo, you're well on your way to developing your method of evaluating scenes before you pull your camera out of your photo bag.

← Sometimes the frame can be just as much of the composition (if not more) as the scene itself. Here the Parliament buildings of Budapest, Hungary are framed by the arches of an historic building on the opposite side of the river.

→ A limited depth of field helps guide the viewer's eye to the bicycle, and adds a feeling of depth, too.

on the part of the photo that is crisp and sharp. The background is still there, adding color and context, but because it isn't in focus it won't distract viewers from what you're really trying to show them.

You can use the very same trick in reverse: by using a large aperture and focusing on the background, you achieve a very similar effect.

Lighting to create depth

If you've done any work in a photo studio, this one will come as no surprise to you. Lighting setups can often be described as "flat" if there's not much depth in the image. This is why you'd often use a three-light setup to help create an elaborate illusion of depth in studio photos.

Even if you're not taking photos in a studio, it's not the worst idea in the world to keep lighting in mind. Remember, light directly from the front (such as photos taken with an on-camera flash) tends to look pretty drab and dreadful. Try to light from above or the side, as that makes an incredible difference to how the light and shadows spill across your subject's face, and that's where depth is going to come from.

CREATING DEPTH

There are a few 3D cameras out there, but that's not the kind of "depth" we're talking about in this case. Photography is generally a two-dimensional medium, but that shouldn't stop you from thinking about depth in your images.

Photos that create a feeling of three-dimensionality tend to feel more alive and dynamic than photos that are "flatter."

Foreground & background contrast

The first trick you can use to create depth in your photos is to use a separate foreground and background. By placing something behind your main subject, a contrast becomes noticeable, between the things that are close to the photographer, and things that are in the background. The simple fact that you can identify things at two (or more) different distances gives the image extra impact.

The top tip here is that you don't even need to have your foreground subject as the main focal point of the photo. As long as there is something there, the background will come alive. This can be nearly anything; a tree branch overhanging a valley, a bird flying, or a person included in the photo can all tell part of the story and add context to your images.

Using depth of field

You can take the foreground/background tip a step further by introducing depth of field to the mix. As we talked about in an earlier chapter, you can get a shallower depth of field by placing your subject close to you and using a relatively wide aperture setting on your camera. Doing this causes the background to drop out of focus.

By having only the foreground in focus, your viewers' eyes will magically glide across the photo, finally sticking

↑ This sweeping vista wouldn't be much of a picture without the motorcyclist in the foreground. By including a person, this photo gets a sense of depth and scale.

↗ Another way to introduce depth to a landscape image is to exploit the natural phenomenon known as aerial perspective. Aerial perspective relies on hazy conditions which make more distant objects appear less

distinct, lacking in contrast and color. This results in clearly defined layers in the image that give a sense of depth. Shoot into the sun and use a telephoto lens for an aerial perspective effect.

→ →→ Both of these images were shot with the same model during the same photo shoot. Using a slightly different lighting set up makes a huge difference to the portrait.

↑ The relatively repetitive white brick pattern interrupted by the metal door gives a minimalist impression, but there is a very obvious focus.

← In a sea of colored crayons, it isn't hard to guess which one you'll be looking at.

SYMMETRY & REPETITION

Somewhere deep inside our brains, we are calmed by the presence of order and simplicity. There's something safe and nicely balanced about an image that has symmetrical or repeated elements in it. Armed with the knowledge that we are pre-programmed to find patterns, repetition, and symmetry, you can implement this in your photography.

Patterns are everywhere; you just have to be on the lookout for them. Whether it's a picket fence running along a road, a row of lamp posts, the bricks in a wall or a dense forest, all the patterns we surround ourselves with can be used for strong photographic effect.

Zooming in tight and composing your shot such that it fills the frame is a good technique as well; by stripping out the context, the visual suggestion is that the pattern continues on forever in all directions. Try coupling that approach with an unusual angle or exotic lighting, and you've got a high-quality abstract shot.

↑ Something about symmetry and repeated subjects in a photo makes us automatically start comparing and playing spot-the-difference.

← Perhaps you can get too literal with the concept of symmetry, but the visual effect in this photo is so striking that the viewer is likely to do a double-take.

↑ Curves lead the viewer through the image and create a fluid dynamism, particularly in this image in which the curves are broken by strong diagonals.

↗ Horizontal lines suggest calmness and stability. Care needs to be taken, however, that the sense of calm doesn't spill over into dull and boring.

↓ Strong vertical lines in an image, such as those created by trees, buildings, street lights, and so on, bring order to a composition and are suggestive of power and growth. Consider the shape of your frame when utilizing vertical lines.

Verticals & horizontals

As well as using lines to lead your viewer into and through an image, you can also use lines in your photos to help composition. Lines can be made up of an infinite number of objects, both natural and artificial, and including them in your images can help encourage a response from the viewer.

Vertical lines, for example, tend to add a sense of order and symmetry to an image. There are countless ways to include vertical lines in your imagery, but trees, buildings, posts, and even standing figures are all good examples. The lines created by such subjects suggest power and solidity.

Horizontal lines, like verticals, also bring order to an image; but unlike the more dynamic power of verticals, horizontals convey a sense of calm. The most obvious natural horizontal line is the horizon, and this is often used by landscape photographers to suggest tranquillity and harmony.

Diagonals & curves

Both diagonals and curves are more dynamic and create less structure in compositions. Diagonals are often found in converging verticals (think of railroad tracks that converge to a point in the distance) and can often inject motion and movement.

Curves are more organic and fluid than straight lines and are often associated with nature. They can be the sensuous curves of the human form, or they can be quite chaotic and dramatic, and are often successfully used to break up the structure of verticals and horizontals.

Implied lines

Lines in photos aren't restricted to physical ones: "implied" lines are just as powerful. These are lines that, for example, join two or more elements that share certain physical similarities, or the eyeline created by someone looking at something in the frame (as in the image below left). Although these lines don't physically exist in the image, we draw them with our mind's eye.

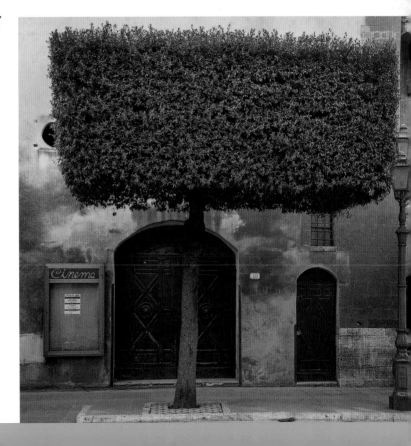

THE POWER OF LINES

Leading lines

If you think you have a mind of your own when you're looking at a photograph, you're sadly mistaken. Humans are remarkably predictable in how they scan a photograph, and how they perceive information. Take a look at the photo below, for example. Look at it for five seconds, and then look away. Now ask yourself, "How many people were in that photo?"

You'd be amazed how many people agree that there is nobody in the photo at all—even though you've probably already cheated and taken a second look. Yes, there's definitely a hitch-hiker there! The reason this happens is that people tend to follow the road with their eyes, and then follow the next natural line in the picture—the row of clouds taking your eyes from the little house at the top of the hill to the top right of the photo. When your eyes make it to the top right, they have "run out" of picture, and suddenly you'll lose interest in the photo.

The problem with this photo is also a great illustration of how powerful leading lines are: unless the lines in an image cause your eyes to stick somewhere, we are less inclined to look at the photo for very long. To use leading lines to their full effect, then, you have to ensure that they help your audience find what you want them to look at.

↑ Look at this photo for five seconds then look away. How many people did you see?

→ Even though this is a very "busy" photo with a lot of detail in the background, your eyes naturally find the main subject. This is because both the horizon and the brick wall lead naturally to the model's face.

↓ Many landscape photographers utilize the rule of thirds to position key elements in the scene.

Another popular use of the rule is to align the horizon along one of the horizontal lines.

↓ The vast expanse of black negative space in this photograph is what gives it impact.

thirds" was coined as early as 1783, but artists had been implementing this rule in practice long before then.

The rule of thirds itself is easy to understand: create a set of imaginary lines that divide the screen into nine equal-sized pieces, and place important bits of your scene along those lines to get a more visually appealing photo. Placing key elements on the intersection of the thirds lines is particularly effective.

Some cameras feature a rule of thirds grid that overlays the image on the LCD screen on the back of the camera that helps users identify the lines and where they intersect.

Use the negative space

The problem people tend to run into when it comes to the rule of thirds isn't the lines themselves. That bit is easy. The challenge is what you do with the rest of the space; surely you can't just leave it empty?

Whether you are working with web design, typesetting, painting, or photography, the use of the area not covered by your main subject is actually rather important. The concept is known as "negative space." What you fill your negative space with adds a lot of feeling to the photo, even if you're not intending the audience to study it in detail.

The key point with negative space is to make it inevitable that your viewer's eyes drift to the place you want them to focus on, either by ensuring that your main subject is the only sharply focused part of the image, or by taking the photo in such a way that there simply isn't anything else to look at.

85

BREAK THE RULE

The only trouble with the rule of thirds is the name, as it shouldn't really be thought of as a strict "rule." There will be many times when you feel it's right to break the rule, and you should go with your gut instinct. This image breaks the rule as the horizon runs right through the middle of the image; but it looks right, with equal weight being given to the sky as to the land. Use all "rules" of composition as guides only, to be broken when you want.

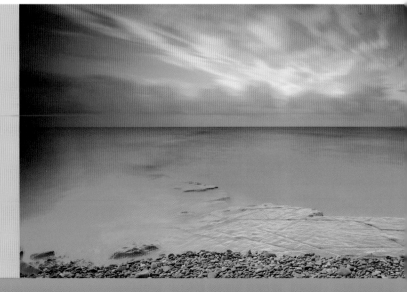

RULE OF THIRDS

There are lots of rules around how composition "works," but the good news is that you don't have to remember that many of them. Implement some of these simple tips, and watch your photos sparkle.

Avoid centering your subject

When you're taking a photo it's natural to be focusing on what is in the center of the frame: after all, that's going to be the most important part of your image. However, if you take a photo where the subject is directly in the middle of the image, you're probably doing your own photography skills a disservice. Most images, with very rare exceptions, look much better with an off-center composition—and this is where the rule of thirds comes in.

A lot of study has gone into what makes something pleasant to look at. Needless to say, marketing and advertising gurus have spent the most time and money on this research. The funny thing is that what they found out is something that has been known among the art community for hundreds of years. The phrase "rule of

↑ This photo shows the rule of thirds—and adds a lovely expanse of negative space to force the viewer to look at the cockerel.

↓ This photo illustrates the rule of thirds perfectly. The subject's eye and the corner of her mouth fall on the corner intersections (sometimes referred to as power points) of the rule of thirds—and the back of her head (where the light falls off) is another third.

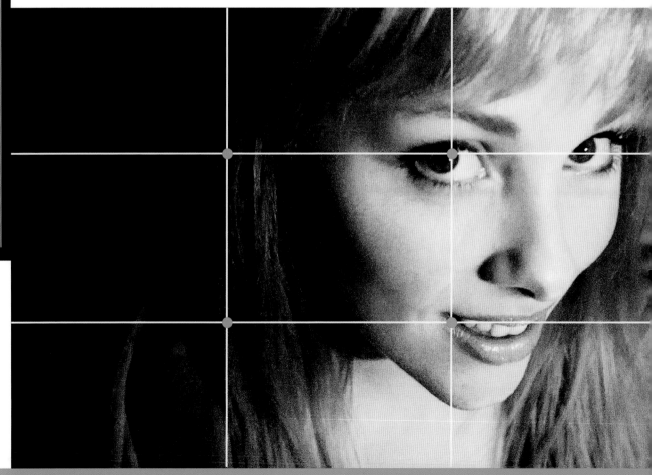

Camera shake: Get a tripod!

There are a few solutions to camera shake. The most convenient option is to increase the shutter speed, as it is less likely that the camera will move during the shot and you're more likely to freeze any movement in your subject. You can also work on holding the camera steady by using both hands and bringing your elbows into your body. If upgrading your camera lenses look for lenses that offer vibration reduction or image-stabilization options. These systems help compensate for camera shake. And note that the closer your subject is, or the longer the focal length of your lens, the more potential there is for camera shake.

Another excellent way of getting really sharp photos of stationary objects is to use a tripod. Most professional landscape and studio-based photographers use a tripod to ensure the camera is perfectly still—even when using fast shutter speeds.

Depth of field too shallow

Using depth of field is a great way to put emphasison particular objects in your shot by blurring the background. This is a popular technique for portraits, but is handy for other types of pictures as well. However, when the depth of field is very shallow you may not be able to keep your subjects in focus, particularly if you are shooting a landscape or other shot where you want everything to be in focus.

In order to improve depth of field you need to manually adjust the aperture setting on your camera. A larger aperture (lower number) lets more light into the lens and decreases depth of field, so it is preferred when you want to focus on a single subject in your shot and have the rest of the scene out of focus. A smaller aperture (higher number) will increase depth of field so you can have more of your shot in focus. However, as you know, you may have to reduce the shutter speed or increase the ISO setting to allow for the smaller aperture.

83

CAMERA SHAKE RULE

To avoid camera shake when you're shooting handheld, the rule of thumb is that you should use a shutter speed equal to the inverse of the focal length of your lens (or faster).

If you are shooting with a 100mm lens, that means you can safely shoot handheld at shutter speeds of 1/100 second and faster; for a 35mm lens, it would be 1/35 second or faster; and for a 400mm lens, 1/400 second or above.

However, if your camera or lens features some sort of image stabilization you can usually increase the shutter speed by at least 2 stops, and possibly even more.

← This image is a perfect example of what happens if you try to handhold a shutter speed of 6 seconds— it'll never work!

ELIMINATING BLUR

Ending up with blurred photos can be extremely frustrating, and without understanding the causes of blur it can truly stunt your photo opportunities. Fortunately, once you understand and can identify what is causing blur in your photos, you can start doing something about it.

Wrong object in focus: Learn how to focus

It is generally easy to identify this cause of blur, as you will notice that other areas of the picture (such as the background or foreground) are in sharp focus, while the subject of your photo is blurry. The problem is caused when the camera chooses to focus on an object in the picture that is not your chosen subject.

To remedy this issue, simply ensure that your camera is focusing on the subject. Sometimes, if your subject is at the side of your frame your camera will focus in the middle—so place your subject in the middle of the frame, focus (by depressing and holding the shutter button half

way), then recompose your image by aiming your camera so your subject is where you want them to be in the frame, and take the shot. Try setting your camera's focusing system so that it uses just the center focusing point rather than all focusing points: at least then you will always know where your camera is trying to focus.

Subject movement: Tell them to stand still!

When your subject moves while you are taking a picture you will often end up with blur. In most cases you can remedy this by increasing your shutter speed, as a faster speed will leave less time for movement.

However, in low light situations you may need all the light you can get, and a slower shutter speed is part of your camera's light-gathering arsenal. In order to fix blur caused by movement you will have to increase your shutter speed, and perhaps adjust your ISO and/or aperture to compensate for the reduction of light reaching the sensor.

↑ Some moments can never be repeated, and you'll kick yourself forever if you fail to capture them as sharply as possible.

→ A great example of subject movement. The photographer in the middle is motionless, but because a slow shutter speed was used, the people walking past are a blur.

FROG'S EYE VIEW

Getting down low in photography is traditionally known as having a frog's perspective. Taking photos from here, then, is known as a frog's eye view of the world. It's a tried and tested composition method, but it can work very well for many different subjects.

Anyone who has ever seen *Reservoir Dogs* knows the power of taking photos (or filming) from a low angle—the subject immediately takes on a far more impressive aspect. Combine the technique with some contrasty black and white, and you're halfway to film noir already.

↑↑ By getting down low, you can create a dramatic contrast in your images.

↑ Shots taken from a low angle aren't just for people photos—it can be used in all sorts of situations. Experiment away.

THE MySpace SHOT

The fact that you look slimmer and saucier when photographed from above appears to have been noticed especially by the people of MySpace, where taking a self-portrait from above became all the rage. It became so ubiquitous, in fact, that the self-portrait-from-above is still known as a "MySpace Shot" in the photography world.

VARYING YOUR VIEWPOINT

Too many photos are taken at eye-level. Not that hard to understand, perhaps; we see with our eyes, and so we have a tendency to hold our cameras at that height. One of the lovely things about a camera, though, is that you don't have to hold it at eye height. Climb on top of something and get a bird's eye view, or hold it just above the ground for a much more dramatic view.

Bird's eye view

If you look around you in the urban landscape, you'll notice there's no shortage of things you can climb on to get higher up. Get creative with stairways, lamp posts, and trash bins to get a slightly different perspective on things.

There are many reasons to get up high when taking photos. People, for example, tend to look better when seen from above, as immortalized in the so-called "MySpace shot." The technique really works, so consider climbing up for some extra-flattering shots.

↑↑ This great overview shot of a street parade in Oslo was made possible by attaching the camera to a monopod, using a 2-second self-timer, and holding the monopod up in the air.

↑ By getting down low, the impact of this photo gets better: it looks as if the model is jumping higher, and the perspective helps to frame her well, with the building in the background.

this extra step to your photographic workflow: for every photo you take, make a mental note of two things—what one technical and one creative thing could improve that particular photograph? If, at the end of the photo editing session, it turns out you have made a lot of mental notes about focus, then perhaps the time is ripe to pencil in a practice session. If you seem to forget to leverage the angles of your photography to the best effect, then perhaps that's what needs to be worked on?

The great thing about self-evaluation is that this technique works well to improve both your creative process and the technical side of your photography at the same time. For every shot you're looking at, the question is simple: What could I have done to make this better? This is especially true for the photos you are most happy with, as the answers are going to be valuable additions to your mental checklist the next time you're out and about with your photography kit. One step at a time, you'll get closer to that ever-elusive perfect photo.

↓ There's much to like about this portrait—it's sharply in focus, the expression is open and natural, and the low camera angle adds dynamism, but there are still ways in which it could be improved.

TURN THE CAMERA

This shot of a beach on the Greek island of Kefalonia, famed for its clear turquoise waters, captures the colors well, but is pretty uninspiring, even for a holiday brochure. Turning the camera slightly so that the line of the beach runs diagonally across the frame creates a more arresting image that holds the attention.

GETTING CREATIVE

You've probably been at a party where someone is telling a story and it seems like everyone is hanging on the storyteller's every word. The onlookers are practically cheering the narrator on to continue with the incredible tale. We're willing to bet that this particular raconteur could make any mundane, trivial topic come to life—and that's what a good photographer can do, too.

If the technical side of photography is the how, then the creative side is the why. A great photograph isn't the absence of blur or perfect exposure; it's telling a visual story, and telling it in such a way that the viewer can't tear themselves away.

If the technical discipline of photography has shutter speeds and ISO choices in its war chest, the creative camp has an impressive array of weapons tucked away too. The crop of an image, angle, choice of colors, taking the photo at the decisive moment, patience, persistence, and the ability to pre-visualize are all aspects of capturing the perfect creative shot.

Many who teach photography are secretly more excited about students who come brimming with ideas but have no photography skills than the ones who know a lot about photography but are lacking original ideas. The challenge

with the creative aspect of the photography is that creativity is extremely difficult to teach. This is a shame, because while most photographers eventually become proficient with their equipment, only a few go on to use those technical skills with amazing outcome—and all of that is down to creativity.

Learning creativity

Picasso, it is said, once drew a sketch on a piece of paper for someone, and then charged them a lot of money for it. "Hey, that only took you ten minutes," the potential buyer reportedly said. "No, that drawing took me thirty years," was the retort. If we assume for a moment that this anecdote is true, it's hard to disagree with Picasso on this one. A photo can take less than a thousandth of a second to make, but nobody learns photography in a day.

To improve your photography, the key is to know where your weaknesses lie. Easier said than done, but try adding

↓ To be able to take photos of flowing motion, you need to be able to use reasonably long shutter speeds. This was taken at 5 seconds. Experimenting with different shutter speeds to see the effect they have on motion is a well-established creative technique —but play around with it to see how it impacts on your own personal photographic style.

↑ This image was rejected by a photo library for lacking in sharp focus; but as a shallow focus effect was the intention, it's hard to argue whether or not it's technically incorrect.

→ Perfect lighting, gorgeous model, nice smile... But the photographer didn't notice until he started processing the image that it was out of focus. Infuriating, but it happens to us all from time to time.

a couple of examples), but in most cases, merely getting a photo in focus and correctly exposed is not enough.

Improving technically

At first, it can be quite hard to become a better photographer technically—where do you start? The trick is to improve your photography a little at a time, by identifying which part of your photographic output needs the most help, from a technical point of view.

Good places to start:

Focusing—Autofocus is extremely good most of the time, but there is a bit of technique needed to be able to use the autofocus to its best potential. If you notice your shots are slightly (or completely) out of focus, paying extra attention to focus for a few days of shooting can help hugely. Zoom in all the way on every photo you take, and see whether your main subjects are in focus. If they aren't, try again. You could even consider using a slightly smaller aperture to increase your depth of field—that way you increase the odds of your focusing being spot on.

Exposure—If your photos are consistently coming out under- or overexposed, you can either start paying more attention to your metering, or try autoexposure bracketing. Bracketing means that your camera takes three photos in quick succession—one slightly over, one slightly under, and one right where the camera thinks it should place its exposure. When you're looking at your photos on your computer later, you should be able to spot a pattern, and determine whether most of your photos are slightly under- or overexposed. Perhaps all you need to fix it is to adjust the exposure compensation setting on your camera? Check your camera manual to find out how to use auto exposure bracketing and exposure compensation.

Blur—We'll be discussing the various types of blur later on in this chapter, but before you get there, have a quick think: do your images suffer from any kind of blur?

IMPROVING TECHNIQUE

The technical side of photography has myriad elements to it, and a good photographer has to juggle all of them to create the perfect photograph. Getting a photograph is an equation of lighting, shutter speed, aperture, ISO, focal length, depth of field, focus, blurring (or the absence thereof), and many other variables. As a photographer, you are akin to a scientist using a sophisticated optical instrument, measuring the world around you a fraction of a second at a time.

Photographers who are just starting out tend to have the biggest problems with the technical side of photography; over- or underexposure are the arch-enemies of many a fledgling snapper. Then there's

the challenges of avoiding focus blur, camera blur, and subject motion blur—we've all been there.

Over time, people learn their tools and what can be done with them. They pick up rules, tips, and tricks that help them compose well-exposed, correctly white-balanced images that are tack-sharp, well lit, and generally attractive, realistic, and accurate depictions of the world.

While being able to take technically perfect photos is a surprisingly rare skill, a technically proficient photographer is still merely a technician. Granted, there are places where photographic technicians have a place (archaeology and crime scene work, to pick

← Technical perfection is something to reach for, but it doesn't necessarily guarantee images that hold our attention.

↑ There's plenty technically wrong with this image. Shot hand-held the image shows signs of camera shake, and there are underexposed areas. But it does accurately convey the wild and desolate nature of areas of the Welsh countryside.

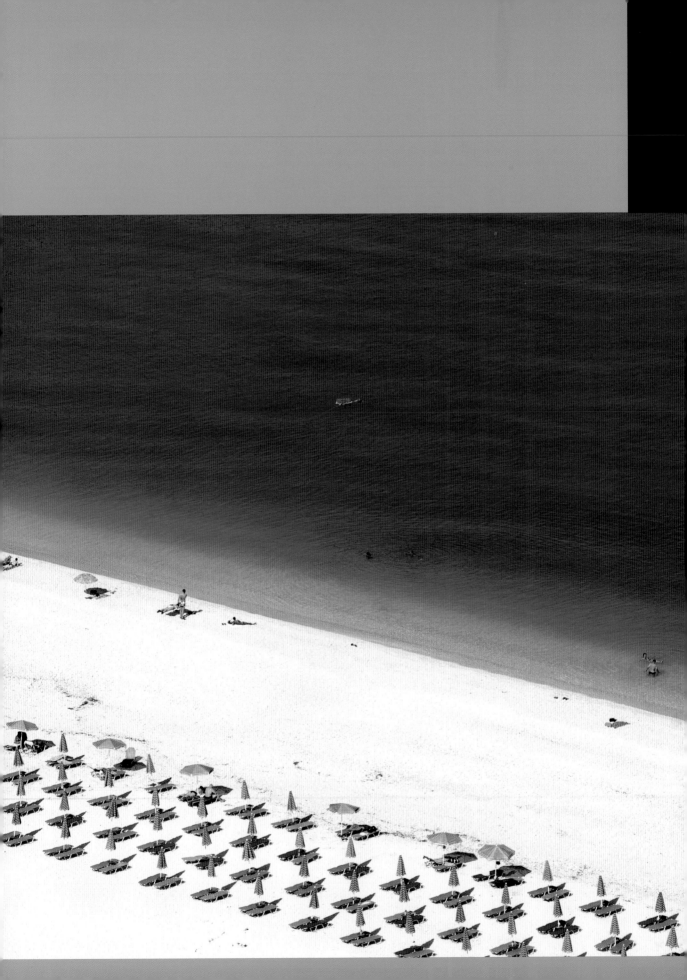

CHAPTER 4

BETTER COMPOSITION, BETTER PICTURES

What makes a good photo? Few things are as overstated and relatively unimportant as the camera you choose to use. What does that really reveal about you as a photographer? After all, a painter is rarely asked about what brand of brushes they use; nor do people care much about which word processor a famous thriller writer uses.

A great photograph needs two things: it needs a creative vision, backed up by a solid set of technical skills. A photo that has one of these two things nailed can be good—but it won't be great.

photos without worrying about over-saturating the rest of your photo. You can also add a negative vibrance to a photo: this has the effect of desaturating the least intense colors even more, which can give some pretty cool effects in some photos. Experiment with varying combinations of high Saturation and low Vibrance and vice-versa for creative effect.

The last slider, Clarity, determines local contrast in an image—increasing it adds contrast to the mid tones for a crisper, sharper look. Reducing this slider gives an effect not unlike using a soft-focus lens (you may have heard the expression "Vaseline on the lens," a technique used in the early years of Hollywood to make the starlets look less flawed).

→ Using the three sliders found under Lightroom's Presence panel provides you with a means of producing many different styles from the same image. Other image-editing software has similar controls, which you can use to achieve the same or similar effects. Try the Hue/Saturation/Lightness command in Photoshop Elements or PaintShop Pro.

NEUTRAL

VIVID

73

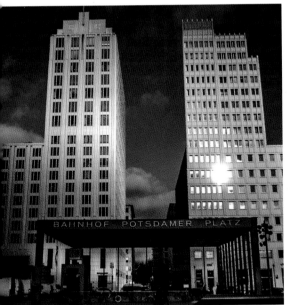

↑ Increasing the Vibrance, but decreasing the overall Saturation for images works very well for certain types of photography. This particular combination of settings gives a slight tinge of otherworldliness to the photos.

→ The Clarity slider has little impact on color directly. Instead it affects local contrast and when increased makes an image sharper and more detailed. Reducing the Clarity setting to a minus figure creates a glowing, soft-focus effect.

CREATIVE COLOR BALANCE

While in general we should aim to get color balance "right," there are exceptions to the white balancing rules, and there are also many fun effects to try by deliberately mis-balancing the color in your photo.

Getting creative with color balance isn't hard. Sometimes you'll find that a happy accident here and there goes a long way toward discovering an unusual-looking technique. Whether your accidents happen in-camera or during digital editing, it's worth paying attention to how you achieve your final result—keep a notebook handy to write down how you made your magic happen.

Make a habit of experimenting with your photos as you're editing them. In particular, with Lightroom's non-destructive photo editing, you can't do any harm: your original photos are a simple click of the Reset button away. If you're using software that actually alters the pixels as you make changes, such as Photoshop Elements or Paint Shop Pro, make a copy of your original image before heading into unknown territory.

Muted, neutral, & vivid colors

Once you've got your white balance set properly, the next choice you have to make is how colorful you want your photographs to be. In Lightroom, three sliders control color: Saturation, Vibrance, and Clarity. They are all found in the Presence panel.

The Saturation slider is fairly intuitive. Increase an image's saturation to make the colors in your photo stronger, or reduce it to make your photos less colorful. All the colors in your photo are affected equally, so colors that are already saturated could become over-saturated. Over-saturation is not necessarily a problem if that's the effect you're going for, but it can look very unnatural, especially if there are people in your photos. Moving the Saturation slider all the way to zero (strictly –100 in Lightroom) results in a black-and-white image.

The Vibrance slider is similar to the Saturation slider, but it only has an effect on colors that aren't very saturated to begin with. Using the Vibrance slider means that you can add a bit more color to your

← Another sunset, this time balanced to an extreme cool color. A blue sunset? It'll be obvious to everybody who sees the photo that you're guilty of digital trickery, but nobody can deny that it looks unusual, even reminiscent of a night shot.

↑ This photo was taken with an underwater camera just after the photographer re-surfaced from a dive, so the white balance was totally wrong. The effect is quite striking though!

As Shot

Auto

↑↗ This sunrise was captured in Raw for maximum quality and flexibility when editing. The version on the left shows the image "As Shot." The rising sun casts a distinctive red glow across the entire landscape, and the viewer gets a sense of the warmth that the sun brings with it.

The shot on the right has been "corrected" using Lightroom's Auto white balance setting. The software has attempted to make white objects white, resulting in a cooler, bluer image.

↓ You can use different light sources for creative effect. Here, setting the white balance for the white rose inside a restaurant gave a beautiful, dramatic blue background, even though in reality, it was just a normal, sunny day.